THE
POLITICS
OF THE
ARTS COUNCIL

Robert Hutchison

Sinclair Browne: London

First published 1982 by Sinclair Browne Ltd,
10 Archway Close, London N19 3TD

Copyright © 1982 Robert Hutchison

British Library Cataloguing in Publication Data

Hutchison, Robert
 The politics of the Arts Council.
 1. Arts Council of Great Britain
 I. Title
 700'.79 NX750.G7

 ISBN 0–86300–016–9
 ISBN 0–86300–017–7 Pbk

Book designed by Richard Kelly
Photoset and printed in Great Britain by
Redwood Burn Limited
Trowbridge, Wiltshire

For Lizzie

Contents

Preface
and
Acknowledgements

I worked at the Arts Council for five years (1973–78) as Senior Research and Information Officer. My work there covered the whole range of the Council's responsibilities, but my main pleasure in the arts has come from literature and drama, and of all the work that I've seen, heard or read in the last eight years that of the Royal Shakespeare Company has given me the most consistent satisfaction.

Like most Arts Council officers in the 1970s, my job gave me no entitlement to see the minutes of Arts Council meetings or many of the papers considered by the Council: a small deprivation but one that fuelled my curiosity. In Spring 1979 I was given permission by the Arts Council's Secretary-General to read all the main papers and minutes of the Arts Council, and its fore-runner CEMA, up to and including those for 1959. In addition, I had access to a number of files marked 'Keynes' which largely consisted of wartime correspondence between J. M. Keynes and Mary Glasgow, the Arts Council's first Secretary-General. In autumn 1979, in answer to a further request, the Secretary-General wrote to tell me that it was the unanimous view of himself and his colleagues that they could not allow me to go through Arts Council papers and minutes from 1959 to 1979. A year later, the Council agreed guidelines for access to its papers by those involved in research. I was allowed to see all papers and minutes of the Council up to 1978. I am grateful for this, and also for permission to reproduce the Arts Council's written evidence to the House of Commons Select Committee on Education, Science and the Arts (see Appendix A). My thanks also to the Federation of Worker Writers and Community Publishers for

allowing me to reproduce their 'Open Letter to Melvyn Bragg' which was first published in *Voices* 22, Autumn 1980.

I am indebted to the following who granted me interviews, supplied information, or commented on some or all of the first draft of the typescript: John Allen, Robert Atkins, Ian Bruce, John Buston, Gabriel Chanan, Sir William Coldstream, Chris Cooper, Lord Donaldson, David Dougan, Lord Drogheda, Anthony Field, Paul Filmer, Pat Gilmour, Mary Glasgow, Lord Goodman, Robin Guthrie, Joe Hodgkinson, Lord Hutchinson, Terence Hutchison, Timothy Hyman, Mary Kennedy, Lizzie Kessler, Barry Lane, Irene Macdonald, Usha Prashar, Richard Pulford, Ken Robinson, Hilary Rubinstein, Sir Roy Shaw, Peter Stark, Judith Strong, Eric White, John Willett, Lady Gertrude Williams.

Rod Fisher and George Darroch – former colleagues in the Arts Council's research and information section – have always been exceptionally helpful and generous with their considerable knowledge, and the writing of this book would have been more laborious without the use of the excellent library that Rod Fisher and others have built up.

At an early stage this book was to have been a collaboration with Rick Wilford, now of Queen's University, Belfast. The Irish sea came between us and the collaboration did not work out, but I benefited greatly from some conversations with him.

A few paragraphs of chapter 2 were first published in an article in *Entertainment and Arts Management*, May 1980, and a few paragraphs of chapter 4 first appeared in *The Stage*, 14 May 1981. Most of the book was written in the first half of 1981; parts were revised in September, and the complete manuscript went to the publisher in mid-October 1981.

Introduction

This book is a critical examination of the Arts Council, its history, assumptions, policies and practices. It is the residues of history that constitute the present and it is worth looking backwards in order to look forward. However, there is a perilously thin line between insisting that there were real choices, real alternatives at every point of a particular history, and moralising about largely forgotten decisions. The political constraints on expanding public subsidy for the arts in the last 35 years have been formidable, and though the history here is necessarily selective it is mindful of just how dominant are the dominant values in British society.

This is a very unofficial book. It is nothing like exhaustive. There are other books to be written in addition to a thorough social history of the Arts Council: books about the development and influence of the Council's policies in the different art forms; a book comparing arts policies and political structures in this country with those elsewhere; a book about Maynard Keynes, the Council for the Encouragement of Music and the Arts (CEMA), and their influence on what followed. Apart from a few paragraphs in Appendix A there is almost nothing here about Scotland and Wales. This book is biased towards the performing arts because it is in them that most Arts Council subsidy is invested.

Although I do not believe that the case for public subsidy of the arts can be taken for granted, the general arguments for such subsidy have been well expressed elsewhere.[1] State patronage of the arts is now the norm across the Western world and Britain is very low, if not at the bottom, of the league table of public spending on the arts by major European countries.

11

My approach has been thematic: to consider the main parameters of Arts Council policy and ideology and relate these to some of the social and political changes since the Second World War. I have been biased towards sub-dominant arguments, alternative assumptions, partly because they have received relatively little attention, partly because they shed light from a different angle on the assumptions on which the Council's policy has been built, and partly because they are of great importance in considering the future. Those wanting a more comprehensive or more sympathetic account of the Arts Council's history are referred to the books by John S. Harris and Eric W. White.[2] Both are very informative but almost completely uncritical and both are dating fast.

For those not familiar with the Arts Council's work I have included, as Appendix A, the Council's written evidence to the House of Commons Select Committee on Education, Science and the Arts which in 1981 was considering private and public funding of the arts. The Arts Council's evidence sets out, clearly and concisely, the basic facts about the Council and the way in which it sees its own role and functions.

There are many strengths in the system of arts subsidy – the Arts Council does indeed act as a buffer between Governments and artists and it does receive expert advice from a wide range of professionals. But even when all the experts agree they are often wrong, and assertions like that of Lord Goodman that the Arts Council is a 'wholly successful national institution',[3] and of Eric White that 'in most respects the Arts Council's record is exemplary,'[4] are replete with that complacency that is one of the Council's most disabling characteristics. However, achievements in the performing arts in Britain since the Second World War owe much to the discriminating support of the Arts Council which has also itself organised many excellent exhibitions and has an international reputation as a producer of high quality arts films. But these achievements have nourished only a small part of the population and the arts are capable of speaking to, and expressing, everybody's condition.

Allocating arts subsidies is, at best, a complex and subtle process – part science, part art – and the Arts Council's job

involving the constant weighing up of like against unlike is invidious and almost absurdly difficult. But a curious suggestion of the comic surrounds the Council and its servants. This derives partly from the spectacle of earnest and sophisticated, if often aged, members of the liberal establishment trying to come to terms with the more dubious offerings of late modernism, and, more generally, from the social abrasions and flying feathers that are an everyday part of a cockpit of struggle over values.

For the arts are value saturated, and to the extent that it controls resources which create, transform and interpret society's values and norms the Arts Council is an intensely political organisation. Power is not simply the prerogative of governments and parties.

The Arts Council's political power, though by no means unqualified, far exceeds its economic power. Chairmen and Secretaries-General of the Arts Council tend to be in office far longer than Arts Ministers and, in politics, staying power is often crucial. While the average life of an Arts Minister is two or three years, Arts Council Chairmen usually serve for at least five years, and there have been only five Secretaries-General – three of whom previously served as members of the Arts Council – in 40 years of CEMA, and the Arts Council. More importantly, the Arts Council has, for the most part, set its own priorities and since, at least until recently, it was a highly credible and authoritative, though in no senses popular, organisation, its powers of definition and seal of approval have often been decisive. Securing an Arts Council grant has often served to unlock other funds for arts organisations and there are dozens of local arts councils and associations mimicking the Arts Council in their expressed aims of developing the knowledge, understanding and practice of the arts.

The profoundest source of the Arts Council's power lies in its official capacity to conceptualise and to identify the arts and the artistic. The arts are disciplined forms of enquiry and expression through which feelings and ideas about experience can be organised and communicated. Not everyone has the skill, talent, disposition and persistence to be an artist. But even with these attributes, many, and perhaps most, artists

are involved in a struggle for confidence and approval. The Arts Council has done much to fashion how that confidence is meted out, to whom approval is given. More generally, it has served to legitimise and encourage some kinds of creativity and to ignore others. Its actions, definitions and inactions influence the educational system, and the way that the arts are thought about (and forgotten about) in relation to changing approaches to work. Its silences have been as significant as its decisions and proclamations.

Notes

1 The justification for public subsidy of the arts is one of the main subjects covered in *The Economics of the Arts*, edited by M. Blaug, Martin Robertson, 1976. The Arts Council's Secretary-General answers the arguments against subsidy in *Progress and Renewal*, Thirty-fifth Annual Report of the Arts Council of Great Britain, 1979–80. Further articles on the rationale of public support for the arts can be found in *Economic Policy for the Arts*, edited by William S. Hendon, James L. Shanahan, Alice J. Macdonald, Abt Books, 1980.

2 John S. Harris, *Government Patronage of the Arts in Great Britain*, University of Chicago Press, 1970; Eric W. White, *The Arts Council of Great Britain*, Davis-Poynter, 1975.

3 Lord Goodman, 'How civilised are the British?' *The Observer*, 11 Dec 1977.

4 White, *op. cit*, p.11.

1
Politicians and the Arts Council

Governmental support for the arts did not begin with the Council for the Encouragement of Music and the Arts, (CEMA) and its successor the Arts Council. It has developed over the last two centuries out of the royal patronage that included George III's active involvement in the affairs of the fledgling Royal Academy which was founded in 1768. This long history, chronicled in Janet Minihan's absurdly mistitled *The Nationalization of Culture*, throws into relief the debate about state subsidies in the period since the War. No less important in influencing the politics of patronage and subsidy in recent times was the pattern of arts provision and promotion in the 1920s and 1930s. There was no shortage of independent groups, in all the art forms, struggling without public money to achieve resounding artistic results. Responding to the needs of such groups was initially seen as the basic purpose of the Arts Council. And seen in these terms, England in the arts, as in other spheres, was, both before and immediately after the Second War, a nation of small shopkeepers. A desire to run one's own show and deep rooted distrust of bureaucratic interference have combined to keep strong central direction or planning of arts provision off the political agenda. Lord Melbourne's verdict, 'God help the minister that meddles with art', expressed in September 1835, has echoed loudly down the last 150 years. The great strength of the British system of subsidy has been that it has allowed 'creative people to work together in ways which they had shown in pre-war years they wished to adopt'.[1]

The Council for the Encouragement of Music and the Arts, (CEMA), whose work received widespread support and en-

15

dorsement during the War, was a British compromise, dependent on Treasury grants, supervised by a Government department, but with Council members appointed, in theory at least, for their expertise rather than their political disposition, and a staff who were not civil servants. The initial assumptions and constitutional position of the Arts Council were almost identical to those of CEMA, though since the Treasury vote already covered a number of cultural and scientific organisations, the Treasury, rather than the Education Ministry, was made directly responsible for the Arts Council. In 1965, responsibility reverted to the Department for Education and Science (DES) at the time of the white paper *A Policy for the Arts* written by Jennie Lee, the first Minister for the Arts, and in 1979 the small Office of Arts and Libraries (OAL) was separated off from the rest of the DES. Before 1965 the Chancellor of the Exchequer appointed new members to the Arts Council.

The control of resources lies at the centre of politics. In the case of the Arts Council, assessors from the appropriate Ministries attend meetings of the Council, the office of the Comptroller and Auditor-General undertakes the annual audit and the Committee of Public Accounts and Select Committees of the House of Commons are authorised to examine its activities. But formally, at any rate, apart from the Ministerial power to appoint (and dismiss) members of the Arts Council, those are the limits of Governmental scrutiny. No Minister needs to answer questions in Parliament about the Arts Council's work: 'I know of no one who carries weight in Parliament who wishes to bring the Arts Council under political control in the sense of subjecting its artistic decisions to questioning in the House of Commons',[2] a former Minister for the Arts has written.

All this, in the phrase popularised by Lord Redcliffe-Maud, is what is known as 'the arm's length principle',[3] whereby those in Government (including Ministers for the Arts) deny themselves responsibility for the detailed distribution of grants to the arts. But in politics, form and substance are in a complex relationship. The Arts Council has a measure of independence from Government, but it operates within some tightly drawn parameters. 'The arm's length

16

principle' is no more than a convention or series of conventions and, since it is customary for a body to direct its arm, arguably, 'all that is gained by an arm's length is a certain notion of removal of directly traceable control'.[4] In 1956 on the tenth anniversary of receiving its Royal Charter, the Council reported 'no single instance on record of a Chancellor of the Exchequer requiring or directing, or even advising, the Arts Council to do this or not to do that'.[5] But where there are natural expectations, where a bargain is struck, such advice or direction is scarcely necessary. For example in presenting estimates for 1954–5 the Secretary-General wrote:

The Bargain with the Chancellor

The Council will wish to bear in mind the letter from the Chancellor to the then Chairman (9.1.53) which contained the following passage:

'You asked for an assurance that for a period of three years your annual grant should not fall below an agreed level. I cannot give you an absolute assurance, but over the next three years I shall do my best not to reduce your grant for ordinary expenditure below £775,000 unless we find ourselves in quite exceptional circumstances. As part of this bargain I shall naturally expect you also not to ask me for more than this sum unless you find yourselves in equally exceptional circumstances'.[6]

Bargains and natural expectations can be violated. When in December 1980 the Council decided, in a major change of policy, that 41 of its clients were to lose their grants the then Minister, Norman St John Stevas, was not, according to him, extended 'the right to be consulted, the right to encourage, and the right to warn'.[7] Far from being 'in the pocket of Ministers'[8] (as Raymond Williams has suggested) the Arts Council, on this occasion, made a show of its independence and greatly angered the Minister for the Arts by doing so.

Though not in the pocket of Government the Arts Council is a creature of Government, a partner with Government. Take the question of the national companies. In the earliest days, with Keynes as Chairman of Covent Garden and the Arts Council, both Government and Arts Council agreed that Covent Garden should be treated as a special case. There was no arm's length principle here – an addendum to the

17

Council's *Third Annual Report* reads: 'In addition an extra grant of £30,000 was made by the Exchequer for Covent Garden Opera Trust'. This was in addition to a supplementary grant of £38,000 to the Council's funds which was 'voted by Parliament for the further assistance of Covent Garden Opera Trust'.[9] Voted by Parliament, not by the Arts Council. Equally the massive funds to the national companies, including the National Theatre, in the 1970s, have been a product of Governmental, as much as Arts Council, priorities. As Richard Hoggart, who served on the Council for six years, has expressed it:

The Treasury's not daft. It just doesn't give money to the Arts Council who goes along and says we want £12 million for theatre. It has to have an indent, it has to look at what the money's for and one of the things the money's for is a big chunk for the National which has been put up by the Government and which is a jewel in our crown for tourists and goodness knows what.[10]

In writing about the 'juggling with monies' necessary to fund the National Theatre's occupancy of its South Bank buildings, Hugh Jenkins wrote: 'In my experience a Labour Government will find increasing sums for the arts providing the Minister is insistent and ruthless'.[11] Such insistency and ruthlessness can rebound on the Arts Council, the Minister's most important client. In May 1975 the Council's Chairman reported that:

the Council could expect a revenue grant for 1976–7 of £26.5 million, which was £1.5 million more than this year. However, there were certain conditions attaching to the increase in that the Minister had made it clear that he had only been able to secure this increase on the understanding that the Arts Council would use whatever proportion of it was required to support the National Theatre in its new theatre.[12]

It is not only certain special grants for a specific purpose that have to be approved by the parent Ministry before being distributed by the Arts Council, but the general direction of the Council's spending in any year has to be approved by Government. The Council's budgets, itemised by categories of expenditure, are published each year in the Civil Estimates, and the civil servants of the Office of Arts and

Libraries (OAL) are, according to the OAL assessor on the Arts Council, 'in day to day and almost hour to hour touch with the details of what goes on'.[13] Appointments to the Council itself are usually negotiated between the Minister for the Arts and the Council's Chairman. The reorganisation of the Arts Council in 1979–80 was encouraged by the Office of Arts and Libraries to bring Arts Council practice closer into line with that of the Civil Service. In pay and grading of posts the Council has always been tied to civil service assessment criteria and, in 1979, the Council's Organisation Working Party found it 'unacceptable that in a number of cases, involving senior posts as well as middle management, it has taken several years of argument with the DES to secure agreement for straightforward promotion involving one step up the grading structure'.[14]

The independence of the Arts Council is heavily qualified by these ties and understandings with Government departments. More generally the Arts Council has to, and does, work within the grain of Government policy.

Political Parties and Arts Ministers
Between the general elections of 1945 and 1979 Labour and Conservative Governments held office for roughly a total of 17 years each. Their respective influences have been less obvious in arts policy than on the structure of broadcasting – where Conservative Governments have tended to pave the way for commercial interests. But while a generally bipartisan approach to the arts has provided some security and a continuity of funding for, and through, the Arts Council, the priorities of the two main parties and the personalities of Ministers have produced changes of emphasis in the pattern of public subsidy.

Between one-third and one-half of central government money to the arts, museums and libraries is channelled through the Arts Council (of the rest the biggest allocations go to the national museums and galleries and the British Library), and Ministers for the Arts help to define the broad outlines of the Arts Council's work. In the 1940s, (long before the appointment of the first Minister for the Arts), the Chancellors of the Exchequer, Hugh Dalton and Stafford

19

Cripps, were important in making a 'special case' out of Covent Garden. But it was not until 1959 that either of the main political parties issued a major policy statement about the arts and they were, to some extent, stirred into activity by the increasing willingness of the Arts Council's Secretary-General in the 1950s to pronounce strongly on the needs of the Council and its clients. The titles of the Council's Annual Reports in the 1950s tell some of the story: 'Public Responsibility for the Arts' is the sober message of 1953–4, but by 1956–7 the slogan has become 'Arts in the Red' and 1958–9 'The Struggle for Survival'. In 1959 the Labour Party first declared (somewhat prematurely in view of recent debates) that the principle that public money ought to be spent on the arts received universal acceptance, and accused Conservative policies of showing an 'almost doctrinaire niggardliness'[15] towards the arts.

There is much in this book about the advances made and the arguments provoked in the second half of the 1960s when that remarkable *pas de deux*, Jennie Lee and Lord Goodman, both of whom had a close relationship with the Prime Minister, added to the gaiety of sections of the middle-classes, and, in the days of single-figure inflation helped to treble the grant (from £3.2 million in 1964–5 to £9.3 million in 1970–1) distributed by the Arts Council. Between them they put the Arts Council on the map and did much to expand the range of the Arts Council's work, and the Arts Council put Lord Goodman on the map and expanded the range of his work.

The 1964–70 Wilson Government put more emphasis than its predecessor on an administrative framework for regional development and this was reflected in a small way in the appointment of a Chief Regional Adviser at the Arts Council. But, like all her successors, Jennie Lee sought rather to increase the pool of financial resources available to the arts rather than to use her influence to redistribute the available resources. Lord Eccles argued strongly in favour of the development of Regional Arts Associations, many of which came to life, and all of which made considerable progress, during his 3½ year Ministership (1970–3). Eccles – who achieved notoriety for his abortive attempt to introduce

museum charges – also placed great emphasis on marketing the arts and on the better coordination and use of existing facilities. He initiated the four experiments in 'Leisure and the Quality of Life' in Stoke, Sunderland, Clwyd and Dunbartonshire, experiments which would have had a more lasting impact had the Arts Council been more research-orientated.

The careers of Hugh Jenkins (1974–6) and Lord Donaldson (1976–9) as Ministers for the Arts were in marked contrast. Jenkins, who had the advantage of having previously served on the Arts Council, tried to encourage and cajole it in the direction of greater democracy, and was removed from his job for his troubles. He suffered remorselessly at the hands of the press but fought well, if not always wisely, for what he believed in, which included a heavily-funded National Theatre, and a wealth tax from which works of art should not be excluded. Jenkins failed in his wealth tax proposals, in trying to introduce Public Lending Right (PLR) and in his attempts to make the Arts Council more democratic, because he could not win much support from fellow Ministers, even though the Labour Government in October 1974 promised 'to bring forward proposals to make the Arts Council more democratic'.[16] Baronial power, the Lords Goodman and Gibson in particular, proved stronger than the elected Jenkins and the Labour Party manifesto. Donaldson came from that old Etonian stable which has been peculiarly prominent in the politics of the arts. His brief spell as Junior Minister in Northern Ireland was likened to the Raj: 'always sunny, with the genial and welcoming Jack Donaldson on the terrace of the colonial setting of Stormont Castle'.[17] 'Whatever happened to the Minister for the Arts?' provided a recurring theme for journalists during Donaldson's three years in the post. In fact Donaldson stomped the country a good deal[18] and made three particular contributions: he secured substantial increases in the purchase grants for the national museums and galleries, and he helped both to establish the National Heritage Fund and to secure an initial government contribution of £1 million to the Covent Garden development fund. He summed up his attitude in a sentence to the House of Lords in 1977: 'As a member, however humble, of this Government, I do not feel that I can quarrel with my leaders,

21

so long as at least they maintain and do not decrease Government support for the arts'.[19] Donaldson's approach, unlike that of Jenkins, was virtually indistinguishable from that of a Conservative Minister. In matters of arts policy the period 1974–79 provided confirmation of the fact that socially conservative pressures can command greater power than their political representation at Westminster might suggest.

Norman St John Stevas, who had enjoyed a three month spell as Minister for the Arts before the February 1974 General Election returned to the post for 19 months in spring 1979 and soon had to be party to an unprecedented cut in the arts budget. At the end of 1979 Stevas announced that:

The arts world must come to terms with the fact that Government policy in general has decisively tilted away from the expansion of the public to the enlargement of the private sector.

The Government fully intends to honour its pledge to maintain public support for the arts as a major feature of policy, but we look to the private sphere to meet any shortfall and to provide immediate means of increase.[20]

Stevas established a Committee of Honour on Business Sponsorship 'to create a favourable climate in which sponsorship can become an accepted means of fund-raising',[21] and to supplement the work of the Association of Business Sponsorship of the Arts (ABSA) which was established in 1976. The Arts Council has made its attitude to business sponsorship admirably clear. Sir Roy Shaw, in an important speech in October 1980, welcomed business sponsorship, rehearsed the limitations and temptations inherent in it, and made some positive suggestions for its future. He said that sponsors 'might consider the need to direct more funds to smaller and less prestigious arts organisations' and that they should 'look more to the needs of the regions'.[22]

It has been estimated that in 1979–80 business sponsorship contributed less than 1½% of total contributions to the arts and museums in Britain (excluding box office and other earned income),[23] yet it is around the question of the relative importance of private and public funding that much of the politics of the arts revolves.

House of Commons Committees

The House of Commons Select Committee on Education, Science and the Arts is investigating the balance between private and public funding in 1981–2.

The two previous large-scale enquiries into the funding of the arts by House of Commons Committees served mainly to reinforce complacency. In both cases (1948–9 and 1967–8) the Arts Council made propaganda out of the generally positive conclusions of the Committees while brushing aside the suggestions from both of them that more democratic arrangements were desirable in the conduct of the Council's business.

Grants for the Arts, the 1967–8 report of the Estimates Committee was subsequently described by Lord Goodman as 'a report of informed but almost unqualified approbation'.[24] But Sub-Committee B of the Estimates Committee, chaired by Renee Short, was not fully informed on its subject; it was almost entirely concerned with the performing arts, when the Arts Council's work also covered the visual arts and literature, and practising artists were, for the most part, noticeable by their absence among those from whom the Committee took evidence.

'Almost unqualified approbation' is even more misleading. The Committee raised serious doubts about the Arts Council's assessment methods, considered that the Council should give more positive encouragement to local authorities, criticised it for taking decisions on too little information and also for its role in creating a situation in which orchestral musicians in London tended to earn twice as much as those in the regions, and expressed concern that consequent upon a 300 per cent increase in rent when the Arts Council changed its headquarters 'so much more has had to be spent on something other than direct support for the arts, out of a very limited store'.[25]

The Arts Council is part of that substantial element of government carried out beyond the Civil Service by non-departmental bodies. Quangos (quasi-autonomous non-governmental organisations) were the subject of some fierce general attacks by Conservative MPs in the run-up to

the 1979 general election. Across the political spectrum the accountability of quangos is constantly questioned and there is also widespread concern about the number of appointments in the patronage of Ministers. In 1980 the Government published a sober White Paper on non-departmental public bodies and, since then, though a number of obscure and lesser spotted quangos have disappeared, fears of a quango-cull have receded.[26]

Both in theory and in practice the case for central Government subsidy of the arts through an Arts Council is now well-rooted. It will need some major and unforeseeable shift in British political or economic circumstance for the Arts Council to be abolished or for its grant-in-aid to be cut in the drastic way suffered by the National Endowment for the Arts in the USA through the activities of the incoming Reagan administration. However its strong roots do not remove the Arts Council from the political arena. Quite the reverse: the arguments over ways of stimulating the trading position of arts organisations through the use of public money and through legal and fiscal measures, the respective merits and importance of central and local and of private and public funding of the arts, the desirability and pace of devolution, the balance between democracy and efficiency, and between the funding of 'high' and popular arts – all these will be the subjects for intense debate. And policies for employment, for broadcasting, for education, for tourism, all have a direct bearing on the patterns of arts provision.

Notes

1 Sir Hugh Willatt, 'How the arts are promoted' in John Pick (ed) *The State and the Arts*, John Offord, 1980, p.35.

2 Hugh Jenkins *The Culture Gap*, Marion Boyars, 1979, p.189.

3 Lord Redcliffe-Maud *Support for the Arts in England and Wales*, Gulbenkian Foundation, 1976, pp.24–5.

4 Raymond Williams, 'The Arts Council', *Political Quarterly*, Spring 1979, p.159.

5 *The First Ten Years*, the Eleventh Annual Report of the Arts Council of Great Britain 1955–6, p.15.

6 Council Paper 339, 'Draft Estimates 1954–5', 17 November 1953.

7 Norman St. John Stevas, 'How not to axe the arts', *Sunday Times*, 8 March 1981.

8 Raymond Williams, *op. cit*, p.159.

9 *The Arts Council of Great Britain Third Annual Report 1947–8*, Addendum and p.6.

10 'The National Theatre: Whose System Is It?' BBC Open University broadcast 1980.

11 Hugh Jenkins, *op. cit*, p.109.

12 Minutes of the Arts Council Meeting 28 May 1975.

13 Minutes of Evidence Taken Before the Select Committee on Education, Science and the Arts, 4 February 1981, para.156.

14 Arts Council of Great Britain, *Organisation and Procedures Report of the Working Party*, 1979, p.22.

15 Labour Party, *Leisure for Living*, 1959, p.12.

16 *Labour Party Manifesto*, October 1974, p.17.

17 Michael Davie, 'No job for a gentleman', *The Observer*, 27 February 1977.

18 Donaldson wasn't always sure of his whereabouts. Opening a bookshop in Exeter, he announced how pleased he was to be in Plymouth.

19 *Hansard*. House of Lords, 10 February 1977, columns 1275–6

20 Norman St. John Stevas 'The Tories and the Arts', *The Observer*, 14 October 1979.

21　Memorandum submitted by the Office of Arts and Libraries to the Select Committee on Education, Science and the Arts, 4 February 1981, para.2.6.

22　See Sir Roy Shaw, 'Business Sponsorship and Public Subsidy' *Arts Council Information Bulletin*, no.37, January 1981.

23　*Arts Council of Great Britain, what it does*, p.7.

24　Lord Goodman, 'How civilised are the British?', *The Observer*, 11 December 1977.

25　House of Commons Select Committee on Estimates, Eighth Report, 1967–8, *Grants for the Arts*, para.44. See also paras.28, 92, 113, 115.

26　Receded, not disappeared; the agenda for the Conservative Party Conference at Blackpool in 1981 included a score of motions urging the Government to reduce 'the excessive number of Quangos that continue to flourish'. There was also a single motion (in a list of 1162 motions) calling for the abolition of the Arts Council.

2
Truly Impartial? or the Making of the English Opera Class

'We believe it is essential that the Council should be free from tied interests or allegiances. Members should be truly impartial in their decision-making'. This, according to the Arts Council's recent Organisation Working Party, chaired by Lord Hutchinson, 'was regarded as an important principle from the earliest days'.[1] But was it? Was Keynes as chairman of the Arts Council truly impartial in dealing with Keynes as chairman of Convent Garden Opera? For by agreeing to be the first chairman of both organisations Keynes set the basis of the relationship, which has been as close as that of Siamese twins, between the Arts Council and Covent Garden (later called the Royal Opera House). Again, at the first meeting of the Arts Council's Executive in February 1945, Keynes argued that as the function of the Arts Council's panels was to be a purely advisory one, 'there was no reason why they should not be composed largely of those working in association with CEMA and receiving the Council's help.'[2] But since the Arts Council has usually taken notice of the advice of its panels and committees, and rubber-stamped their grant recommendations, select groups of mice were given a lot of responsibility for distributing the cheese. Vested interests were fully involved in the Arts Council's decision-making from the outset, not as representatives or delegates, just as vested interests.

In the case of the Royal Opera House (ROH), always by far the most heavily subsidised of the Arts Council's clients, the facts are stark indeed. Between 1946 and 1981 there have been 47 Trustees and directors of the Royal Opera House.[3] Four of them – Lords Keynes, Clark, Goodman and Gibson – have

also been chairmen of the Arts Council. A further six – Sir Stanley Marchant, Edric Cundell, The Earl of Harewood, Sir William Coldstream, Sir William Glock, Sir John Pope-Hennessy – have served as full members of the Arts Council. Angus Stirling was Deputy Secretary-General of the Arts Council; Sir Steuart Wilson was on the Board of the Opera House while serving as the Arts Council's music director, and later was Deputy General Administrator of the Opera House. Samuel Courtauld and Sir Colin Anderson served on the Arts Council's Art Panel. Sir George Dyson was CEMA's director of music and Sir Barry Jackson served on the CEMA drama panel. The Hon. James Smith was on the Council's short-lived Opera and Ballet Panel. In the mid-1970s the Hon. Wynne Godley chaired an Arts Council enquiry into lyric theatres in London and in the late 1970s Sir John Sainsbury was on the Council's Organisation Working Party. That is 19 out of 47 Opera House Board members with direct CEMA or Arts Council experience. It might be argued that only Keynes was simultaneously chairman of the Opera House Board and of the Arts Council, but four Opera House directors have been simultaneously members of the Arts Council. And the human bonds, the ties and allegiances, the traffic in staff and advisers between the two organisations has been still more extensive: David Webster, who for more than two decades was the general administrator of the Royal Opera House, had previously served as CEMA's financial adviser. D. P. Lund was the ROH Secretary and Accountant from 1946 to 1972 and for fourteen of those years was also the Arts Council's accountant.

Written in the 1970s, mostly about the middle four decades of the century, Kenneth Clark's two volumes of autobiography and Lord Drogheda's memoirs provide vignettes and anecdotes important to a full understanding of the politics of the arts in Britain. Clark and Drogheda exerted authority and considerable power in a range of different roles and their *obiter dicta* and depiction of scenes from what Clark calls High Society are very revealing. As a source of information on the Arts Council Clark hardly wins readers' confidence by telling us 'that I cannot remember a single thing that I did there',[4] but by that point he has already spilled some important beans.

Consider this, in its ingenuousness:

When I was at Oxford, a young Don, who believed himself to be a judge of character, said to me 'You have no loyalties, outside your family'. This was, and has remained, true: with one exception: the Royal Opera House, Covent Garden. For thirty years I have not only enjoyed performances there, but have developed an affection for the whole place – the auditorium, the foyer and the members of staff, which is like a family feeling. Not being able to go there during the seven or eight years of Jane's illness was the only deprivation that I really minded; and the fact that my daughter has become the first woman to be a director of Covent Garden, and loves it as much as I do, is one of the things in my life that has given me most pleasure.[5]

No shadow of a suggestion there (or elsewhere) that there might be a conflict of interest between his family feeling for the Royal Opera House and his role as Chairman of the Arts Council. Quite the reverse; as Lord Drogheda puts it, though as Clark *might* have put it, when Clark became chairman of the Arts Council, 'for the Opera House it was extremely valuable to have at the helm of the Government's disbursing agency for the Arts someone who has first-hand experience of some of the problems'.[6]

Shortly before Sir Kenneth Clark's term of office ended at the Arts Council the system of appointment to the Royal Opera House Board was discussed at the Arts Council:

The Chairman reported that as a result of further talks and correspondence with Lord Drogheda and Mr Trend of the Treasury it had now been agreed that although the Royal Opera House had the right under its articles to re-appoint retiring Directors, this right would not be used to produce an 'indefensible degree of self-perpetuation'. A letter from Mr Trend of the Treasury explained this to mean that there would be no objection if, in any one year, the Board were to re-appoint members due to retire, provided that over a period of five years there was a 'reasonable degree of change in the composition of the Board'. It was assumed that this arrangement would apply to the Chairman as well as to the other members of the Board. For this purpose the Board's proposals would be submitted to the Arts Council for discussion with the Treasury and either the Treasury or the Council would be free to dissent in any particular case.

The Chairman said these proposals had been accepted by the

Treasury and Covent Garden and *it was agreed* that this represented a satisfactory solution of the problem.[7]

But has there, over five year periods, been 'a reasonable degree of change in the composition of the Board'? Of the thirteen Board members listed in the ROH Annual Report for 1979–80 five had served on the Board for 15 years or more, and a further five for 5 years or more. The 13 Board members had served for an average of 11 years each, a figure that went down to 9 years when two of them retired in 1980. A reasonable degree of change? And the 1960 assumption that 'this arrangement would apply to the Chairman as well' did not prove justified. Lord Drogheda served on the Board for 20 years, 16 of them as chairman. By 1981 his successor Sir Claus Moser had been on the Board for 16 years, 7 of them as chairman.

The somewhat incestuous world of opera house politics can be characterised further: 13 of the 46 male members of the ROH Board since the war went to Eton and over half to one of five public schools; most went to Oxbridge; most were members of one or more of three London clubs: the Athenaeum, Brooks and the Garrick. The 1979–80 ROH Board was of similar composition to the ROH Boards that have gone before it. Of its 13 members two have been chairmen of the Arts Council and one had been its Deputy Secretary-General, there are three Old Etonians and an Old Wykehamist, there are four peers and four knights, five who have been leading academics and four who have civilised the image of commerce (Burnet Pavitt who retired from the Board in 1980 at the age of 73 represented the unacceptable face of capitalism having worked for years for the international drugs company Hoffman La Roche. But what is important for the family feeling was that he was a kindred spirit of Lord Drogheda's wife 'with music making, often on two pianos, only one of their many bonds').[8] Three ROH Board members in 1979–80 were, or had been, trustees of the National Gallery.

And this overlapping and multiple-holding of trusteeships, directorships and advisers is characteristic of the national companies, national galleries and the Arts Council.[9] Of the 57 trustees of the Tate Gallery since 1946, 25 have served either

on the Arts Council or on its art panel, or both. The present Chairman of the Tate Gallery's trustees and the gallery's present director are former members of the Arts Council. 8 of the 61 trustees of the National Gallery since the War have been Board members of the Royal Opera House and a dozen have been on the Arts Council or its art panel. Eleven past and present members of the Arts Council have also served on the Board of English National (formerly Sadler's Wells) Opera; and the Earl of Harewood, the Managing Director of English National Opera is a former member of the Arts Council and of the Royal Opera House Board.[10] All seven chairmen of the Arts Council have also served, often as chairmen, on the governing bodies of one or both of the national opera companies.

It is, of course, a masculine and metropolitan world: Kenneth Clark's daughter has been the only woman member of the ROH Board and Clark's wife was on the Board of Sadler's Wells Opera. But outside the Clark family women have usually been overlooked when appointments to the Arts Council or the governing bodies of national companies and galleries have been made. In 35 years there have been only two women trustees of the Tate Gallery and only four women trustees of the National Gallery.[11] Comparing the social composition of the Arts Council at the end of the 1970s with that thirty years earlier one sees that little has changed. The Council was slightly smaller in 1949–50 – 16 as opposed to 20 in 1979–80. The titled and landed are much less prominent now than in the 1940s and the growth of academe and the power of television is reflected in the present make-up of the Council. But whereas there were 13 women among the first 66 appointments to the Arts Council (between 1945 and 1966) there were only 9 women among the next 66 (appointed between 1967 and 1980). More significantly, of the 19 people who have served on the Arts Council for seven years or more, only one has been a woman. And still, at the end of 1981, nobody under 30 has ever served on the Council, ethnic minorities have been grossly under-represented and a document prepared by a working group of Arts Council and RAA directors did not find it possible to justify the present disproportionately low level of regional membership on the

31

Arts Council. In recommending that appointments to the Arts Council should provide a better balance of regional membership, the working group notes that 'similar recommendations have been made in the past and have apparently been accepted by those concerned. But in practice there has been very little change'.[12]

From the first there have been important links into Government. R. A. (later Lord) Butler played an important part in the discussions that turned CEMA into the Arts Council. He is the son-in-law of Samuel Courtauld, a great benefactor in the visual arts who, for fifteen years, was a trustee of the National Gallery (for much of that period Kenneth Clark was its director), was one of the first trustees of the Royal Opera House and also a member of the Arts Council's art panel.

The first chairman of the National Theatre, Oliver Lyttelton (later Lord Chandos) and the longest serving chairman of the Royal Opera House (Lord Drogheda) shared a wartime residence. Drogheda was Lyttelton's private secretary and Lyttelton was Minister of Production in Churchill's war cabinet. Previously Drogheda had worked in the war cabinet secretariat where he had met Norman Brook (later Lord Normanbrook), Sir Edward (later Lord) Bridges, and Ronald (later Sir Ronald) Harris, all of whom were subsequently at the Treasury and helpful to Drogheda when he was chairman of the Opera House (from 1958 to 1974). And Drogheda's predecessor as chairman of the Opera House was Lord Waverley, formerly Sir John Anderson, of Anderson shelter fame. Although his knowledge of opera and ballet were minimal 'it was thought quite rightly that he would be pretty good at finding his way through the Whitehall maze'.[13] It was Anderson who, as Chancellor of the Exchequer, announced in the House of Commons in June 1945 the Government's decision to continue the existence of CEMA as the Arts Council of Great Britain.

So the links between the Government, the Arts Council, the Royal Opera House and the embryonic National Theatre were forged in the heat of wartime. And these links are not just of historical interest. For, although changes of Government obviously have their effects on appointments, there are

necessary continuities in the perpetuation of the oligarchy. It would be possible to trace many of the continuities and the school, family and business links, the old persons networks, in more detail: the links between the Angleseys and the Donaldsons,[14] between the Opera House and Lord Cowdray's business empire, between the Droghedas and the Rothschilds, between the Clarks and Bloomsbury. Of the twelve men (and one woman) who have served either as Chairmen of the Arts Council or as Ministers for the Arts, eight went either to Eton or Winchester. The appointment of Paul Channon as Minister for the Arts in 1981 has interesting echoes across two generations. For it was on the recommendation of Paul Channon's father, 'Chips' Channon, that the Droghedas spent their honeymoon in 1935 in a castle belonging to a German count. And just before the honeymoon Lady Drogheda had the misfortune to let the bath overflow at Lord and Lady Anglesey's country house. But Lady Anglesey was very understanding, and her daughter-in-law was a member of the Arts Council for most of the 1970s.

In allocating resources and making key appointments, a few have wielded a lot of power, have effectively governed the growing subsidised arts world. Oligarchy, in this case, is the result of a system of Government by patronage. How then are appointments made? The details, as Raymond Williams, who served on the Arts Council for three years, has said, 'are shrouded in the usual mellow dusk'.[15] But Kenneth Clark is interesting about the appointment of Keynes' successor:

The Treasury has a principle that a volatile chairman, and in Keynes' case a brilliant one, should be succeeded by what the eighteenth century used to call 'a man of bottom'; and they discovered an amiable example in Sir Ernest Pooley, who was warden of the Draper's Company. Having no interest in the arts he could be relied on not to press their claims too strongly.[16]

Clark succeeded Pooley seven years later and he too could be relied on not to press the claims of the arts, or at any rate of the Arts Council, too strongly. 'I am not in favour of giving the Arts Council a very much larger grant because I think it will simply get itself into trouble',[17] he told the House of

Commons Select Committee on Estimates in 1949, a year in which the Arts Council's total grant-in-aid was less than 1 per cent of what it is now.

Clark also tells us that Pooley 'set himself to get rid of'[18] the then Secretary-General, Mary Glasgow. W. E. Williams, who had already had a long and distinguished career in adult education, made it clear that he was available for the job. A few years earlier Williams had written: 'But wherever we dare to decide woman's "place" should be, we must make an end of the mischievous delusion that woman is the lesser partner in citizenship and government. Whether rearing babies or wiring aeroplanes, she is a full partner in running the national show.'[19]

Except, Williams failed to add, that part of the national show called the Arts Council for most of its first 35 years. During the ten years from the late summer of 1950 three women served as Arts Council directors (one Secretary-General, one Regional Director, one Director for Wales). The three were either dismissed from their posts, or asked for their resignations or offered demotion. There was no woman director of the Arts Council between 1960 and 1978,[20] although three of the directors appointed since 1978 have been women.

Certain key appointments in the subsidised arts have not been made in consultation with the members of the oligarchy who might reasonably have been involved, but by an oligarchy within an oligarchy. For example, when Peter Hall was appointed in 1971–2 to succeed Lord Olivier as Director of the National Theatre the appointment was not even discussed at Board meetings and at least one board member only heard about it when it was a *fait accompli*.[21]

As to how the important Panel Chairmen of the Arts Council are appointed, it is, according to Raymond Williams,

... the mellow dusk again.... There was one case when a Chairman of a Panel resigned from the Council; a successor had to be found. I kept expecting the matter to be raised in Council, but the next I heard of it was from an acquaintance who seemed to be negotiating the scope of his task as the new Chairman with the relevant departmental officer.... In another case, an existing member

became Chairman of an important Panel by a process of private con-
sultation between the Chairman of the Council and its officers.
Given the fact that Chairmen of Panels can serve longer terms than
ordinary members, this is of course a clear case of administered con-
sensus by co-option.[22]

The Arts Council system of advisory panels is a further
part of the Keynesian legacy, though R. A. Butler, then Presi-
dent of the Board of Education, actually set up the first three
CEMA panels (for Music, Drama and Art) in 1942. Keynes
chaired all three and initially it was agreed that their decisions
would have the full force of Council decisions; but, by July
1943, Keynes found that he couldn't attend Panel meetings
regularly and he became dissatisfied with the Panels as they
had tended to usurp the functions of the Council and from
then on the panels were relegated to an advisory role only and
were chaired by a member of the Arts Council, not the
Chairman of the Arts Council. It is this basic model of
internal organisation that the Arts Council still operates,
although the number of panels and committees grew steadily
for three-and-a-half decades until a large number of them
were axed, and the numbers serving on them were pruned, in
the wake of the Council's Organisation Working Party report
of 1979.

On major policy questions the system of panels and com-
mittees is often by-passed. For example, opera subsidy
consumes a large part (approaching 25 per cent) of the
Council's general expenditure on the arts in Great Britain but
questions of opera policy have frequently been played very
close to the chests of senior Arts Council members and direc-
tors. At a meeting of the Music Panel in May 1953:

The Panel was reminded by the appearance on its agenda of a report
on the Carl Rosa Opera Company that, for some years past, opera
has not been part of its terms of reference from the Council. They
wish to call the Council's attention, at this juncture, to the fact that
opera is an integral part of the art of music, the exclusion of opera
from this purview is not warranted either by history or by the
present increase of interest in opera. The Panel would welcome the
opportunity of offering its advice and comments on the operatic life
of the country.[23]

Much more recently a research report, funded by the Social Science Research Council, on whether cost-effectiveness ideas could be used in the Arts Council, took opera as an example of the Arts Council's work, and concluded that 'overall policy discussions on opera do not take place, or if they do it is between small informal groups not reporting to any body'.[24]

On numerous occasions over the last 35 years, members of Arts Council panels and committees, both individually and collectively, have expressed dissatisfaction with the discrepancy between their responsibilities and their powers, dissatisfaction with the fact that they often appear to have made decisions when in reality they have only acquiesced in them.[25]

How are the panel members themselves appointed? In 1967 Lord Goodman told the House of Commons Select Committee on Estimates: 'I think it is true that suggestions are made about appointments by other members of those panels, by members of the Council and by the directors themselves. . . . Usually they are people of established position and distinction in that particular art.'[26] In the 1970s the 'trawl' for possible new panel members was widened and in 1977 the procedure for appointment to panels and committees was systematised when a committee, chaired by the Council's Vice-Chairman, was given responsibility for recommending such appointments and re-appointments to the Council.

The arguments for an elected element on the Arts Council
The complete reliance on appointment as a method of choosing people to serve on the Arts Council and its panels and committees was criticised from very early in the Council's life. In its evidence to the 1948–9 Select Committee on Estimates the British Actors' Equity Association argued:

That the Arts Council lacks continuous contact with the people, employers and the employed, who work in the various fields which it covers. This lack of contact springs, we believe, from the fact that the members of the Arts Council and of its advisory panels are nominated individuals responsible to no one but themselves. In practice this makes for the autocracy of a small group of officials. . . . The remedy we propose . . . is that the Drama Panel

should include a proportion of members elected by theatrical orga-
nisations and responsible to those organisations. Each panel in turn
should elect at least two representatives to the Arts Council itself. In
this way it should be possible for the organisations of the theatre,
authors, managers, artists and musicians to receive regular reports
on the work of the Arts Council and to raise matters on which they
seek information.[27]

And nearly twenty years later another Select Committee on
Estimates report produced as its first recommendation that:

The Arts Council should carry out, in conjunction with the bodies
representative of artists in the arts supported by the Council, a study
of how performing artists (including theatre directors) can be more
fully and directly represented on the Arts Council and on its Panels.
The relevant appointments should be made at the earliest oppor-
tunity thereafter.[28]

The Arts Council responded to the recommendation by
providing lists of theatre directors, managers, performers,
writers and artists who had served on the music and drama
panels and on the Council in the previous ten years. The
Council also stated that for individuals to act as representa-
tives of outside associations 'would entail a fundamental
departure from a principle which the Council has hitherto
adopted in its own appointments, and which has been
followed by successive Ministers in making appointments to
the Council – that members should be free from any ties to
appointing bodies'. This response was wholly in accord with
the view of the then Secretary of State for Education and
Science, Edward Short, and so the study recommended by
the Select Committee was never carried out.[29]

It was not until Hugh Jenkins became Minister for the Arts
in 1974 that the question of having an elected element on the
Arts Council was raised again. Hugh Jenkins has written his
own account of how he 'tried to get away from the present
position in which the Government appoints a group of all-
powerful poodles and then throws away the lead'. Such a
group, which does not derive any part of its authority directly
from artists or the public, operates, Jenkins argues, 'out of
consciousness of its own worth: it has no other justifi-
cation'.[30] Jenkins' proposals for having a sizeable elected

element on the Arts Council and its panels have never been entirely clear. Like Raymond Williams, in his article on the Arts Council in *Political Quarterly*, Jenkins in his book does not fully confront the difficulties of deciding precisely which arts organisations should be represented on the advisory panels. But he had one clear proposal:

I wrote to Gibson on 5 August 1975 proposing that, as a gesture towards democracy, the Drama and Literature Panels should be invited to choose their own chairmen whom I could then appoint to the Council. . . . Gibson did not reply to my letter until 21 August and it was clear that he had explored the ground in the meantime and had come to the conclusion that he could safely defy me. For he retracted from his earlier attitude of reluctant readiness to move a little in my direction. He said that I was asking him to change the character of the Arts Council and this he point blank and quite brusquely refused to do.[31]

Later Gibson argued that 'Mr Jenkins confuses syndicalism and democracy.... He is advocating syndicalism.... It would lead to a total disaster'.[32]

But Jenkins was not alone in wanting advisory panels to elect their own chairman and have that person serve on the Council. This has been sought by a number of panels and committees. The Council has always resisted such moves and its Organisation Working Party (OWP) reporting in 1979, made two objections to them: that members of the Council should not be answerable to any particular electorate, they are there to serve the wider public interest, and that 'were such an elected member to turn out incompetent or unsatisfactory on the Council, acute problems would arise as to the Minister's and Chairman's positions as regards his or her removal'. The latter objection seems exaggerated – many a Minister and Chairman has courageously dealt with more acute, and less everyday, problems. But is it possible for an Arts Council member both to satisfactorily serve and represent, say the Drama Panel, and be responsible to 'the wider public'? This can be seen as a specific question in the general challenge of finding alternatives to excessive Ministerial patronage. Well, why should the balanced judgements of those elected (but not mandated) be intrinsically less virtuous or sophisticated than those of the appointed? Richard Hoggart, formerly Vice-

chairman of the Arts Council, has admitted that some members of the Council owe their nominations 'more to their membership of a quite small, upper bourgeois "cultivated" in-group than to their likely grasp of Council matters'.[33] And, of course, the positive side of the argument is vital: no other single measure is likely to do more to improve the often strained relations between Council and a panel or panels.

If the main panels and committees, which cover the major responsibilities of the Council, provide one set of readily identifiable and broadly-based constituencies for elections to the Council, another is provided by the Regional Arts Associations, which exclude no legitimate (or illegitimate) arts interest-group from their activities. To avoid the cumbersome procedures advocated by the Labour Party's 1977 policy paper on the arts, the governing bodies of the twelve RAAs in England could together form an electoral college to choose, though not necessarily from their own members, say 6–8 members of the Arts Council. Arts Council members elected in this way would not be delegates and the form of their election would militate against their unilaterally advancing the interests of a particular RAA. But a further democratic element would have been introduced into the Council's life, and people overlooked by the Minister (and his advisers) will have a chance of serving the Council, which is still committed to devolution of responsibility for regional activities. The OWP argued that the result of having an elected element on the Council (and the proposal here is that the Minister should still appoint about a third of the Council's members) would 'certainly be to create a wholly different type of Council'.

Isn't there a whiff of superstition, some irrational fear of the unknown, about that assertion? Wholly different? And the OWP's reasoning goes askew at this point for though a wholly different Council is envisaged, an elected Council would only be (in the OWP's words) 'a facile bow to democracy'.[34] The changes wrought by a facile bow!

Nobody is wholly impartial or totally free from tied interests and allegiances. Even a man of such obvious integrity as the late Lord Boyle was willing to use his place on the Arts Council to try to advance the interests of his friends the Maudlings. In the mid-1960s Mrs Maudling was much

involved in fund-raising for the Adeline Genee Theatre at East Grinstead and Sir Edward did what he could to interest the Arts Council in the project.[35] That the Arts Council is the body with a trusteeship on behalf of the nation for the arts should be perfectly clear, and it is no less clear that any elected members would have wider responsibilities than simply those to the people that elected them. The argument for introducing an elected element onto the Arts Council is not only an argument against oligarchy but also an argument for invigoration, for letting more approaches to the arts contend. But the forms of election described above, the retention of an appointed group on the Council and the by now quite lengthy traditions of the Council would all serve to minimise the possibility of the Council being reduced to a set of competing sub-units.

Notes

1 Arts Council of Great Britain, *Organisation and Procedures*, Report of the Working Party, 1979, p.26.

2 Minutes of Arts Council Executive Meeting 14 February 1945.

3 From February 1946 to March 1950, the governing body of the Opera House was called the Covent Garden Opera Trust. The Royal Opera House, Covent Garden Ltd, was incorporated on April Fool's day 1950 and, since then, the Board members have been called directors.

4 Kenneth Clark, *The Other Half*, John Murray, 1977, p.145.

5 Kenneth Clark, *op. cit*, p.134.

6 Lord Drogheda, *Double Harness*, Weidenfeld, 1978, p.240.

7 Minutes of Arts Council meeting 27 January 1960.

8 Lord Drogheda, *op. cit*, p.252.

9 Sir William Coldstream in the 1950s and 1960s and Lord Goodman in the 1960s and 1970s are the two figures who have

held the widest range of posts in the politics of the arts. In addition to his influence on art education, Coldstream was a trustee of the Tate Gallery and the National Gallery, a director of the Royal Opera House, Vice-Chairman of the Arts Council and Chairman of the British Film Institute. But then he always was good at cultivating those in authority: as a small boy he won a prize for growing his teacher's initials in mustard and cress.

10 The Earl of Harewood, son of the Princess Royal, has been one of the Arts Council's links with the Royal Family. Lords Harlech and Snowdon, both fringe royalty, have served on the Arts Council, and Lady Diana Spencer's grandmother, Ruth, Lady Fermoy, was a member of the Council in the mid-1950s.

11 One of the women trustees of the National Gallery has been the historian Veronica Wedgwood. She also served on the Arts Council, but, according to Lady Gertrude Williams, and as befitted the author of a book on *William the Silent*, she didn't say a word during her entire three years on the Council.

12 *The Arts Council of Great Britain and the Regional Arts Associations: Towards a New Relationship*, Report on an Informal ACGB/RAA Working Group, 1980, p.17. For more on the social composition of the Council see the author's 'The Arts Council: A Changing Profile', *Art Monthly*, July/August 1981.

13 Lord Drogheda, *op.cit*, pp.226–7.

14 In 1976 Lord Donaldson was somewhat surprisingly appointed to be Minister for the Arts; he has enjoyed a lifelong friendship with Lord Drogheda, with whom he was at Eton and Cambridge, and has been a director of both the national opera companies.

15 Raymond Williams, 'The Arts Council', *Political Quarterly*, Spring 1979, p.160. Kenneth Robinson, chairman of the Arts Council (1977–82) helped us to peer into the mellow dusk a little when he gave evidence to a House of Commons Select Committee recently: 'If I have lost the chairman of the Drama Panel through the normal process of retirement I will feel it is my duty to suggest one or two names to the Minister, but equally he suggests names to me, and the appointment is ultimately a resolution of these different approaches'. House of

Commons Education, Science and Arts Committee session 1980–1 'Public and Private Funding of the Arts', Minutes of Evidence, 13 May 1981, para.803.

16 Kenneth Clark, *op. cit*, p.129.

17 Minutes of Evidence Taken Before the Select Committee on Estimates (Sub-Committee C), 'The Arts Council', House of Commons Paper 315, HMSO, 1949, p.54, para.5328.

18 Kenneth Clark, *op. cit*, p.129.

19 W. E. Williams *Woman's Place*, Current Affairs Series No.20, Bureau of Current Affairs, 11 January 1947.

20 For students of sexism there was another strange coincidence in 1980 when an all-male committee selected 19 award winners from 670 applications for the Arts Council's visual art awards. No women received awards, or were even shortlisted, although nearly a quarter of the applicants were women. See *Art Monthly*, No.41, November 1980.

21 John Elsom and Nicholas Tomalin, *The History of the National Theatre*, Jonathan Cape, 1978, pp.232–3.

22 Raymond Williams, *op. cit*, pp.160–1.

23 Minutes of the Music Panel meeting on 21 May 1953.

24 Richard Graham, John Norman, David Shearn, *Cost Effectiveness and Opera Subsidy, Final Report*, Division of Economic Studies University of Sheffield, July 1981, p.15.

25 See, for the latest example, Margaret Forster 'Why I quit the Arts Council's Literature Panel', *The Times*, 21 September 1981.

26 Select Committee on Estimates, Eighth Report, 1967–8, *Grants for the Arts*, 1968, para.242.

27 Select Committee on Estimates (Sub-Committee C), 'The Arts Council', House of Commons Paper 315, 1949, 'Memorandum from British Actors' Equity Association'.

28 Select Committee on Estimates, Eighth Report, 1967–8, *op. cit*, Recommendation 1.

29 *Grants for the Arts*, Observation by the Secretary of State for Education and Science, the Secretary of State for Wales and the Arts Council, Cmd 4023, July 1969.

30 Hugh Jenkins, *The Culture Gap*, Marion Boyars, 1979, pp.197–8.

31 Hugh Jenkins, *op. cit*, p.199.

32 *The Times*, 16 April 1977.

33 'Doubts about Arts Council selection', *Times Higher Education Supplement*, 4 January 1980.

34 The quotations from the Organisation Working Party report in these paragraphs are on pages 26, 27 and 44 of that report. See note 1, above.

35 Minutes of Arts Council meetings on 29 June 1966, 25 January 1967 and 29 March 1967.

3
Amateur
and
Professional

CEMA's self-defined terms of reference included 'the encouragement of music-making and play-acting by the people themselves'.[1] The voluntary societies with which it chose to work in the emergency conditions of 1940 were selected largely because of their grass-roots strength and the network of contacts that they provided. Thomas Jones, who, from all accounts, was more responsible than anybody else for getting CEMA going, had a powerful belief in the work of the National Council of Social Service and other agencies of rural and community development.[2]

CEMA was initially seen as a morale-boosting exercise with a limited life-expectancy. Yet it would be misleading to dismiss its earliest work simply as social service, for some of the founding fathers of CEMA had a definite vision of the importance of arts for all as *arts* for all, not merely as compensation for wartime privations and miseries. This vision – particularly of Sir Walford Davies, a great populariser and a very successful broadcaster who died in 1941 – placed overriding emphasis on local work, on encouraging arts activity in every village and town.

The idea of music travellers was Sir Walford Davies' most striking contribution to CEMA. By summer 1941 there were nine such travellers, talented performers each working in one particular region, who both made music with people and helped to organise concerts. Working with and through the Rural Music Schools Council the travellers bridged the worlds of the amateur and the professional.

In drama, too, most of the earliest efforts and finances of CEMA were directed towards amateurs. Four drama advisers

were employed in England and during 1940 and 1941 hundreds of plays were put on, and numerous conferences, festivals, and training sessions for directors were organised with help from these advisers.

But throughout 1940 and 1941 Keynes was lobbying CEMA on behalf of professional artists. He became chairman in 1942 and on his appointment *The Times* declared that 'CEMA's activities are now well established with assistance from the Exchequer'.[3] But although its activities were well established its policies were not. At the end of 1941 CEMA had decided to hand over responsibility for amateur drama to the voluntary sector and soon after Keynes assumed the chairmanship, the music director, Dr Reginald Jacques, reported that several of the music travellers found the work too exhausting. (Some months earlier a number of the travellers had asked for secretarial help.) Dr Jacques suggested that 'the travellers work be handed over, the concert organising to the (CEMA) regional officers, and the music-making to the Carnegie County Music Advisers'.[4] Eventually CEMA decided to wind up the travellers' scheme with effect from March 1944, despite the fact that in 1943 the Carnegie Trustees made it clear that they were not interested in the particular work which the travellers were doing and could not be responsible for its continuance.

Keynes frowned upon amateurs; he was concerned with the professionalisation of CEMA's own administration as well as with the health of the professional arts. Throughout the war there was a good deal of conflict within CEMA on the relative merits of supporting amateurs and professionals. Thomas Jones, Walford Davies and Margery Fry, all of whom in the first year of CEMA stressed the value of co-operation between amateurs and professionals, had all, by early 1943, left the scene. It was – in the small, overworked and diffused CEMA organisation – left to Ralph Vaughan Williams to conduct much of the fight on behalf of the music travellers and in support of the idea that CEMA should put its weight behind collaborations between professionals and amateurs. In January 1944 Vaughan Williams wrote a paper for the Council arguing not only for the reinstatement of the travellers but for more of them:

Abolishing the travellers and setting up Regional Officers in their place ... is described officially as a development of the travellers system, but surely this is not so; it is rather a reversal of policy – the personal element has been eliminated, CEMA has concentrated on efficient administration – in fact it has become a concert agency. . . . If this is to be the *metier* of CEMA, why not frankly subsidise Ibbs and Tillett, who understand their business thoroughly? The ideal of Walford Davies and his travellers as always explained in his instructions was to combine the amateur and the professional. In this way the humblest amateur in a village felt himself to be part of a hierarchy which stretched upwards to those whose names are world famous. But if the two branches of the art are hermetically segregated we should lose that vitality in English art which comes from making it creative from the top to the bottom.[5]

But despite a considerable volume of protest, the ideal of Walford Davies and his music travellers died the death. In drama fewer tears were shed over the decline, after 1942, of CEMA support for amateur work. In 1944 the drama panel, largely comprised of actors and directors from companies working in association with CEMA, promised themselves a full discussion on the Council's share in assisting amateur bodies. But this discussion never took place.

On 30 January 1945, Keynes brought forward proposals for the re-organisation of CEMA into what he called a Royal Council of the Arts. In Keynes' memorandum, paragraph 4 read:

The scope and purposes of the RCA would be stated in the Charter in general terms as follows:
(a) To increase and widen the distribution of the audience for the arts
(b) to improve the standard of execution in the arts
(c) to encourage and aid an adequate system of professional training in the arts
(d) to advise and co-operate with Government Departments, Local Authorities and other public and semi-public bodies and administer on their behalf, if they request it, any matters (including grants) concerned directly or indirectly, with the above purposes.[6]

In the discussion on these proposals Vaughan Williams asked whether it was sufficiently clear that amateur music

might be included among the Council's activities. He also asked for scope to include the sponsoring of various kinds of publications, including plays and art reproductions. Two days later Keynes wrote to R. A. Butler, the Minister of Education, that the members of CEMA

asked me to suggest to you that paragraph 4 of my proposals should perhaps be re-worded to run somewhat as follows:
'The scope and purposes of the RCA will be stated in the Charter as being in general terms to encourage the knowledge, understanding and practice of the arts, and in particular
(a) to increase the accessibility of the arts to the public throughout the country
(b) to improve the standard of execution of the arts
(c) to encourage and aid proficiency in the arts
(d) to improve and maintain the status of the artists.'

Clause (d) in Keynes' first draft proposals simply became clause (e) in the revised draft.

In fact clauses (c) and (d) of the revised draft were omitted from the Arts Council's first charter, dated 9 August 1946, whose general wording implied no discrimination between amateur and professional.

But like CEMA under Keynes the Arts Council directed its assistance almost exclusively to professional organisations; indeed there was almost total continuity between the work of CEMA and that of the Arts Council. Nevertheless the Council, in its earliest years, showed considerable interest in the possibilities of amateurs and professionals working under the same roof. In 1945, after consultation with the Ministry of Town and Country Planning, the Council produced a model of an arts centre suitable for a small town. The model, and the accompanying booklet *Plans for an Arts Centre* (a booklet which, incidentally, Keynes detested)[7] gave details of a possible composite building with an all-purpose hall, a foyer with exhibition space, rehearsal and practice rooms, and a restaurant. The model toured the country and great interest was shown in it by local authorities and others, but, in the event, no arts centres were built as a direct result of this initiative. However, Helen Munro, the Council's regional director for the Southern Region was able to report in 1948 that 'The idea of the arts centre is catching the imagination of the general

public which is full of curiosity about developments in Bridgwater. The development of community centres and arts centres should go hand in hand."[8]

Developments in Bridgwater? In the autumn of 1946 a house at Bridgwater which had been used by the War Office was de-requisitioned and the Council agreed to rent it and run it as an arts centre. The centre was under the direction of Cyril Wood, the Council's regional director for the south-west, who claimed, after the first eighteen months of operation, that the arts centre had brought

an aesthetic and spiritual revolution in this small Somerset market-town. The arts centre is doing a great deal more than provide a varied weekly programme for the people – it is providing a simple demonstration in the art of living. People there are beginning to look upon the arts not merely as amusement, or as pretty decoration for occasional spare-time leisure, but as an integral part of every day life . . .

The lesson which seems to emerge very clearly is that it is the 'Arts Centre' – as a new element in the social structure – which holds the key to the ultimate solution of most, if not all, of our problems."[9]

Writing early in 1948 Wood was less enthusiastic about the performance of many of the arts clubs which worked in association with the Arts Council. Arts clubs were organisations, normally lacking their own premises, which presented a mixed amateur and professional programme. Throughout the second half of the 1940s dozens of arts clubs and a very few arts centres worked in association with the Arts Council. A great many of them came into existence in the latter stages of the war and the early stages of the peace; in its 1946–7 Annual Report the Council saw their rapid establishment and success as one of the most encouraging developments and the Council helped in adapting a number of buildings for use as arts centres. Even so, throughout this period the Council never devoted more than 1 per cent of its total budget to the work of arts centres and arts clubs. But in the early 1950s with changes in government and a shift in ideological climate even the meagre sums set aside for arts centres and clubs were cut. The Council's decision of November 1948 that a replacement for *Plans for an Arts Centre* should be published as soon as possible was not implemented.

In 1952 the Council withdrew its policy of association with arts centres and arts clubs, 'not because it did not approve the excellent work they were doing, but because it wished to reserve its formal association for a select number of professional undertakings.'[10] A positive approach to the arts centres and arts clubs movement in the mid-1940s had, by 1952, been reduced to little more than a pat on the head.

In its early years the Arts Council's drama panel (on which in the 1940s an extraordinarily accomplished group of theatre professionals served albeit in somewhat haphazard fashion[11]) saw the amateur theatre world more as a threat than a promise. The dominant attitude towards amateur drama inside the Arts Council is expressed in a comment in the *Annual Report* for 1951–2: 'To the many problems the theatre has to confront in the provinces there seems to be added nowadays the mounting strength of the amateur theatrical movement'. Thus 'strength' was seen as a 'problem', but at the end of a paragraph worrying about 'the present trend which so much favours the amateur theatres', the author concluded that 'there is scope for a *rapprochement* between forces which ought to be allies.'[12]

The Arts Council was well placed to overcome the apartheid of amateur and professional theatre. Indeed, in November 1948, the Council had agreed that a more definite policy was needed for assisting amateurs in the theatre. But apart from affirming the desirability of establishing the closest possible relations with the British Drama League and the County Drama Committees and Organisers, such a policy was never articulated, let alone acted upon. Nevertheless 'How to bring aid to the amateurs?' has been a recurring, if to many Council members and directors irritating, question in Arts Council deliberations. There have been three general answers to the question.

Firstly, it was agreed with the Carnegie UK Trust in 1942–3 that Arts Council subsidy would be directed for the most part to professional organisations, and that Carnegie's work in the arts would largely be confined to the encouragement of amateurs. Indeed in the 1940s the Carnegie UK Trust played a vital role in the appointment of drama and music advisers who were later absorbed into the employment of local edu-

cation authorities. But there is some irony in the fact that W. E. Williams referring to 'the Carnegie UK Trust and other sustaining bodies' was to describe the amateur field as 'well organised for its specific tasks'[13] just at a time when Carnegie's allocation for music and drama for 1956–60 showed a major cut in comparison to Carnegie's expenditure on music and drama in the previous quinquennium.[14]

Secondly the Council has passed the buck of responsibility for supporting amateur arts activity to the local authorities who have wide powers to promote cultural and recreational activities. In doing so in 1963–4 the Secretary-General asked: 'Is there a case for a special body, perhaps on the lines of the proposed Sports Council, to deal with amateur activities as part of a "youth service", or as part of some wider general social service concerned with public provision for "leisure"?'[15] In posing the question in this way Nigel Abercrombie, then Secretary-General, betrayed a characteristic Arts Council attitude. Amateur activities are seen not as having intrinsic merit and strength as arts activities but as part of 'some wider general social service.' A few years later when Chairman of the Arts Council, Lord Goodman told the House of Lords: 'I speak for the Arts; I do not speak for amateur theatricals.'[16]

Thirdly the Council has always given some help to amateurs. Most positively, almost from its inception, it has given assistance to amateur choral and orchestral societies and music clubs affiliated to the National Federation of Music Societies by providing part of the cost of engaging professional conductors, soloists and orchestral players.

Arts Centres and the growth of the Regional Arts Associations
In the last twenty years it has also taken 'more than a cautious interest'[17] in the growth of the arts centres movement. For the Council did not cut off all financial aid to arts centres and arts clubs in 1952 when it carried through its policy of disassociation from the centres and clubs. But the closure of the Arts Council regional offices in the 1950s badly hit the small organisations, and the Council was less than wholehearted in responding to the great blossoming of the arts centres movement in the late 1960s and 1970s.

Though arts centres in Britain are extraordinarily diverse in their operations and achievements and their patterns of subsidy and activity, they do, with few exceptions, generally provide an environment conducive to part-timers and full-timers working together, conducive to that *rapprochement* between professionals and amateurs referred to in an early Arts Council report. The social, economic and political reasons for the sprouting of so many arts centres in the last fifteen years are of great interest. The movement was given a spur by the 1965 white paper, *A Policy for the Arts*. The student protests and personal liberation movement of the late 1960s and the simultaneous opening of arts labs in practically every university town and city, as well as in numerous other havens of the counter-culture, gave a rare impetus and energy to those interested in transcending the barriers between art forms and between different kinds of practitioner. The rapid growth of local authority expenditure in the early 1970s enabled more local authorities to initiate and finance arts centres.

In the mid-1960s there were, at most, two or three dozen arts centres in Britain worthy of the label; at the start of the 1980s, and depending on the sharpness of the definition, there are two or three hundred. Of these only a handful receive direct subsidy from the Arts Council, responsibility for subsidy of arts centres having been passed mainly to regional arts associations and local authorities.

But the RAAs have much wider responsibilities than those of the Arts Council and in the five years 1974–5 to 1979–80 – a time when more and more arts centres were struggling to open their doors and keep them open, the total expenditure of the twelve English RAAs increased from £2.5 million to £8.4 million while the total expenditure of the Arts Council in England increased from £16.5 million to £49.4 million. After allowing for inflation, the increased disposable income of the Arts Council in the second half of the 1970s relative to that of the RAAs gave the Council more scope to greatly increase expenditure on a wide range of arts centres should it have opted to do so, channelling the funds through the RAAs if necessary. It didn't, and undoubtedly, for the most part, arts centres have suffered financially through receiving subsidy

from RAAs rather than from the Arts Council. The growth of the RAAs has helped the Council maintain its aloof stance in relation to most amateur activities. However, when the chairman of the Arts Council, Patrick Gibson, in his introduction to the Annual Report for 1972–3 (against the grain of all Arts Council policy and to the surprise of Arts Council directors) expressed interest in amateur arts activities, his indiscretion was fielded by Roy Shaw, then chairman of the Council's regional committee and soon to be appointed Secretary-General of the Arts Council. Shaw, on the Arts Council's behalf, commissioned a family friend, Betty Renaudon, to study the amateur arts in Stoke-on-Trent. Discussion on the report *Amateur Arts in a City* was deferred by the Arts Council in April 1975 until the views of the appropriate advisory panels were known; the Council never discussed the report.

In 1980 a set of broad policy guidelines from the Arts Council advised its panels and committees to avoid policies which would extend the scope or range of the Council's present very limited support for amateur work',[18] and when grants were withdrawn from the National Youth Theatre, National Youth Brass Band and National Youth Orchestra one of the reasons given was that these organisations were amateur and that grants to them represented an anomaly.[19]

Community arts
The development of community arts in the 1970s was, in part, a reaction against the social and professional exclusiveness that characterised much of the activity supported by the Arts Council. A new generation of artists and would-be artists, in a variety of media, was determined to break out of the restrictions imposed by the conventional institutions of both the commercial and the subsidised arts world. Primarily concerned to involve wider sections of the public in artistic activity, the work of community artists cuts across the distinctions between professional and amateur. Some have been influenced by the work of *animateurs* in France and elsewhere.[20] Many see their role as catalysts or facilitators, helping the development of locally based groups, providing training in communication skills – printing, photography

and video, for example – and assisting with local festivals. Some community artists come from a background in community work and the best community artists (like those in Telford or Sunderland for example) do much to enrich the lives of those with whom they work; but some have sold short their own ideals and aspirations, the media in which they work, and the people with whom they work. It is a legitimate criticism of much community arts work (and much that is not labelled 'community arts') that it belittles, often through a rejection of the best in our common social and artistic traditions, the very people that the work is intended to reach.[21] But community artists are unequivocal in their desire to see much wider participation in the arts. Though intentions and results can be worlds apart, the community arts movement – hotch-potch though it may be, strident though many of its devotees are – is in part a product of the Council's neglect of important chartered obligations and, with its implied identification with the underprivileged and the local, challenges the assumption of so much social policy: that the working classes are the essentially inert objects of benevolent administration.

The Council's response to community arts work was slow. But two positive reports on community arts were produced in 1974 and 1977 and members of the Community Arts Committee (established in 1975) worked hard to ensure that justice was done in distributing an allocation which enabled a wide range of groups to work at little above subsistence level. But despite all this – and given that there was opposition to any such funding within the Arts Council, it is evidence that the Council is protean not monolithic – the Council's directors for years neglected the training needs of community artists.[22] Moreover the Council's Secretary-General at the end of 1970s, Sir Roy Shaw, evoked the atmosphere of the Victorian soup-kitchens with his considered opinion that the Arts Council 'took in community arts because no-one else would',[23] and on numerous occasions, most notably in his *Annual Report* for 1978–9, used a wrong-headed paragraph about the relation between community arts and the cultural heritage, in a book *Artists and People* by Su Braden, to make a more general assault on the community arts movement,

which now includes well over one hundred groups whose aims, approaches, skills and achievements are extremely varied.

The Arts Council has done a great deal to create the arts administration profession,[24] and the weight of Arts Council subsidy and procedures has gone to maintain a professional exclusiveness. It is, for the most part, professionals who sit on Council panels and committees, it is professional organisations and professional artists that receive practically the whole of the subsidies distributed by the Arts Council; indeed the terms of financial assistance offered by the Council to most of its client organisations inhibit them from using any of their subsidy for work with amateurs.[25]

This professional exclusiveness serves, and can be seen as an expression of, a particular view of men's and women's imaginative potential and their potential for disciplined respectful creative work, their potential as artists. It is partly because the boundary between amateur and professional work is often highly arbitrary, partly because some of the world's most influential companies have begun as amateurs, and partly because the arts are so demanding, are such hard taskmasters, that the questions of access and opportunity are so important.

Of course 'amateur' is often a synonym for self-indulgence, many amateur groups are more concerned with their social activities than with artistic achievement, and many are extremely, often justifiably, proud of their independence and would neither ask for, nor accept, any public money. But others are interested in improving their standards of work and would value professional help. Large numbers of people live *for* their artistic pursuits without wanting to have to live *by* them.

Even with the great growth of arts and adult education provision since the Second War, the distribution of opportunities for artistic expression and development is patchy, and the questions posed by this uneven distribution are directly related to the relative importance accorded by government agencies to amateur and professional work, and to the expectations surrounding that work. To push the argument

further: distinguished psychologists, Fromm, Jung and others, have argued that people have a need to express their grasp of the world of the senses – be this expressed through song, dance, drama, music, painting, or whatever – and whether this expression is conducted individually or collectively, whether it is called art or ritual, it is something that everyone needs to join in, not simply have served up by 'professionals'. Despite the protestation of its chairman that the Arts Council responds to need, not to demand,[26] the Council, blinkered by professional exclusiveness, has largely ignored this basic need. Indeed it has made no serious attempt to explore the concept of cultural need.[27] For example, although the 1976 report *The Arts Britain Ignores*, on the arts of ethnic minorities in Britain, has had some influence on attitudes, such arts activities are still, all too readily, dismissed as amateur, even when part-timers and full-timers, amateurs and professionals, are working together.

There is an important, if subtle, difference of emphasis between asserting the specialness of the artist (in whatever medium), the 'limited amount of talent available'[28] and accepting the obvious truths that not all human beings are equally gifted, or equally disciplined, or all forms of self-expression equally worthwhile. But the repeated worry about professions already overcrowded is a reminder that professionalism is not only a description of the inherent nature of a particular occupation, but also the means of controlling entry to an occupation. Professionalism can all too easily act as a form of social closure.[29]

The desirability, the social need, described by Durkheim nearly a century ago, for occupational groups to become organised on a national basis is not being contested. And the Arts Council is not immune from the power of trade unions, from the increased pressure and organising ability of developing professional groupings.

But there is nothing in the Arts Council's charter to justify the policy of professional exclusiveness that it has, for the most part, pursued. Quite the reverse. Despite Keynes' original draft the charter was worded to avoid the suggestion that the Council should maintain a high degree of professional exclusiveness. The concepts of 'amateur' and

'professional', related as they are to 'gentleman' and 'players', are crucial and loaded in the class-ridden social history of Britain. It is for ideological, as well as for more obvious economic, reasons that Arts Council subsidies have largely been directed towards professionals while those of the Sports Council have mainly gone to assist amateurs. High standards of achievement are the monopoly of neither professionals nor amateurs and arguably there is neither enough professionalism nor enough genuine amateurism, enough enthusiasm fuelled by love and dedication, in the arts. Nor is it being suggested that the Arts Council should ever have been heavily involved in the administration of grants to amateur organisations or that more than a very small percentage of available subsidies should be used for these purposes. In addition to the youth organisations, there are a number of national organisations (for example the British Theatre Association) which have for years struggled, with little official recognition, to support amateurs and improve their standards. They could, and should, be much better funded even while a number of Regional Arts Associations are showing an increasing interest in amateur work.[30]

The economic climate of the 1980s might prove peculiarly conducive to consideration of how best part-timers and full-timers, professionals and amateurs, can work together in every sector. There are already numerous examples of such collaboration, not least in the world of adult education, and the Arts Council, and, with their much smaller resources, the Regional Arts Associations, play some small part in fostering them. There is nothing new about such collaborations; but at present they remain outside the main lines of policy.

Notes

1 From 'Memorandum in Support of an Application to the Treasury for Financial Assistance' signed by Lord Macmillan and Lord De La Warr, 6 March 1940.

2 In an interview on 15 March 1979 Mary Glasgow said 'Whatever anybody may say the founder of CEMA and the Arts Council was Tom Jones . . . I am absolutely certain that it was

Tom Jones who had the first idea and instigated the whole thing both through Lord De La Warr on the one side and through his own chairman of the Pilgrim Trust who was Lord Macmillan on the other.' See also 'The History of CEMA from December 1939' Draft by Mary Glasgow, first secretary of CEMA, prepared for D. Du B. Davidson, Board of Education War Diarist. Dated 3 April 1944. Public Record Office File ED 138, No.14.
On Thomas Jones's role, see also *Lewis and Sybil* by John Casson, Collins, 1972, p.219, and *The Other Half* by Kenneth Clark, John Murray, 1977, pp.24–5.

3 *The Times* 19 February 1942.

4 CEMA paper 142 for seventeenth meeting of CEMA 2 September 1942.

5 'CEMA and Rural Music', CEMA paper 176, 25 January 1944.

6 CEMA paper 190.

7 'Who on earth foisted this rubbish on us?' Keynes wrote to Mary Glasgow on 7 November 1945.

8 Helen Munro, 'Report on Berkshire, Bucks, Dorset, Hants, Oxon and the Isle of Wight.'

9 Cyril Wood 'Report on Region 7', February 1948.

10. *The Public and the Arts, The Eighth Annual Report of the Arts Council of Great Britain, 1952–1953*, p.28.

11. For example during 1949, twenty-one people served on the Drama Panel. They included Peggy Ashcroft, Noel Coward, Dame Edith Evans, John Gielgud, Tyrone Guthrie, Sir Laurence Olivier and Alistair Sim. The Panel met eight times that year and only six of the twenty-one attended more than half the meetings.

12 *The Arts in Great Britain, the Seventh Annual Report of the Arts Council of Great Britain 1951–2*, pp.22–3.

14 In the quinquennium 1951–5 the Carnegie UK Trust spent a total of £50,694 on music and drama. The total allocation for

music and drama for 1956–60 was £40,000. *Carnegie UK Trust Annual Report 1955*, see p.7 and p.48.

15 *State of Play, the Nineteenth Annual Report of the Arts Council of Great Britain* 1963–4, pp.29–30

16 *Hansard*, House of Lords debate on Regional Arts Associations, 22 March 1972, column 734.

17 The phrase comes from *State of Play, the Nineteenth Annual Report of the Arts Council of Great Britain, op. cit.*, p.30

18 Council Paper 760 'Broad Policy Guidelines for the Council's Panels and Committees', May 1980, reprinted in *Arts Council Bulletin* no. 43, October 1981

19 See for example, Sir Roy Shaw, 'We had to be tough...' *New Standard* 4 February 1981

20 The Council of Europe, through its project on socio-cultural community development, did much to advance the discussion and understanding of what in France is called *animation socio-culturelle*. The director of the project, J. A. Simpson, defined *animation* as 'that stimulus to the mental, physical and affective life in a given area or community which moves people to undertake a range of experiences through which they find a greater degree of self-realisation, self-expression and awareness of belonging to a society over which they can exercise an influence, and in the affairs of which they are impelled to participate.' See Finn Jor, *The Demystification of Culture*, Council of Europe, 1976.

21 The paper 'Excellence and Access: the Arts Council' by Richard Hoggart, *New Universities Quarterly*, Autumn 1979, is an important contribution to the debate about community arts.

22 At a meeting of the Secretary-General's Advisory Committee (largely consisting of Arts Council directors) on 12 October 1976 'it was unanimously agreed that if it was raised the Council should not be recommended to support training of community artists'.

23 *Thirty-Fourth Annual Report and Accounts of the Arts Council of Great Britain*, 1978–9, p.9

24 In vocational training for the arts, arts administration training courses have been the Council's main interest.

25 For example paragraph 12 of the Conditions of Financial Assistance (Art), April 1979, reads: 'The Council shall be notified of any lettings to amateur societies or organisations and no part of the Council's subsidy shall be applied to any performance given by such societies or organisations.'

26 See his letter to *The Guardian*, 13 August 1979.

27 For a useful and stimulating discussion of the concept of cultural need see Stephen Mennell 'Theoretical Considerations of the Study of Cultural "Needs"', *Sociology*, Vol. 13, No.2, May 1979.

28 See for example, W. E. Williams, 'The Arts and Public Patronage', *Lloyds Bank Review*, July 1958.

29 Jim McGuigan has discussed this point in relation to the Arts Council's grants to writers. See *Writers and the Arts Council*, Arts Council, 1981, chapter 5.

30 Although Lord Redcliffe-Maud's report on *Support for the Arts in England and Wales*, Gulbenkian Foundation, 1976, has been much quoted and discussed, his two paragraphs on amateur drama (pp.121–2), and his argument that 'we must . . . encourage amateurs in *every* section of society', seem to have been largely neglected.

4

Standards
and
Double Standards

In the Spring of 1951, William Emrys Williams took up the job of Secretary-General of the Arts Council of Great Britain and the concluding sentences of the *Annual Report* for 1950–51 bear his unmistakable stamp:

In reconsidering the exhortation of its Charter to 'Raise and Spread' the Council may decide for the time being to emphasize the first more than the second word, and to devote itself to the support of two or three exemplary theatres which might re-affirm the supremacy of standards in our national theatre. As the Governors of the Old Vic have recently expressed a similar motive in their policy, the Council may well count upon experienced allies in its further projects.

High standards can be built only on a limited scale. The motto which Meleager wrote to be carved over a patrician nursery might be one for the Arts Council to follow in deciding what to support during the next few straitened years – 'Few, but roses' – including, of course, regional roses.'[1]

Undoubtedly the Council did decide for the time being to emphasise the first more than the second word. Though the Arts Council's annual grant-in-aid more than doubled between 1950 and 1960 (though it was only £1½ million in 1960–61) there was only a small increase in the number of organisations offered grants or financial guarantees. Indeed there has probably never been a clearer, more succinct statement of Arts Council policy than that which appeared in the last of W. E. Williams' annual reports, that for 1961–2:

The essence of Arts Council policy nowadays is to sustain the best possible standards of performance at a limited number of insti-

60

tutions. . . . Even if its income were larger it would still prefer to consolidate these priorities than to dissipate its resources upon an extensive provision of the second-rate. If the power-houses were to fail there would be a black-out of the living arts in Britain.'[2]

'Few but roses' or 'the best possible standards of perform-ance at a limited number of institutions', the main theme of W. E. Williams' annual reports in the 1950s, is both repetitive (literally so, for the later annual reports include chunks lifted from the earlier ones) and clear. The complaint, frequently made in the 1970s, that the Arts Council lacked a policy, could hardly have been justified in the 1950s. Yet one sees in the above three sentences from the 1961–2 report, a fine example of one time-honoured method of Arts Council rationalisation – the false antithesis. The policy choice posited is between consolidating priorities and dissipating resources 'upon an extensive provision of the second-rate'. It was never so simple. Expanding the categories of work supported, the development of new kinds of organisation and new kinds of partnership with other agencies, high quality educational work, improving the standards of, and facilities for, amateur performance, support for individual artists of ability, are among the range of policy options that are left out of account, and that fell then and fall now within the Council's obli-gations.

The shorthand 'Raise and Spread' is a revealing and distort-ing distillation of the exhortation of the 1946 Royal Charter by which the Council was charged '*in particular* to increase the accessibility of the fine arts to the public throughout Our Realm, to improve the standard of execution of the fine arts', and both these, and to advise and co-operate with other public bodies 'for the purpose of developing a greater knowl-edge, understanding and practice of the fine arts exclusively' (italics added).

The 'Spread' of 'Raise and Spread' elides availability and accessibility and underemphasises the *in particular* that the Council was charged to give to accessibility; nor does it give much hint of the explicit educational responsibilities men-tioned in the Charter. So while 'Raise and Spread' was a commonly used shorthand in policy discussions, particularly on drama subsidy, in the Arts Council of the 1950s it served

to obscure the Council's chartered obligations and gave a mysteriously Shamanist role to the Council: raising here, spreading there.

The tension between trying to improve artistic standards in a relatively limited number of organisations and increasing opportunities for performance, exhibition and practice of all kinds, admits of no final resolution. The emphasis on standards is the main consistent thread through the 40-year history of CEMA and the Arts Council, for the very first sentence of CEMA's self-defined terms of reference reads: 'The preservation of the highest standards in the arts of music, drama and painting'.[3] But the 'few but roses' philosophy while being wise in its recognition that audiences for the arts should not be patronised by the second rate, and while demanding respect both for its results and for its tough-mindedness, was a very narrow response to a complex set of obligations. It was no more satisfactory as a cultural policy than it would have been as a policy for horticulture. Indeed it is worth noting how, in its late (1961–2) manifestations, it falls back on the Churchillian image of the Council as a bastion against the dark forces: 'If the power-houses were to fail, there would be a black-out of the living arts in Britain'. The Arts Council as Central Electricity Generating Board!

The 1950s policy has had a pronounced influence on, and has set the terms of the debate for, what has followed. And although the seeds of the 'few but roses' philosophy were sown in the 1940s, the preoccupations of the Arts Council in 1957–8 are in marked contrast to those of a decade earlier. In 1957–8 the problems of opera companies dominate the agendas of the Council and also of its Music Panel which spent most, in some cases all, of its six meetings in 1958 discussing opera in general and the ailing Carl Rosa company in particular. Anything resembling in its concern a minute like the following from the twentieth meeting of the Executive in June 1947 is not to be found ten years later (and not only because there were no regional directors in 1957):

The Chairman gave a report on his recent tour. He has been accompanied by the Secretary-General, and the Vice-Chairman has been present during the two days in Scotland. The party had visited Edinburgh, Perth, Newcastle-upon-Tyne, Durham, Leeds, Ossett,

Sheffield, Birmingham and Coventry. Everywhere he had gone, he had found evidence of the excellent work done by the Council's Regional Directors. He had had numerous opportunities of meeting local people – particularly representatives of the Local Authorities and persons known to be interested in the arts – and he had formed the impression that, though the Arts Council and its attitudes were well known and appreciated by the upper and middle classes, it was not reaching the working classes on a broad enough front. He was doubtful whether the Arts Council was succeeding in time of peace in consolidating the previous work in the arts carried out by CEMA and other workers during the war.

Sir Kenneth Clark and Mr W. E. Williams shared the Chairman's doubts. They both felt that, although there were undoubtedly great difficulties to be overcome, the Council must not lose sight of its mandate to make the fine arts easily accessible to every section of the population.

As recently as 1960–61 over 50 per cent of the Council's financial resources were going to grant-aid the two main opera and ballet companies, not that Keynes, who expected much of the funding to come from individual deeds of covenant, was able to foresee this.[4] Keynes was in America for most of 1945 and Kenneth Clark conducted the negotiations with Boosey and Hawkes about the possibility of the newly-formed Arts Council taking responsibility for Covent Garden. Clark tells us 'When Keynes returned he said to me, "How much will it cost? About £25,000 I suppose," which showed a kind of *légèreté* that I often observed in him. I said "Add a couple of noughts", but he thought I was joking'.[5] Keynes *légèreté*, and his hopes that Covent Garden would be neither too exclusive nor too heavily subsidised an organisation, prompted him to write to Mary Glasgow at about this time 'I do hope in planning the programme of Covent Garden there is at least a month of Gilbert and Sullivan every year.'[6]

In drama policy metropolitan prestige was an early preoccupation of the Arts Council. Charles Landstone, who worked in the drama department of first CEMA, then the Arts Council, from 1940 to 1951, and whose book *Off-Stage* conveys something of the London clubland ambience of the Council in the 1940s and early 1950s, reported that:

From the moment that the power of the Drama Panel was reduced

by Lord Keynes in 1945, each successive Drama Director has had to struggle with a Council of which only a minority had any understanding of theatre problems. Solely taken up with what we term 'Tennentry' and 'Old Vickery' they have never really regarded the work in the provinces as anything but window-dressing, wise to maintain for political reasons.[7]

Landstone argued that it was Keynes' love of glamour that led him to be more partial to the work of the Tennent companies than to that of the Old Vic. This, of course, was before there was any certainty that the Old Vic company would form the basis of the National Theatre. John Elsom has charted the continuous toings and froings that comprise *The History of the National Theatre*[8]. There were attempts in the late 1950s and early 1960s both to pool the resources of what are now the National Theatre and the Royal Shakespeare Company and to effect a marriage between the Sadlers' Wells (now English National) Opera and the Royal Opera House. As far back as 1935, John Gielgud had written:

Supposing the three institutions, Stratford, the Old Vic and Sadlers' Wells were in a sense amalgamated, and endowed on a large scale as the genuine foundation of a National Theatre. In the first place, the companies would be interchangeable, and infinitely more care could be given to each production. A play could run for a month at the Old Vic, then go to Stratford, then to Sadlers' Wells, and then perhaps tour for a month. Having only to produce a new play every three or four months would give a producer much more time to put his best work into each. . . . To my mind the Old Vic, subsidised and linked with Stratford-upon-Avon, has the best claims to be made the basis of a really National Theatre.[9]

But none of these proposals for merger or amalgamation came to anything and in 1964–5 the Council agreed its first annual subvention to the Royal Shakespeare Theatre. In that year, which also marked the first full season of the National Theatre Company, the four national companies, the two theatres just mentioned, the Royal Opera House and Sadler's Wells, received subsidies totalling about £1.7 million out of total Arts Council expenditure in England of £2.7 million. The acceptance by government and the Arts Council of four national companies (and particularly the crucial decisions surrounding the National Theatre) are part of the history of

1958–63, the years that fall between the first utterances of two great slogans of economic growthmanship and political and technocratic optimism. Harold Macmillan's 'They've never had it so good' burst upon the world at a speech in Bedford in July 1957 and Harold Wilson's promise of what the 'white heat of the technological revolution' would do was made at the Labour Party conference in 1963. These were also years of relatively rapid withdrawal from Empire: the creation of national companies helped to bolster national pride as 'influence' overseas was declining.

Throughout the late 1950s and early 1960s almost the entire theatrical profession (aided and abetted by the Arts Council) was pressing for a new National Theatre building, but, as John Elsom has remarked: 'Within twenty years, from 1956 to 1976, the commonly expressed attitudes within the theatrical profession to the new National underwent an abrupt change. In 1956, the National was an honourable cause, not lost, but infinitely delayed. By 1976, it had become an object of much jealousy, a threat to lesser theatres, a symbol of privilege'.[10]

But throughout the very lengthy gestation period of the National Theatre and in the first 17 years of its work a variety of serious alternatives to the organisational structure and artistic purposes of the National have been mooted by respected men of the theatre. Geoffrey Whitworth, founder of the British Drama League, and, for three decades one of the most active advocates of the National's cause, saw the National Theatre as 'no more, and no less, than a Community Theatre writ large'.[11] At the end of the war, Basil Dean, who had run ENSA (Entertainments National Service Association) argued:

Standards must be national in scope if they are to have effective influence and draw fresh life from all the people all the time. This is the main justification for what is loosely called the national theatre. It also explains why the proposal, as hitherto presented, has made so little headway with a public that has now shown itself avid for good things. . . . It is not a building at all. Hence those who dream of stately piles in Kensington or South London are planning a permanent address for something not yet in existence. The only way to achieve and maintain these essential standards is by the foundation of national companies, to perform everywhere and not solely for the

delight of the metropolis. . . . It is not always appreciated that there is a grave political objection to the national exchequer bearing the whole cost of a national theatre in London, the benefits of which can only occasionally be shared by those who live in the provinces.[12]

Basil Dean's thinking finds some echoes in ideas put forward by Benn Levy, the playwright and Labour MP, who in 1953–4 argued for a National Theatre for the Provinces, a grid of companies in the larger cities, as a counterpart to the National Theatre on the South Bank, and twenty years later Jonathan Miller, who for a short time was a member of the Arts Council, and who was heavily involved as a director at the National Theatre in the early 1970s, saw the concentration of the National Theatre on the South Bank as 'a bad idea theatrically and a ridiculous idea socially. . . . It's rather like saying that Beethoven's Quartets, having qualified, should be performed at Wembley'. What Miller wanted to see were 'small intense congregations all over England where actors perform for no more than a hundred people at a time. I think that they might all be called the National Theatre, in exactly the same way as the NHS isn't localised at St Thomas's Hospital, but it's everywhere'.[13]

There have always been alternative ideas for the national companies and for the National Theatre in particular; the creation and development of four heavily subsidised national companies in their present form has been the result of a complex though deliberate and heavily deliberated set of choices made largely at a time of economic and technological optimism. In 1964–5 the national companies took about 53 per cent of the Arts Council's total grant-in-aid; by the early 1980s this aggregate percentage is almost static at approximately half that figure.

The subsidy requirements of the four national companies pale in comparison to those of equivalent organisations on the Continent. For example, in the case of the Royal Opera House, grants from the Arts Council currently account for 50 per cent to 55 per cent of income. This compares with a subsidy level of 75 per cent to 80 per cent for other major European opera houses. In Belgium, subsidy to the national theatre in 1979–80 accounted for 51 per cent of the total subsidy to the theatre in that country. Such international

comparisons illuminate up to a point, but they inevitably ignore major historical, economic and cultural differences.

More relevant, perhaps, in defence of the national companies, is the fact that each of them acts as an umbrella for a number of performing groups; the Finance Director of the Arts Council has argued that 'what is referred to in our annual reports as four national companies is, in fact, the equivalent of seventeen performing companies'.[14] Indeed two of the main results of the great increase in subsidy to the four national companies have been to increase the numbers and improve the pay and conditions of those working in the companies, and to increase the amount of work, the number of productions and performances, that they have provided. In the case of the National Theatre in recent years there has also been the enormous, and largely unforeseen, costs of maintaining a vast new theatre complex.

But more grandiloquent justifications have been needed for the existence of the national companies. Characteristic of these have been that provided by Lord Bridges in his Romanes lecture in 1958: 'It is the duty of the state to provide something of the best in each of the arts as an example or inspiration to the whole country'.[15] Or as a leading article in the *Daily Telegraph* put it: 'We cannot all afford a Rolls or to shop at Harrods, to go to Covent Garden or dine at the Ritz. But the standards thus set circle outwards like ripples on a pool'.[16] From a different perspective Hugh Jenkins MP, when Minister for the Arts, argued:

Our theatre generally is of enormous prestige value to our country.... We once had a great reputation as a sporting nation, but we don't have that now. What we do have is an international reputation in the world of the arts. For drama, music, ballet, opera. The National Theatre ought to become the symbol of our achievements in the theatre.[17]

The symbol of our achievements, an example or inspiration, of enormous prestige value, something of the best, the ripple effect. These phrases embody the principal justifications for the priority given to the national companies. And, in the language of the Arts Council, they carry great weight.

But they also embody ambiguities and beg important

questions. One person's prestige value is another's unjustified extravagance; an inspiration to some is a grotesque spectacle to others. And in the field of opera in particular, numerous commentators have seen the special privilege attributed by Government and Arts Council to the Royal Opera House as little more than the rich looking after their own pleasures. Straight after the 1980 budget, in which a further thousand million pounds was cut from public spending, Simon Hoggart mingled with the crowd at the Charity Gala Night at Covent Garden:

These people manage to beat the Budget every year by being incredibly rich. . . . The souvenir programme (with it being a Gala Night the programme cost more than a seat in some other theatres) promised 'knights, esquires, ladies, ruffians, pages, maskers, soldiers, ushers, halbediers, cupbearers, and gondoliers'. How true, and that was only the audience. . . . You can tell the very rich by their evening dress. The more they earn, the sillier it is. One man wore something that looked like a pair of paisley pyjamas with a black tie on top. Some wore quilted affairs like sawn-off dressing gowns. Others had yards of ruffling on their shirts, so their chests were puffed out like swans on heat.[18]

But stepping away from the heavy necklace of glamour and the loaded world of prestige, the policy questions remain: what is meant by high artistic standards and how does the fostering of them relate to the supply of public subsidy? And to what extent should the maintaining of the highest standards in the arts be the main priority of Government arts policy and Arts Council practice?

Discussions of artistic standards are themselves of very variable standard. At the Arts Council the work of one or more companies has often been examined in great detail and there have been some protracted and earnest discussions. But more typically discussions of standards have been superficial and fragmented. And the discussions have been complicated by the fact that only some of the criteria implicit and occasionally explicit in the Arts Council's assessments of its grant allocations, are concerned with artistic standards. As Kenneth Robinson, the Council's Chairman, reported early in 1981:

The Council has taken account of a wide range of factors in deter-

mining the overall disposition of its resources for 1981–2. They include considerations of artistic and creative strength and potential; audience trends and box-office returns; the balance of provision between London and the other regions; the levels of local authority support; the adequacy and security of tenure of the premises in which clients operate; clients' annual records in the matter of housekeeping and budgeting; the urgency and nature of any more underlying fundamental financial problems; and the Council's existing general policies, such as the priority which it has consistently given to full-time professional work.[19]

But it is to questions of artistic standards that all discussions of arts subsidy sooner or later return; indeed the word standards has partly taken the place of the word taste ('probably the most overworked and ill-defined word in the English language'[20]) in the early nineteenth century. And while, as Lord Gibson has admitted, 'it is easier to talk about standards than to define them',[21] it is the relentless discussion of criteria for judging different types of arts activities and the particular qualities of the work of different companies and groups that is a necessary core of the Arts Council's work.[22] The Council's decisions at the end of 1980 served to reveal that its discussions of standards are neither open, rigorous, or systematic enough.

In December 1980 the Arts Council decided not to renew grants to 41 organisations and, at the same time, substantially to increase its grants in 1981–2 to 46 of its regular revenue clients, including the major regional orchestras. The Council's Chairman argued that the Council had

. . . come under increasing criticism from its clients, the unions and the public generally for spreading available finance too thinly, leaving companies with insufficient funds to mount their work. Thus new theatre buildings have sometimes been closed for as much as a third of the year; new performing groups have often been unable to perform for more than a few weeks at a time; orchestras have been denied the opportunity to develop a wider repertoire; and established opera and dance companies have had to restrict touring and cancel projected new productions.[23]

There is no reason to doubt the truth of all this, but there is nothing new about any of it. And what is not said is that established and successful orchestras and companies (like the

46 who had their grants increased) are, in general, much better placed to raise money from sources other than the Arts Council than many of the companies whose grants were withdrawn. Of the latter, the Prospect Theatre Company was the most heavily subsidised; Angus Stirling, formerly Deputy Secretary-General of the Arts Council, spoke for the Company's board:

What we find hard to understand is that, having decided to withdraw the subsidy, they have done it in such a way as to make it virtually impossible for the company to raise money elsewhere, although it has had a successful season.[24]

Through the storm of outrage that greeted the Council's December 1980 decisions, a storm that rumbled on for several months, the most convincing general criticisms were not of the fact that the Council had redistributed resources or cut 41 companies, but the manner of doing so. There were no warnings: some companies first heard of the Arts Council's decisions from broadcasts or from journalists. No specific reasons or explanations were given to the companies concerned, and there was no right of appeal. The reasons for offering no right of appeal were persuasive: 'The process of considering 41 appeals would inevitably be protracted. If it were not to be a purely cosmetic exercise, it would be bound to delay for months the process of intimating 1981–2 subsidies to the Council's continuing clients'.[25]

Why is it that the Arts Council waited 35 years (1945–80) before making any substantial cuts in the number of companies that it supported? Firstly, because the decision to cut a company is a difficult one. Livelihoods are at stake. Like is never being compared with like, improvement may be just round the corner, there are extraneous factors, not least the interests of local authorities, to bear in mind. Secondly, because of inertia. It was always easier, with a consistent if often small expansion in available resources, to go on acquiring clients than to establish sharp priorities and act accordingly. Indeed inertia has its own rewards and can be given a virtuous shine. As Sir Hugh Willatt, the Arts Council's Secretary-General in the early 1970s, expressed it: 'It has over the years been something of a triumph to keep

solvent a mounting number of enterprises with the help of a minimum grant'.[26] Thirdly, because in its early attempts to cut companies the Council burnt its fingers badly. Both the withdrawal of support from the Carl Rosa Company at the end of the 1950s and from Phoenix Opera in 1974–5 generated much adverse publicity, and, leaving aside the merits of the cases, it is clear from studying them that both were unsatisfactorily handled.

Criticisms of the Arts Council's methods of assessment have a long history. In *Grants for the Arts* the 1967–8 Estimates Committee of the House of Commons reported that:

Doubts were expressed whether the assessors came as frequently as desired or paid sufficient attention to the artistic aspects of the productions. The Council of Repertory Theatres said they thought 'the Drama Department had found it impossible to visit theatres in the provinces on anything approaching a regular basis. It is therefore not too much to say that a breakdown in communication has taken place.'[27]

There were a number of changes in the committee structure administered by the Council's drama department in the 1970s, and the Council's Organisation Working Party in 1979 not only recommended an increase in the drama department's staff as a matter of urgency but its report also resulted in more responsibility being delegated to officers in all departments.

How, after all this, is a realistic and efficient system of assessment to be achieved? There is a strong case for the Arts Council publishing (perhaps every two or three years) regular reports on each of its revenue clients. These would involve the Council and its officers in looking more systematically than hitherto at the relations – both specific and general – between financial inputs and artistic outputs. Is it, in one case, standards of performance, of design, of direction, that are being improved by increasing subsidy, or is it simply standards of audience comfort? In another case is a company using an increased grant to improve pay, increase its number of rehearsals, or do more innovative work – or all three? And these judgments need not only to be made (indeed many such judgments are made every week) but made more systematically, made more explicit and made in relation to the aims and

plans of subsidised companies, which also should be published. In this way thinking about artistic standards can be made more rigorous, the varied uses of the term can be clarified and – in withdrawing subsidies – companies can be given clear warnings and justice can be seen to be done.

Secretary-General Sir Roy Shaw, in his 1977–8 *Annual Report*, argued against the publication of assessments. But his statement that the Arts Council is 'involved in delicate negotiations with hundreds of clients', has a hollow ring after the events of December 1980. And his analogy with the banking system, 'it would be as inappropriate for us to publish this kind of detail as it would be for a banker to publicise transactions with clients', is also misplaced. For most bankers' clients are private individuals and organisations while the Arts Council is distributing public money. Sir Roy gave two further reasons why the council could not publish assessments. First 'the many confidential reports which are received from the Council's advisors on clients' performance, organisation and efficiency could hardly be as candid if they were to be published and hence would be of little use to us'. But any loss of candidness in such reports might be more than compensated for by an increase in sensitivity (knowing that the reports might be published), and the art of writing candid, sensitive reports is one that needs to be developed in a mature democracy.

Secondly, 'long Arts Council experience shows that to attempt to explain unfavourable judgments (and no one raises questions about the overwhelming number of favourable ones!) leads to interminable discussions since no disappointed applicant can ever be persuaded that an unfavourable judgment may also be just'. Verbal diarrhoea is a common affliction but there is no good reason why discussions should be interminable, some discussion is preferable to summary justice, and the explanation of unfavourable judgments is a necessary part of the work of well-remunerated public servants. Indeed the biggest single argument for regular published reports is that open healthy criticism is likely to help to improve standards rather than depress them. And as with organisations, so with new projects and individuals. A recent research report on the Arts Council's grants to writers

scheme discovered that 'unsuccessful applicants tend to be particularly bemused and in some cases very upset, especially by the brevity of the refusal letter'.[28]

Every decision about arts subsidy is a difficult one. For there is no necessary or intrinsic connection between high standards, however defined, and heavy subsidy. To take just two examples: many critics judged the productions of *The Changeling* and *The Cherry Orchard* at the Riverside Studios in Hammersmith in 1978 to be more successful and satisfying artistically than the much more heavily subsidised productions of the same plays in the same year by the Royal Shakespeare Company and the National Theatre respectively. Ironically perhaps, Peter Gill, the Stafford Cripps of the subsidised theatre, who directed the two productions at Hammersmith, took up a post at the National Theatre two years later.

But just as increases in public subsidy do not necessarily improve standards of work (although they do tend to increase the number of people employed in the subsidised sector, with most administrators characteristically doing better financially than most artists) so reductions in subsidy do not necessarily lower artistic standards, though an all too common knee-jerk reaction is that they do. What is true is that economic cutbacks in the performing arts tend to result in more conservative programming. The situation is complicated by the fact that there is a minimum income necessary for a company to work together or to stay together in a fruitful way. Nobody can say for certain what that minimum is, but most people working in the arts spend time trying to raise the bidding on minimum requirements; for while, in the relatively unsophisticated poker game of arts subsidy, seriously threatening to resign or to 'close the theatre for six months of the year'[29] unless more money is found, is commonplace among theatre managers and directors, the truism remains that it is artists who most heavily subsidise the arts.

But here too we touch on a paradox: 'Skeptics ... argue that the ready availability of government funds has accelerated the increase in the costs of producing live arts performances, and that increased ... government subsidies permit artists to perform unorthodox presentations more

pleasing to the performers than to actual or potential custo-
mers.'[30] The Skeptics are, significantly perhaps, with a 'K',
for such concerns are more likely to be expressed in North
America, where there is a greater variety of, and importance
attached to, private funding of the arts. In Britain there is
rather more concern with the distortions engendered by
having a limited number of relatively heavily subsidised
companies.

Not only have the four national companies been allocated a
lion's share of the Arts Council's resources, they have also
been a considerable drain on its time. In the 1970s it was the
affairs of the National Theatre that provided a constant preoc-
cupation; before that, as the Secretary-General reported in
1970, it had not been possible to plan in a strategic way
'because repeated crises at Covent Garden and Sadler's Wells,
calling for the urgent supply of large sums of money, had pre-
vented thoughtful attention being given to the needs of other
organisations'.[31] His suggestion was that there should be an
inquiry into the finances of the four national companies in
order to arrive at an accurate assessment of their real needs.
(The Finance and Policy Committee had considered whether
the national companies could be treated as a separate category
and had, in what in retrospect seems a blessed state of inno-
cence, agreed 'that it would be ideal if a plateau figure could
be worked out for each organisation which could then be aug-
mented each year by a cost-of-living increase').[32]

Some months later the firm of management consultants,
Peat Marwick, Mitchell and Co. (PMM) was hired to conduct
this inquiry and make the 'accurate assessment ... of real
needs'; in January 1972 PMM reported that without any
changes in artistic policy 'there was a possibility of savings
which in total represented the equivalent of Arts Council
subsidy to several repertory theatres'.[33] In 1975 PMM was
employed again by the Arts Council to consider the financial
consequences, and examine the budgets, for the National
Theatre's move to the South Bank. As a result of this report
and a report by a working party of the Arts Council's Drama
Panel on the National Theatre's budget for 1975–6 and 1976–7,
the management of the National Theatre 'admitted there
was some overstaffing and cuts would be made'.[34]

The employment of a large and sophisticated firm of management consultants to explore some of the most testing and delicate questions in arts subsidy, the financial resources needed by the most heavily subsidised companies, served to reinforce the double standards that operate in the Arts Council under the blanket of concern with standards. For PMM includes among its clients 'many of the largest industrial and commercial undertakings in the private sector'.[35] There may be many affinities, shared assumptions and reference points between the people who run such undertakings, the management of the national companies and PMM. It is less likely that there will be such affinities and assumptions, about management structure and management style, about what is necessary waste and what is unnecessary extravagance, about what accurate assessments of real needs in the arts might amount to, between those working in the hundreds of smaller arts organisations and those managing large enterprises. For a dragon on stage for eight minutes in four performances of *Siegfried* at the Royal Opera House can cost (indeed did cost) more than the entire subsidy for a year to some small theatre groups.[36]

Subsidies to the national companies do need to be considered alongside those to others, and there are monumental anomalies in available resources right across the subsidised arts. Some anomalies are bound to exist in a mixed economy; it is the ludicrous aspects of them – the *Siegfried* dragon or the fees commanded by some opera singers and orchestral conductors, for example[37] – that discredit the system of arts subsidy and it is the perfunctory lavishness of some of the productions of the national companies that exacerbate cynicism about double standards. If, as the Arts Council's Finance Director has asserted 'there is no doubt that over the past thirty years new small-scale work has "ridden in" on the back of the star items in the Council's application to the Treasury',[38] there is also no doubt that the Council has encouraged the concept of 'star items' and that 'star items' is a euphemism for prestige projects.

'Living in two worlds' was the Drama Director's euphemism for double standards in 1973. He told the Council that 'the repertory companies paid at least union rates, and the

National Theatre and RSC when touring would pay allowances of over £20 p.w.; however, actors performing in the experimental groups were by and large receiving only nominal wages, no touring allowance at all, and put up with sub-standard conditions'.[39]

The following year concern about double standards had spread amongst most of the middle-grade officers of the Arts Council to the extent that in December 1974 sixteen of them combined to send a memorandum to the Council's directorate arguing for a threefold increase in the allocation of what were then called 'developing activities', which included fringe and experimental drama, photography and community arts. The officers argued that:

Until now, what have been loosely described as new or experimental or small-scale activities (and indeed awards to individual artists) have suffered from a triple disadvantage:
1. They are, almost always, and unlike most 'established' activities, categories of work that have very limited chance of drawing finance from other sources. They have no rich friends.
2. Because the sums involved are small, budgets and proposals have been scrutinised by the relevant committee with a fastidiousness which is not usually apparent when the budgets of large companies are examined. . . . Thus a double standard operates.
3. They generally have last call on the Council's overall allocations. We think that all this has led to a false set of priorities and engendered a great deal of bad feeling among creative people. We feel that it is essential that the Council should not be grudging or condescending in its subsidy of new risky work. . . It is a mistaken policy only to finance new activities out of an overall increase in the Council's allocation.[40]

The Independent Theatre Council, the Association of Community Theatres and the Association of Community Artists were pressing the Council along similar lines at this time.[41] But although many of the arguments were accepted by the Council, and the allocations for fringe and experimental theatre and community arts were greatly increased, the extent to which the late announcement by the Government of the Arts Council's grant-in-aid and the very structure of Government and Arts Council funding made for some degree of double standards became evident early in 1975

when 'it was agreed to increase the sum unallocated by freezing 50 per cent of the allocations under the Council's direct control until 1 October 1975 when the position would be reviewed'. It was known that many large well-established companies 'had already entered into all sorts of commitments which could not possibly be revoked at least without incurring additional expenditure'.[42] Whereas the allocations of which 50 per cent were frozen, the so-called uncommitted allocations, were those that went to just those small and developing activities – as well as to individual artists – to whose requirements the sixteen officers had drawn attention.

In the visual arts world there has been persistent discontent about the completely different scale of resources available for organising Arts Council exhibitions, as opposed to the relatively small resources available for others in subsidised galleries and arts centres organising temporary exhibitions. In 1981 a working party was established 'to consider existing arrangements and possible improvements or alternatives to the Council's own provision'.[43]

But to what extent should the maintaining of national companies, 'centres of excellence', be the dominant priority of Government policy and Arts Council practice? For, in these matters, Government policy and Arts Council practice are woven together. As the Deputy Secretary-General reported to the Arts Council in July 1980:

The Treasury's standing instruction to the Secretary-General as Accounting Officer is that the Council should accept responsibility 'for the financial well-being of its major clients', a term which plainly includes the national companies above all; and there is a strong though tacit presumption that, were the Council to reduce significantly or to withdraw its subsidy for any of the national companies, that decision would be reflected in a reduction *pari passu* in the Council's total Grant-in-Aid.[44]

Clearly, then, it would need a change of Government policy, not just Arts Council policy, to decide that for example there were more important priorities for arts subsidy than staying near the top of the international opera league. In the arts only the best is ever good enough. But that statement

begs important questions – the best of what, for whom, and why? Excellence can take many forms. At what opportunity cost are the artistic achievements of the heavily-subsidised being offered?

A progressive and comprehensive policy for the arts would have to face up to the fact that, in Richard Hoggart's words, 'most of the new money is going towards subsidising and improving the artistic pursuits of those who already know and enjoy the arts. To them that hath is being given'.[45] It would have to look more systematically at what can be done with relatively small sums of money, and it would have to take a much more positive view of the possibilities of sophisticated work taking place in new or unusual contexts. Above all, it would have to be based on a published body of case-law analysing more fully the artistic achievements and financial realities of organisations across the whole range of the subsidised arts. It is only with a continuous and open programme of evaluation and research that firm and well-informed judgements can be made about the value of the heavily subsidised companies.

Keynes, with all the confidence of a man who knew little of England outside Cambridge and the South-East warned that 'nothing can be more damaging than the excessive prestige of metropolitan standards and fashions'.[46] But Jennie Lee stood Keynes on his head. She told the House of Commons in 1970: 'I have insisted that there should be no cutting back on metropolitan standards in order to spread the available money more evenly throughout the country. That would be the worst possible disservice'.[47] It is the Jennie Lee view that has prevailed.

Notes

1 The Arts Council of Great Britain, *Sixth Annual Report, 1950–51*, p.34.

2 *A Brighter Prospect, the 17th Annual Report of the Arts Council of Great Britain 1961–62*, p.14.

3 From 'Memorandum in Support of an Application to the

Treasury for Financial Assistance' signed by Lord Macmillan and Lord De La Warr, 6 March 1940.

4 'He (Keynes) had had some subscriptions promised, and one of them was going to yield as much as £25,000 a year. Dalton's Bill (the Finance Bill at the beginning of 1946) decreed that people couldn't make a deed of covenant with surtax. £25,000 – and more – was lost at a stroke.' Montague Haltrecht, *The Quiet Showman: Sir David Webster and the Royal Opera House*, Collins, 1975, p.66.

5 Kenneth Clark, *The Other Half*, John Murray, 1977, p.131.

6 From interview with Mary Glasgow, 15 March 1979.

7 Charles Landstone, *Off-Stage*, Elek, 1953, p.107.

8 See John Elsom and Nicholas Tomalin, *The History of the National Theatre*, Jonathan Cape, 1978, particularly pp.121–2.

9 Elsom and Tomalin, *op. cit*, p.73.

10 Elsom and Tomalin, *op. cit*, p.142.

11 Elsom and Tomalin, *op. cit*, pp.59–60.

12 'A National Theatre' by Basil Dean, *The Times*, 18 August 1945.

13 Judith Cook, *Directors Theatre*, Harrap, 1976, pp.106–7.

14 James L. Shanahan, William S. Hendon, Alice J. Macdonald (eds.) *Economic Policy for the Arts*, Abt Books, 1980, p.66.

15 Lord Bridges, *The State and the Arts*, Clarendon Press, 1958, p.16.

16 Editorial in Daily Telegraph quoted in *Private Eye*, Pseuds Corner, 23 January 1976.

17 Quoted in Elsom and Tomalin, *op. cit*, p.277.

18 Simon Hoggart, 'Budget night at the opera', *The Guardian*, 28 March 1980.

19 Arts Council of Great Britain, *Information Bulletin* No.38, February 1981.

20 Janet Minihan, *The Nationalisation of Culture*, Hamish Hamilton, 1977, p.26.

21 *Arts Council of Great Britain, Thirty-first Annual Report and Accounts 1975–6, The arts in hard times,* p.7.

22 On the pseudo-objective use of 'standards', see John Pick, *Weasel Words,* City Arts series, n.d.

23 Arts Council of Great Britain, *Information Bulletin*, No.38, February 1981.

24 In Laurence Marks 'Unkindness in the Cut', *The Observer*, 10 May 1981.

25 Arts Council of Great Britain *Information Bulletin* No.38, February 1981.

26 Sir Hugh Willatt, 'How the Arts are Promoted' in John Pick (ed.) *The State and the Arts*, John Offord, 1980, p.26.

27 House of Commons Select Committee on Estimates, Eighth Report, 1967–8, *Grants for the Arts*, para. 28.

28 Jim McGuigan *Writers and the Arts Council*, 1981, p.80.

29 A threat used by Braham Murray, a director of the Royal Exchange Theatre, Manchester, on the BBC Radio 4 programme 'The World at One', 27 October 1980.

30 Steven Globerman, 'An Exploratory Analysis of the Effects of Public Funding of the Performing Arts' in James L. Shanahan, William S. Hendon, Alice J. Macdonald (eds.) *Economic Policy for the Arts*, Abt Books, 1980, p.67.

31–2 Minutes of the Arts Council meeting, 28 January 1970.

33 This was Lord Goodman's view recorded in the minutes of the Arts Council meeting 26 January 1972.

34 Minutes of the Arts Council meeting 24 November 1976. A further Arts Council Committee of Enquiry – in 1978–9 – into the operation and finances of the National Theatre did not fulfill its, albeit limited, terms of reference.

35 Peat Marwick Mitchell and Co. *A Service to Management*, 1980, p.27.

36 Stephen Fay 'Inflation tolls the knell of grand opera', *The Sunday Times*, 21 September 1975.

37 See, for example, Jeremy Bugler 'Maestros on a musical gravy train', *The Observer*, 18 April 1976, and Hilmar Hoffman, 'Tomorrow's music theatres – needs and potential'. *The Democratic Renewal of the Performing Arts*, Council of Europe, 1976.

38 Anthony Field in Shanahan, Hendon and Macdonald (eds.) *op. cit*, p.65.

39 Minutes of Arts Council meeting 31 January 1973.

40 Memorandum from sixteen Arts Council officers to Arts Council directorate 16 December 1974.

41 See Catherine Itzin, *Stages in the Revolution*, Eyre Methuen 1980, particularly pp.211–215.

42 Minutes of Arts Council meeting 26 February 1975.

43 Arts Council of Great Britain *Information Bulletin* No.38, February 1981.

44 'The National Companies', note by the Deputy Secretary-General, accompanying Arts Council Paper 763, July 1980.

45 Richard Hoggart, 'We must bridge theory and practice in study of the arts', *Times Higher Education Supplement*, 12 August 1977.

46 Lord Keynes 'The Arts Council: its policy and hopes' *The Listener*, 12 July 1945, reprinted in The Arts Council of Great Britain *First Annual Report, 1945* p.23.

47 House of Commons, *Hansard*, 5 February 1970, column 716.

5
The Selective Tradition

'At a philosophical level, at the true level of theory and at the level of the history of various practices, there is a process which I call the selective tradition: that which, within the terms of an effective dominant culture, is always passed off as 'the tradition', 'the significant past'. But always the selectivity is the point; the way in which from a whole possible area of past and present, certain meanings and practices are chosen for emphasis, certain other meanings and practices are neglected and excluded.'

Raymond Williams[1]

Implicit in most of the Arts Council's work, as in Kenneth Clark's celebrated television series, is the tendency to equate civilisation with the 'high' cultures of western Europe. This tendency provides an important part of the explanation of the 'what' and 'why' of arts subsidy: the high degree of receptivity at the Arts Council to, for example, opera, and European classical music and ballet, and the considerable lack of receptivity, to take three more examples, to the arts of ethnic minorities, of folk music, and of working-class writing.

When the Arts Council received its first Charter in 1946 the adjective 'fine' was put in front of the word 'arts' at two places in the description of the Council's aims and objects. It was considered that under the Scientific Societies Act of 1843 the Council would gain exemption from paying rates if it used that form of words, and since the Oxford English Dictionary defined the fine arts as 'those in which the mind and imagination are chiefly concerned' and since the founding fathers of the Council had no specific wish to be involved in what were then called the 'technical arts', Keynes was confident that 'fine arts' could be 'interpreted very widely so as to cover anything of interest to us'.[2]

To remove any doubts about the elasticity of the concept of 'fine arts', when the Council received a new Charter in 1967 the objects clause referred to the 'arts' rather that the 'fine arts', the attempt to gain exemption from paying rates having

been unsuccessful. But though the phrase 'fine arts' could be interpreted broadly it was interpreted narrowly. Lack of money is normally given as the principal reason why the categories of work funded by the Council were only expanded very slowly, but this is hardly a convincing explanation since on several occasions the Council seems to have underbid rather than overbid for financial resources from the Treasury and the DES. As already reported in chapter 2, Kenneth Clark, Arts Council Chairman from 1953 to 1960, told the House of Commons Select Committee on Estimates in 1949: 'I am not in favour of giving the Arts Council a very much larger grant because I think it will simply get itself into trouble.'[3]

Clark was particularly concerned that the Arts Council should not play too dominant a role in the field of drama. His sentiments were reflected in the Arts Council's Quinquennial Estimates for the years 1951–56 which saw opera and ballet as the main fields of expansion: the Council's overall plans reflected in these estimates seem unambitious, envisaging little innovation and few new areas of work.[4] In October 1950 Mrs Dalton proposed that architecture should be included in the field of the Council's work and the Council agreed that the Executive should give consideration to the question of making funds available for architecture when the estimates for 1951–2 were being prepared.[5] But no provision was made for architecture. In the mid-1970s the then Minister for the Arts tells us that the Chairman of the Council, Lord Gibson, settled for a smaller increase in the Arts Council grant than the Minister himself felt confident that he could have secured for the Council.[6] Of course, there is a sense in which Kenneth Clark was prophetic; as the categories of work funded by the Council have expanded, there has been more 'trouble'.

In music, jazz was admitted to the Arts Council canon in 1967 when Graham Collier received a small award. But folk music, despite the efforts of Ralph Vaughan Williams, who argued forcefully that folk music was a fine art, has been neglected.[7] This neglect has been rationalised in various ways: that folk music is largely an amateur activity, that it is 'by its nature a matter of regional, or local, rather than national interest', and that the English Folk Dance and Song Society receives funds from the Sports Council![8] Yet on vir-

tually any definition, there are dozens, if not hundreds, of professional folk musicians in Britain and a number of folk festivals and organisations that should have a claim on national resources. Why the prejudice?

A. L. Lloyd, the great collector and chronicler of folk music, provides some clues in a book that was, ironically, subsidised to a small extent by the Arts Council:

Whatever the case elsewhere, in England folk song is the musical and poetic expression of the fantasy of the lower classes – and by no means exclusively the country workers. In the main the songs are evolved by labouring people to suit their ways and conditions of life, and they reflect the aspirations that rise from those ways and conditions. In the process of creating this fund of song, economic conditions are more decisive than any real distance from formal culture, book education and the like, for our experience shows that, as elsewhere, the most inventive bearers of English folk song are likely to be the liveliest-minded, best-informed of their community, but among the poorest.[9]

That paragraph was written in the mid-1960s and economic circumstances and the social contexts of folk music have changed since then. There is a dialectical relationship between traditional music and dance and 'contemporary folk' and certainly it is now several decades since folk music in Britain was predominantly a working-class activity. But like other aspects of the oral tradition it has, for all the usefulness of the BBC in these areas, suffered the official neglect that comes with inherited class prejudice and the doctrine of professional exclusiveness.

In the case of the arts of ethnic minorities, class prejudice and professional exclusiveness can be further spiced with a dose of chauvinism. Roy Fuller, who was for a time the chairman of the Council's Literature Panel, arguing against any Arts Council expenditure on ethnic minorities' arts activities opined that 'there was a strong argument for integrating ethnic minorities as soon as possible: separation simply led to dissident political groupings'.[10] Most members and senior officers of the Arts Council would probably not share Roy Fuller's views on this question, but the Council has done little to overcome the marginal position of ethnic arts activities in what is now a multi-cultural society.

It was not until after the publication in 1965 of the white paper *A Policy for the Arts* that the Council developed its long-standing interest in poetry into taking responsibility for literature. But here, too, class factors have been at work. In the early 1970s there was a prolonged but half-hearted and abortive attempt to set up a writers-in-factories scheme. In the late 1970s one of the most striking examples of ideology in practice at the Arts Council has been the long-running saga of the Federation of Worker Writers and Community Publishers (FWWCP). For two and a half years the Federation, of more than twenty groups, fought for an Arts Council grant for a national development officer to advance its work. They were finally successful in achieving some Arts Council backing at the end of 1980, but the story is of such central interest to the concerns of this book that the Open Letter from the Chairperson of the FWWCP to Melvyn Bragg is printed as an appendix. The issues raised by the shifting and stalling inside the Arts Council on this issue were discussed by Jim McGuigan in his report on *Writers and the Arts Council*, but this section of the McGuigan report was omitted from the version of the report published by the Arts Council. McGuigan pointed out that 'the FWWCP challenges the taken-for-granted assumption that only exceptional individuals with rare talent are capable of producing art of good quality'.[11]

In drama the most telling case of a rough-and-ready insubordination refusing to take 'no' for an answer from the Arts Council lies in the history of Joan Littlewood's Theatre Workshop. For nine years, from 1946 to 1955, the Council refused any grant-aid to this company which was finally forced into liquidation. However, in 1955 a new company was formed by Littlewood and others called Pioneer Theatres Ltd, and at the end of that year the Arts Council offered Pioneer Theatres Ltd 'a grant of £500 . . . for the period up to March 31, 1956, on the condition that grants totalling £1000 were also obtained from local authorities and other sources in the same period'.[12] The selective tradition was at work; there is probably no other theatre where an Arts Council grant has been offered on such ungenerous terms: a pound for every two local authority pounds. But in 1959 Joan Littlewood was

able to cock a snook at the Arts Council – that was the year of her three very successful West End transfers. Since then alternative groups and community theatre groups partly through their own artistic effectiveness and strength of numbers and partly thanks to some responsive and persistent Arts Council officers and panel members have won more time, space and funds for themselves. As Catherine Itzin in her history of recent political theatre points out: in 1968 there were half-a-dozen 'fringe' theatre groups; by 1978 there were well over a hundred 'alternative' theatre companies, plus another fifty or more young people's theatre companies.[13]

It is in the visual arts that the Council's work is at its most exposed. For the Council not only funds visual artists through a variety of schemes, it is probably also the most important organiser of temporary exhibitions in Britain. Indeed so involved is the Arts Council in the day-to-day world of contemporary visual arts practice and so widespread is the belief that modern artists have been perpetrating a confidence trick for long enough, that the Council is often on the receiving end of ridicule and criticism that should more correctly be addressed elsewhere. But while some inadequate work is bound to be subsidised and some ridicule and public scorn is inevitable if a broad range of contemporary work is to be supported, insufficient attempt has been made to show new or controversial work in relation to relevant antecedents or as part of a tradition. And while the decadence evident in the arts always gives cause for concern,[14] many of the fulminations against modern artists consist of little more than practising the ancient sport of kicking the barometer: blaming the artist for telling us that the news is bad. It was perhaps no mere coincidence that Fyfe Robertson's famous rant against phoney-art or *phart*[15] came soon after the worst bout of inflation in contemporary British history.

However, many of the Arts Council's exhibitions have been widely acclaimed, not least the selection from its own collection 'British Art 1940–80' on show at the Hayward Gallery in summer 1980. But has the Council given too much emphasis, too many of its resources, too heavy a seal-of-approval, to late modernism in general, to its vapid formalist abstractions and post-conceptual antics in particular? An

exhibition like 'Towards Another Picture' shown at Nottingham in 1977 suggests that contemporary British visual arts practice is more diverse than the work obviously validated by the Arts Council and the Tate Gallery. Marina Vaizey, who served on the Arts Council from 1976 to 1978 is of the opinion that:

There is an emphasis, but I don't see how it can be wholly avoided. The art community is not big; it shares teachers, galleries, academies; the same people turn up. So something of this is inescapable. But . . . I think there has been an honest even arduous attempt to involve as many tastes as possible.[16]

But Janet Daley, a lecturer at the Royal College of Art argues that the 'emphasis' has amounted to a conspiracy; she has traced some of the links in what she has called 'the new orthodoxy' and 'the official circuit' arguing that:

Many of the most frequently occurring names on the circuit have done turns on the Art Panel of the Arts Council and cynics could be forgiven for concluding that the annual handing out of awards and exhibitions was a kind of ritual dance in which the partners periodically change position, but no one ever leaves the floor.[17]

The annual hand-out of visual arts awards at the Arts Council is being discontinued and, in any case, bigger questions beckon. And it is here that the organisations funded by the taxpayer shrink in size besides the giant corporations of an advanced technological society: to what extent does the thrust of what the critic Peter Fuller has called a mega-visual society, of television and advertising, lasers and ever-more sophisticated forms of electronic communication, render the fine artist obsolete or impotently embattled? And how best can the trained visual artist be liberated from the isolation of having skills and talents but no agreed social role?[18] One way out is through more partnerships with architects. But there has been no consistent or wholehearted attempt to encourage artists and architects to work together[19], or to negotiate those changes in art education which would be a pre-requisite of good quality murals, frescoes, mosaics and outdoor sculpture becoming more widespread. In the 1960s the Council's Art Panel came to the view that legislation – ensuring that a percentage of public building costs should be allocated for the

commission and purchase of works of art for public buildings – was not the best method of encouraging artist-architect collaborations, and in 1967 the Council introduced its own Works of Art for Public Buildings scheme, but this has never received more than a tiny part of the Council's funds (less than 1½ per cent of the Council's expenditure on the visual arts in England in 1979–80).

In recent years many ambitious and successful murals have been painted in Britain – like Walter Kershaw's work in Rochdale and that of the Greenwich Mural Workshop, but murals are too easily thought of as external embellishment, too easily relegated to being a form of outdoor relief work, gilding the ghetto as it often seems.[20] There are many problems (not least of maintenance) in developing what is loosely called public art, and always a cost, a risk, involved in creating opportunities for more challenging work.[21] But exaggerated concern over the quality of a single work is liable to inhibit the growth of such public art and the opportunities of developing a greater visual awareness and a greatly improved visual environment through public art have been largely sacrificed in favour of maintaining a gallery-based fine art tradition.

Half of Britain's adult population owns a camera, and photography, being largely based on an aesthetic of realism, is a medium accessible to all. It was not until 1967, after Lord Goodman had been giving out the prizes at a gathering of the Institute of Incorporated Photographers that the Art Panel agreed to recommend to the Council

. . . that it should extend its activities so as to organise an occasional photographic exhibition but that it should not undertake to subsidise photographic societies or clubs. It was also agreed that a small committee should be set up by the Council to advise on photographic exhibitions and that Lord Snowdon should be invited to act as chairman.[22]

Throughout the 1970s the scope of, and budget for, the Council's contribution to photography expanded very considerably. But in 1979 the Council axed its photography sub-committee and refused to reinstate it despite the unanimous recommendation of its Art Panel that it should do so.

The struggle for a separate photography committee or panel, a separate forum for photography, can be seen in part as a struggle against the selective tradition, a struggle to assert that photography has a breadth of aims, uses and potential, that, while having a legitimate claim on funds for the arts, partly lie outside the fine art concerns that predominate in official visual arts policy.[23]

The development of a selective tradition involves a constant filtering process and a continuous set of boundary disputes, both within, and between, art forms. Some of those disputes and conflicts in the main categories of art subsidised by the Arts Council have been mentioned. But two other major distinctions and discriminations have been necessary to the Arts Council in focussing its work. These can be touched on only briefly and in the most general terms: first, the distinction between the fine and the applied arts; and secondly, that between 'art' and 'entertainment'.

Photography has been a particularly contested area at the Arts Council because it is an art both fine and applied, and in the dominant ideology of capitalist society the advancement of the applied arts and crafts have been accorded a much lower priority than the funding of the fine arts – the Crafts Advisory Committee was not set up until 1971.[24] The crafts represent a challenge to the separation of industrial production from art, but craftsmen, as manual workers, working producers of goods, are seen as less essential to civilisation than artists to those who believe with Norman St John Stevas that 'the essence of a civilisation lies in the mind and spirit, and in the works of art that witness to them'.[25]

The separation between, and attachment of different status to, the fine and applied arts goes back to the distinction which developed in the seventeenth and eighteenth century between 'artists' and 'artisans'. Later, in the nineteenth century, the fine arts separated themselves decisively from pastimes and entertainments,[26] so that when the state came to widen its involvement with the arts at the start of the Second World War, it revived the Entertainments National Service Association (ENSA), which had been set up during the first war, and it created CEMA. Both agencies passed from the scene at the end

of the war, but there was an opportunity for the newly-created Arts Council not only to assume the mantle of CEMA, but to take on board some of the concerns of ENSA. As Mary Glasgow wrote to Keynes on 7 September 1945:

I remember how you have always said that if we only wait, ENSA will fall into our lap like a ripe plum. It almost looks as if it will be a cart-load of plums, and, indeed, the first has already fallen. The Ministry of Labour have asked us to take over the whole of ENSA music in the factories. The formal request has not yet come, but Steuart Wilson and I were asked to see officials at the Ministry, as they told us that all Ministry of Labour subsidy to ENSA will cease at the end of the financial year, but that the Minister wants to be sure that the war-time work in the factories will be adequately followed up. We said we thought the Council would be perfectly prepared to take over, provided it was clearly understood that our ways were not ENSA's. The variety entertainments would cease; the gramophone recitals would cease (if only because we have no records and it is now impossible to get them); the cheap symphony concerts at one shilling a head would cease and so would the free music clubs which ENSA has been running.

Those of the ripe plums of ENSA that were not immediately discarded fairly quickly proved indigestible, and in 1948 the suggestion from the Variety Artists Federation that the Council might sponsor tours of 'high-class' variety entertainment in theatreless towns was not adopted:

Sir Kenneth Clark doubted whether such entertainment could be considered as coming within the objects of the Council laid down in the Charter and pointed to the difficulty of establishing a controlling standard in work of this kind.[27]

In recent years there has been a further brief flirtation with variety artists, to see if the Arts Council can assist with their training needs, and, more fruitfully, an investment in touring two large-scale musicals, *My Fair Lady* and *Oklahoma!* But these investments have been belated gestures towards popular entertainment and partly justified in terms of the somewhat condescending premise that Rodgers and Hammerstein might act as stepping-stones towards Verdi and Wagner.[28]

Popular entertainment is considerably sustained through the programmes of some local authorities and through the

broadcasting companies ('You mean you have a Department of *Heavy* Entertainment?' an American asked on being introduced to the BBC's Head of Light Entertainment). The distinction between 'art' and 'entertainment' is often false to the best in both categories, but a great deal that is labelled 'entertainment' readily takes its place in a commercial milieu, and there is not much of a case for spending public money on entertainment and arts activities that are commercially viable in their own right. At the same time public subsidy, directly or indirectly, is often used to buy time – for rehearsal, experimentation, research and technical development – for all kinds of artists. While, for example, novelists, actors, composers and painters have in varying degrees had access to public funds with which to buy time, comedians and music hall artists, rock musicians and folk singers have, for the most part, been denied similar access.

Like training opportunities, critical standards and critical debate are equally important to popular and 'high' arts; the label 'entertainment' does not automatically produce absolution from making judgments. The terms of such debate, the struggle over these meanings, 'entertainment', 'art', 'popular', 'high', and the priorities and practices that they underpin, are major ways through which reality is continually formed and changed. The struggle has a long history; in recent times it has been fought out most crucially perhaps in the mass media and, in particular, in television, an area to which, despite funding the making of films on arts subjects, and despite having a number of broadcasting executives serving on its panels and its governing body, the Arts Council has given almost no systematic attention.

In this chapter I have outlined ways in which the Arts Council has interpreted its responsibilities narrowly to give emphasis and defence to certain skills and purposes as *the arts*. Such emphasis and defence, class-based if not class-bound, has had the effect, in a developing division of labour, of discriminating against both the useful arts and a number of art forms and practices that have their roots in working-class experience. The official biases are often crude and obvious, sometimes they are as subtle as that gentle curved course familiar to

bowls players.

The concept of the arts, and the social position of artists, have both differed radically at various periods of history, and although the practice of art is often a solitary business, the arts should be seen primarily as social processes. The attempt to distinguish 'art' from other, often closely related, practices is, as Raymond Williams has argued 'a quite extraordinarily important historical and social process.... The attempt to distinguish "aesthetic" from other kinds of attention and response is, as a historical and social process, perhaps even more important. The attempt to distinguish between good, bad and indifferent work in specific practices is, when made in full seriousness and without the presumption of privileged classes and habits, an indispensable element of the central process of conscious human production. And when we see these attempts as themselves social processes, we can continue the inquiry instead of cutting it short'.[29]

Notes

1 In 'Base and Superstructure in Marxist Cultural Theory', *New Left Review*, No. 82, Nov–Dec 1973, p.9.

2 Letter from Keynes to Mary Glasgow 7 November 1945.

3 Minutes of Evidence Taken Before the Select Committee on Estimates (Sub-Committee C), 'The Arts Council', *House of Commons Paper 315*, HMSO, 1949, p.45, para 5328.

4 Memorandum from the Arts Council of Great Britain to the Chancellor of the Exchequer on the Council's Quinquennial Estimates for the years 1951–56, 1950.

5 Minutes of the Arts Council meeting, 11 October 1950

6 Hugh Jenkins, *The Culture Gap*, Marion Boyars, 1979, pp198–9.

7 See, for example, his President's speech to the English Folk Dance and Song Society, 14 November, 1953 in the 1953–4 Annual Report of that organisation: 'Are folk song and dance

fine arts? I say that they are, at all events that they ought to be. You may answer "We are out just to enjoy ourselves." But you do not enjoy yourselves by saying that you are going to do so. The only way to get pleasure out of an art is to do it as well as you possibly can'.

8 From note of a discussion on folk music held at the Arts Council on 26 January 1977. These rationalisations were repeated by John Cruft, the Council's music director at the open forum on music policy held at the Arts Council in February 1979.

9 A. L. Lloyd, *Folk Song in England*, Paladin, 1975 edition, p.22.

10 Minutes of the Arts Council meeting on 26 May 1976.

11 Jim McGuigan, *Writers and the Arts Council*, unpublished first draft, 1979, p.105.

12 Minutes of the Drama Panel meeting on 8 December 1955.

13 Catherine Itzin, *Stages in the Revolution*, Eyre Methuen, 1980, p.xiv. For more on experimental, alternative and political theatre since 1968 see Peter Ansorge, *Disrupting the Spectacle*, Pitman, 1975 and Sandy Craig (ed.) *Dreams and Deconstructions*, Amber Lane, 1980.

14 See, for example, Stephen Trombley 'What has happened to the arts'? in *New Universities Quarterly*, volume 35, no. 1., Winter 1980–81.

15 Fyfe Robertson's television programme, prompted by the Hayward Annual exhibition in 1977, was transmitted at peak viewing time on BBC-1 on 15 August 1977. A transcript of the programme was published in *Art Monthly*, no. 11, October 1977.

16 Marina Vaizey, 'The English art of public patronage', *The Sunday Times,* 20 July 1980.

17 Janet Daley, 'Cliques and coteries – warnings from the world of the visual arts', *New Universities Quarterly*, Volume 35, no. 1, Winter 1980/81, p.64.

18 Peter Fuller raises these questions in 'Fine Art After Modernism', *Beyond the Crisis in Art*, Writers and Readers, 1980.

19 The opening by the Arts Council of a slide index intended to be of service to architects able to offer opportunities to artists is a step in the right direction. See 'Index links artists with potential patrons', *The Times*, 12 December 1980.

20 For illustrations of many of the best examples of external murals in the UK see Graham Cooper and Doug Sargent *Painting the Town*, Phaidon, 1979.

21 For a survey of recent sculptural commissions and their attendant problems see Deanna Petherbridge, 'Sculpture up front' in *Art Monthly*, no. 43, 1981. The Arts Council's 'Art into Landscape' competitions and exhibitions held in 1974, 1977 and 1980 have provided opportunities to people in all walks of life to enliven under-used public spaces; they represent one important set of approaches to public art. The problems involved in commissioning more works of art for public buildings – not least the implications for art schools – have been discussed by Alister Warman in 'Hawaii, Alaska ... and Milton Keynes', *Art Monthly*, no. 18, July/August 1978.

22 Minutes of the Art Panel meeting on 11 October 1967.

23 See 'The Arts Council and Photography', *Camerawork*, no. 18, Half Moon Photography Workshop, March 1980. In Spring 1981 the Arts Council agreed that 'the procedures for dealing with photography should be re-examined'. See *Arts Council Information Bulletin*, no. 39, April/May 1981.

24 The Crafts Advisory Committee was re-named the Crafts Council in 1979 and in 1979-80 the grant voted to it by Parliament (£1.1 million) was equivalent to the grant from the Arts Council to the Royal Opera House for 8 weeks.

25 Norman St John Stevas, 'Double Our Money', *The Sunday Times*, 17 November 1974.

26 Some of the important terms in the language of cultural transformation have been examined by Raymond Williams in *Keywords*, Fontana, 1976. Nicholas Pearson's as yet unpub-

lished PhD thesis 'The Social Construction of Art' submitted to Leicester University provides a thorough historical analysis of the social relations of art. The social history of the division between fine arts and entertainments has been explored by John Pick in *The Privileged Arts*, City Arts series, n.d.

27 Minutes of the Arts Council's Executive meeting on 17 November 1948.

28 The issues involved in the funding of musicals by the Arts Council were given some superficial coverage in the second of two BBC-2 programmes on the Council's work – 'Calling the Tune', transmitted on 10 July 1980.

29 Raymond Williams, *Culture*, Fontana, 1981, p.126.

6
The Importance
of Context

Towards the end of the war Keynes expressed his belief that state investment in the arts should primarily be used for building theatres, concert halls and galleries – 'nor will that expenditure be unproductive in financial terms', for 'if with state aid the material frame can be constructed the public and the artists will do the rest between them.'[1]

But when, in 1943, following the successful rescue by CEMA of the Bristol Old Vic, Keynes wanted the Council to assist with the purchase of two nineteenth century theatres in Bedford and Luton that were coming on the market, Vaughan Williams protested.[2] He thought that the Council should invest in people rather than buildings and that argument soon achieved *cliché*-status.

But an important strand in the policy debate in the formative years of the Council concerned the kinds of context, the kinds of building that were, and were not, appropriate for arts activities and the effect on audiences of these different kinds of context. A great deal of CEMA's work consisted in the organisation, the direct provision, of concerts, theatre tours and exhibitions. The exhibition work has continued to this day, but gradually after the war the Arts Council decided to withdraw from direct provision and instead to encourage the development of self-governing non-profit performing arts companies. CEMA's direct provision had developed in the hostels attached to Royal Ordnance Factories, in the canteens of these factories, indeed as was reported in *The Arts in Wartime, C.E.M.A. 1942 and 1943* (p.10):

Every kind of experiment has been made for housing the arts, from cathedrals to village inns, and from public libraries to air-raid

shelters. Some of them may endure and, as experiments, all have their value in suggesting that the arts can become a part of daily life.

But after the war 'a part of daily life' gradually became 'apart from daily life'; the pressure – at an early stage articulated by Keynes – for specialised arts buildings became very strong. Though the new buildings, new theatres and galleries were a long time coming, a number of very different examples help to illustrate the degree of uncertainty that entered into the tactics of diffusing the arts, and begin to point up the extent to which raising standards in specialised buildings took over much of the resources and energy that had previously gone to demonstrating that the arts can become a part of daily life.

There were, of course, incongruities and some heavy paternalism in many of the populist 'art for all' attempts of the 1940s. It might have been interesting to have been present at the meeting in 1948 when Dr James Welsh, Chairman of the Council's Scottish Committee, discussed with one of the football supporters' clubs the suggestion that the club might be used to popularise some of the Arts Council entertainments such as concerts; the suggestion did not receive an encouraging welcome.[3]

Relationships with Butlin's Holiday Camps also caused much heart-searching at the Council in 1947. Mary Glasgow, the Council's first Secretary-General, reported to the Council's Executive in January 1947 that 'In the course of the past year, several approaches have been made to the Arts Council and to its associated companies by the organisers of Butlin's Camps.'

One approach was from Mr Butlin's Press Officer inviting the Council's Chairman to write an introduction to the programme of the performances given in two of the Camps by the San Carlo Opera Company. This the Chairman refused saying he was, nevertheless, interested in the project and would like to discuss future co-operation with Mr Butlin personally. Later a programme of the Opera at the Camps appeared with a statement printed in the centre of the page that 'Butlin's work in full Association with the Arts Council of Great Britain.'[4] This was the first that the Council knew of

its 'full Association' with Butlin's. But later that year the Bristol Old Vic's 'bright and gay' production of *Much Ado About Nothing* at Butlin's Filey Camp 'held its own against counter-attractions on the camp', as Douglas Fayers the Council's regional director for Yorkshire reported:

The audience returned to their seats punctually after the intervals (they were ordered to by loud speakers) but their enjoyment and appreciation of what to many must have been their first Shakespearean production was sufficient evidence that Butlin's might prove the means of bringing good theatre – and music – to the masses.[5]

The following year, 1948, Butlin's asked the Council's Welsh office to arrange an exhibition of reproductions at its Pwllheli Camp and the Council's Executive accepted the advice of its Art Panel that the exhibition should go ahead provided that it was shown in appropriate rooms such as a reading room or quiet room and not in the general halls or dining room and provided that there was no music accompanying the exhibitions. Though some members of the Council were not satisfied that the best interests of the Council would be served by such an arrangement, the exhibition went ahead and that autumn the Art Director reported that very little interest had been shown in it.

A year later the Arts Council took over the administration of the British Institute for Adult Education's 'Art for the People' scheme of travelling exhibitions which had been launched in 1935 and had been expanded considerably during the war. One of the particular characteristics of this scheme was the provision of small exhibitions for schools, canteens, shops and factories. The Council's *Annual Report* for 1948–9 contained some heart-searching on what it saw as 'an event of historical importance':

In absorbing the 'Art for the People' scheme, the Council was conscious of a certain caution. While the union was an obvious and a happy one, there remained the danger, evident to many on both sides, that by losing its identity in a large official organisation the scheme might also end by losing its traditional advantages of simple working and an unofficial approach. However hard the Arts Council tries to escape formality in its dealings, it cannot avoid working with other formal organisations in the world of the arts,

such as City Councils and Municipal Art Galleries. The British Institute on the other hand owes much of its success to the working arrangements it has established with lay organisations in small places. Those who arranged the union assured one another that they would try to keep the special character and the special advantages of the Institute's methods intact, and this is perhaps a good opportunity to record the intention and confirm it.[6]

But whatever the intentions the outcome is clear. Arts Council exhibitions are, on the whole, not found in schools, canteens, shops and factories. Since the 1940s the Council has not encouraged the arts at places of work; experiments 'in suggesting that the arts can become a part of daily life' were effectively abandoned.

In presenting drama the debate about places and spaces is integral to the evaluation of drama as social expression. Writing soon after his retirement from the Arts Council in 1952, after ten years as Associate Drama Director, Charles Landstone opined:

Experiences with the regional companies at Salisbury, in the West of England, and with our own tours, showed that the public was interested only in the play and its presentation and were quite indifferent to the nature of the seats. True, had there been a competitive theatre with more comfortable accommodation, they would have gone there in preference, but there was no competition and this lack of comparative comfort has never kept them away.[7]

But three years later Joe Hodgkinson, the Drama Director, informed the Council:

There are unmistakable signs in many areas that the public has had enough of these ill-equipped uncomfortable halls where the pleasures of the play are reduced to a minimum; rather than tolerate these conditions people will travel long distances to main centres where the evening out is an occasion rather than an endurance.[8]

What happened? Did aching buttocks suddenly begin to weigh heavily with the public in the second quarter of the 1950s? Whatever the evidence, and the bases for Landstone's and Hodgkinson's judgments (and by the time Hodgkinson was writing the Council was troubled by the possible—and to a lesser extent actual—effects of television on audiences for live drama) the assumptions shifted away from the public 'being

interested only in the play and its presentation' and towards the 'evening out' as 'an occasion'. The Council accepted Hodgkinson's view, which was totally in accord with that of the Secretary-General. There was a further scaling down of tours to theatreless towns, and the subsidised arts in small towns and villages more often took the appearance of a bus or coach ready to take organised parties to their nearest 'main centre'. Theatre transport subsidy, it was argued, was both better economics, in that the costs of the transport were recovered several times over at the box office, and better theatre. In fact only very limited numbers were involved in the subsidised coach parties (a total of about 85,000 subsidised trips to 16 theatres in 1961–2). The 1940s emphasis on taking the arts to the people and encouraging the art of the people had largely evaporated by the late 1950s.

By then the Government had asked the Arts Council to undertake 'a comprehensive survey of the needs for cultural building in London and the rest of the country.[9] The two parts of the ensuing report *Housing the Arts in Great Britain* were published in 1959 and 1961. Following the white paper *A Policy for the Arts* in 1965 a Housing the Arts fund and a Housing the Arts committee were established at the Arts Council. This is the one major area of the Council's work where a relatively small amount of centrally provided money has proved very successful in stimulating other parties (including local authorities) to find the balance needed to ensure that schemes can go ahead. In the first 15 years of the existence of the Housing the Arts fund, over £12 million has been paid or offered to 343 projects in England, Scotland and Wales. The estimated total capital costs of these schemes was £70 million, towards which the Arts Council's contribution averaged 17.5 per cent.

Most of the Arts Council's Housing the Arts funds have gone towards the costs of buildings for the performing arts, particularly drama. Television and the harsh realities of theatre economics have combined with Arts Council policies to change the face of drama – outside London at any rate. In the 1950s, many commercial managements decided to sell off their theatres for development purposes. Other theatres were deemed uneconomic or unsuitable in the face of

100

the new demands of directors, actors and audiences for higher standards of work in more comfortable surroundings. From the opening of the Belgrade Theatre, Coventry, in 1958, and particularly in the late 1960s and early 1970s, dozens of new theatres were built and opened up and down the country, and nearly all of them housed companies subsidised by the Arts Council. It is extremely unlikely that this spate of building would have been possible without Arts Council encouragement and some financial support.

Architects have sat on the Council's Housing the Arts committee since its inception and in June 1973, one of them, Peter Moro, reported that the Architecture and Planning Committee of the Association of British Theatre Technicians was: 'appalled at the low standard of most of the submissions (of design for new theatres and arts centres) and find it painful to think that provided certain technical requirements have been met, public money is used to enable these buildings to be realised.'

Moro argued that:

... the Arts Council is in a unique position to stipulate that buildings requiring their support should be subject to architectural competition whenever possible... It is not unreasonable to suggest that it is the Arts Council's responsibility to take its terms of reference to include architecture and to ensure that the arts are housed in the best possible buildings. [10]

Moro's suggestion about competitions has not been acted upon, nor has the Council accepted that its terms of reference should include architecture, but it does believe 'that it has a responsibility to ensure that public buildings, largely paid for with public money, should maintain a reasonable architectural standard, and to this end it asks promoters to submit their proposals to the Royal Fine Art Commission.' [11]

Leaving aside purely architectural considerations one of the main and, in the 1960s largely unforeseen, consequences of opening new, purpose-built theatres and arts centres, is the extent to which their maintenance has gobbled up much of the increased subsidy that the Government and local authorities have made available. For example, the total revenue costs of the National Theatre in the year ending April 1980

were £8.2 million. Of this, £1.5 million went on the building (cleaning, security, safety, electrical, mechanical and systems engineering, repairs and maintenance, depreciation, rates, insurance).[12] Some of the major new theatres outside London are similarly burdened with 'fixed fabric' and 'variable upkeep' costs.

At the same time there have been many imaginative conversions of old buildings for use as arts centres and in one way at least the squeeze on local authority spending in the 1970s was a blessing in disguise: it put the brake on the development of enormously costly and often ill-designed leisure emporia. The neighbouring local authorities of Windsor and Slough provide an instructive contrast in provision for the arts. In Windsor an energetic and imaginative group of residents with a real enthusiasm for increasing opportunities for the arts, has won a protracted struggle to re-cycle part of a redundant police station into an arts centre. In Slough, a giant complex has been thrust upon the ratepayers with insufficient advanced thought given to either costs or usage.[13]

Of practical interest to a number of local authorities is the question of how best to treat the heritage of pre-1914 theatres still to be found in many towns and cities and still much in demand for touring companies and others. The Arts Council's Theatre Enquiry report in 1970 saw that the main hope for survival of many of these lay in their passing from private hands to local authorities:

The acquisition of former commercial theatres by local authorities could have significant consequences for the Arts Council. . . . This impending liability in the next few years is one which the Arts Council must anticipate as soon as it can. . . . The nation needs new theatres but many cities still need the old ones.[14]

And as a result of Arts Council initiatives, there were major reconstructions of theatres in Leeds, Liverpool, Newcastle and Nottingham and 1981 saw the re-opening of important theatres in Manchester, Birmingham and Blackpool.

It was argued in a recent Arts Council *Annual Report* that the Council is engaged in 'unceasing work to promote vitality in the theatres, orchestras, arts centres, through festivals, exhibi-

tions, literature, community arts, the many touring companies, *and every other form of creative work.*[15] (emphasis added) But, as was discovered by the Leisure and the Quality of Life experiments, which the Arts Council helped to fund in the mid-1970s: 'A localised network of buildings and equipment might well suit most people's needs and interests.'[16] Necessary and successful, sometimes even magnificent, though many of them are, the development of comfortable, often well-appointed and prestigious buildings for the arts has also, in many cases, pre-empted the creation of that localised network of buildings, for, in the words of the Council's *Annual Report* 'every other form of creative work.'

Because of the strict cash limits imposed, the pressure on the Housing the Arts Fund since the middle 1970s has been particularly severe. This has been partly compensated for by the availability of funds from other sources: for example, EEC funds have helped the development of theatres in Pitlochry and Plymouth, and labour paid for by the Manpower Services Commission has been widely used in a range of small and middle-scale projects. Overall, there has been a growing emphasis on the refurbishment and improvement of existing buildings, and an increasing use of converted buildings.

Multi-purpose arts and community centres have many limitations and may be no more readily accessible than theatres or galleries, but arts centres, particularly in converted buildings, are generally free of that odour of sanctity, that exclusive atmosphere, that surrounds some of the specialised buildings. It is, as always, a matter of balance. But in the arts, as in other areas of life, the buildings available, their character and distribution, should in part be a reflection of a general right to participate.

Notes

1 J. M. Keynes, 'The Arts in Wartime – Widening Scope of CEMA – Reopening of Bristol Theatre Tonight'. *The Times*, 11 May 1943.

2 Minutes of CEMA meeting 20 July 1943.

3 Minutes of the Arts Council meeting on 8 December 1948.

4 Mary Glasgow, Executive Note. No. 50, 'Butlin's Camps,' 9 January 1947.

5 Report on the East and West Ridings of Yorkshire, by Douglas Fayers, December 1947.

6 *The Arts Council of Great Britain, Fourth Annual Report 1948–9*, p.12.

7 Charles Landstone, *Off-Stage*, Elek, 1953, p.106.

8 Council Paper 381, 20 May 1955.

9 Report by the Arts Council of Great Britain, *Housing the Arts in Great Britain*, Part I, 1959, p.ix.

10 'Notes' circulated to the Housing the Arts Committee 8 June 1973.

11 *Thirty-first annual report and accounts 1975–6, The arts in hard times*, Arts Council of Great Britain, p.16.

12 National Theatre, *The National Figures 1979–80*.

13 The entries for Fulcrum Entertainment Centre, Slough and The Old Court, Windsor, in *Directory of Arts Centres 2*, John Offord, 1981, convey something of the different histories and *ambience* of the two centres.

14 *The Theatre Today in England and Wales*, Arts Council of Great Britain, 1970, p.15.

15 *Patronage and Responsibility, Thirty-fourth annual report and accounts*, 1978–9, Arts Council of Great Britain, p.12.

16 *Leisure and the Quality of Life, A Report on Four Local Experiments, Vol. I*, HMSO 1977, p.50

7
Artists and Experiments

His sensibility made him particularly sympathetic to the problems of the living artist.

Eric W. White on Sir Kenneth (later Lord) Clark[1]

When one passes from the executant to the creator I doubt very much if there is anything the State can do. We know that certain writers, composers and artists go through bad times, but an Arts Council must not become a charitable organisation.

Sir Kenneth (later Lord) Clark[2]

Along with Kenneth Clark's worry, expressed by many others since, about the danger of the Arts Council becoming a charitable organisation, there has been another constant worry: the danger of developing a panel of state-approved writers, painters and musicians.[3] More generally, weighed alongside the value of other forms of support for the arts, the fruitfulness of making grants to individuals has been the subject of much official doubt. In the mid-1960s the Arts Council's Secretary-General was claiming, *à propos* new work in drama that 'the encouragement and establishment in their profession of all the forward-looking dramatists of the present generation, and the creation of a unique national tradition of acting and direction, count for infinitely more in the way of "help to British artists" than can ever be achieved through piecemeal individual grants'.[4]

But once again it was the white paper *A Policy for the Arts*, published in February 1965, that brought some change in the climate of official opinion and had reverberations throughout the arts world. The white paper declared that 'one of the main objectives of the Government's policy is to encourage the living artist' and it announced an increase from £10,000 to £50,000 in Arts Council funds for assisting young artists. This was, among many young artists, the beginning of a revolution of rising expectations of support for new and experimental work. The expectations were fuelled by the unprecedented publicity and recognition in 'Swinging

London' which a few British painters were receiving through Sunday colour supplements, television, paperbacks and films – and even sales of work, often in new galleries.

In the period 1968-70 arts labs opened – usually in extremely make-shift premises – in all major cities and in many towns in Britain. In 1969-70 an *Arts Lab Newsletter* was produced monthly which contained dozens of reports from up and down the country. Some of the organisations reported on have survived and did much good work in the 1970s: the Beaford Centre in Devon and the Birmingham Arts Laboratory would be examples. Many others were quickly into trouble of various kinds like the Chelmsford Arts Lab which in November 1969 'was slowly grinding to a halt 'cos of nicker-wetting from straights and over-coolness from heads'.[5] Frank Kermode, a member of the Arts Council at the time, argued that the Arts Labs 'have their charismatic lunge and rapidly die'.[6] But was such a trajectory inevitable in so many cases?

The late 1960s also saw artists, particularly young artists, meet and confer in a way that was unprecedented in Britain. For example issue 10/11 of the newsletter *Circuit* was given over to a report of

... a conference of 350 artists and others held at St. Katherine's Docks, London on 8 June 1969. We discussed the role of the artist in society, the problems of patronage, the need to spend money on living rather than dead art, the situation of the Arts Labs, the need for new and better buildings for the arts. The Arts Council was continuously attacked for its indifference, ignorance and irrelevance to the real needs of living artists.

A few weeks previously six members of FACOP (the ironically-titled Friends of the Arts Council Operative which organised the June 1969 conference) invaded a meeting of the New Activities Committee of the Arts Council to present a case for replacing that Committee with an Artists Panel, because they thought that the Committee members, being drawn 'from the Paunch Belt'[7], knew nothing about new activities.

This was a time of considerable social and educational

change and the Arts Council found that its past had caught up with it: there had been a relative neglect of the regions, of young people, and of experimental work. Between 1961 and 1969 twenty-two universities were founded in the UK, equal to the number founded from 1249 to 1954. At the end of the 1960s large sections of the educated young were no longer willing to be compliant. As the New Activities Committee report put it:

New Activities, in almost all their manifestations, can be seen as a concerted response and reaction by a section of the present younger generation – together with certain intellectuals and artists of an older generation – to the prevailing established culture. . . . A significant feature of the present revolt is the participation of some of the most intelligent and idealistic among contemporary young people.[8]

The Arts Council brought some young people on to the advisory panels and appointed a Chief Regional Adviser. Between 1965-6 and 1968-9 (a time of very little inflation) the funds available to the Arts Council doubled. When there is more money there are new applicants. And, at the end of 1968 the Arts Council set up its first sub-committee to investigate new activities. This produced an interim report in May 1969, after which a full New Activities Committee, chaired by the Hon. Michael Astor, was established, half of whose members were to be young people, though the proportion of young people fell as the Committee expanded. The Committee distributed its £15,000 allocation for the financial year 1969-70 amongst eight regions where the regional co-ordinators were encouraged to promote 'gatherings':

These gatherings we hoped would demonstrate the range of activity in each region, would promote communication and interchange of ideas between the regions, and from the regions to the Committee, and would unearth information needed by the Committee.

Though the gatherings were considered to have achieved their aims 'a great deal of what may be rightly termed "new activities", in particular all premises-based and community-based activities could not be shown, as their work is dependent on its local context.'[9] The artists in the London

region, instead of holding a gathering, opted to hear applications for their regional grant at a series of open meetings. Following these the representatives of the London artists included in their recommendations that the Arts Council should pay £10 to one of their number who had been fined for firing a cap-pistol at the US Embassy. This recommendation did not meet with the approval of the New Activities Committee, the Arts Council or the press. Lord Goodman said that this recommendation was made 'as much to twist the tail of the Arts Council as the general public. They must be congratulated on a substantial measure of success in this objective.'[10]

Michael Astor's draft was rejected by the Committee that he chaired and with his Alternate Chairman, J. W. Lambert, he later produced a minority set of recommendations to the Committee's report. But apart from Astor and Lambert the other four members of the Arts Council on the Committee did not do their jobs as committee members. Lord Harewood and Sir Edward Boyle did not attend any of the Committee's meetings and in due course resigned from it – though Sir Edward, who had chaired the earlier sub-committee on new activities made a widely reported and sympathetic speech about the Committee's work to the House of Commons.[11] Peter Hall and Frank Kermode only attended occasionally. The lack of zeal shown by these Arts Council members was more than compensated for by some overzealous artists on the Committee who, without consultation with the Committee's chairman, organised an all-day assembly to discuss the Committee's work. And because Astor's draft was rejected, the Committee's report was written in a hurry: there were, after all, hundreds of artists awaiting the Committee's findings. None of this helped the credibility of the Committee when it came to present its report which was, however, endorsed by the great majority of its members.

The main differences between the majority and the minority recommendations were that the former expected much more in the way of committees and funds from the Arts Council. Astor and Lambert were keen to draw a sharp line between what was primarily social and what was primarily

artistic. They also recommended the dencentralisation of responsibility for arts laboratories to the regional arts associations (at a time when most of the English RAAS were fledgling organisations with a combined income of little more than half a million pounds and three of them had yet to be born), and spoke in terms of an additional £40,000 as the beginnings of an Experimental Arts Fund.[12] The majority recommendations spoke of £100,000 being allocated by a New Activities and Multi-Media Committee, arguing that it was not generally feasible at the moment to channel money for new activities through the RAAS. The recommendations, endorsed by the majority, that the Arts Council should set up 'The Arts and the Community Committee' and initiate a full-scale enquiry into the relationship between industry and the arts were both ignored by the Council. It was a further four years before the Council set up a full enquiry into community arts. Most of the recommendations of the majority on the New Activities Committee were rejected by the Council and those of Astor and Lambert accepted. And having helped to stimulate a great deal of activity and interest and to raise a lot of expectations in 1968–70, the Council made no separate allocation for new activities or experimental projects in 1970–1. Indeed although some members of the New Activities Committee saw the need for 'a distinction between professional artists who had decided not to work within the established institutions of art, and the groundswell movement which consisted of young people having a go themselves',[13] some senior officers of the Arts Council were keen to see new activists and new activities thoroughly buried – and preferably at a decent distance. In Council Paper 447, written in July 1970, Nigel Abercrombie, the Council's former Secretary-General who had become Chief Regional Adviser, and Keith Jeffrey, then Assistant to the Secretary-General, wrote in paragraphs 9 and 10:

9. The Council will doubtless attach weight to the recommendations of the Chairman and Vice-Chairman of the New Activities Committee in their report, where emphasis is placed upon the largely non-cultural (and in some cases even non-artistic) nature of the enterprises that were brought before their Committee's attention. For a project to commend itself for support from central

Government funds, the Council must first be satisfied that it is of a sufficiently high artistic standard, sufficiently national in concept and sufficiently responsibly envisaged in a professional sense both as to its administration and its execution. It is hard to find any single so-called 'new activity' among the host considered and even encouraged by the former New Activities Committee that falls into this category. The problem is therefore likely to resolve itself both readily and rapidly into a mainly regional one, and it is totally proper that 'new activities' in this specialised sense should be dealt with regionally and that their sponsors should look to local government and Regional Arts Associations for their primary support in cases where they can be judged to be of likely benefit to the artistic life of the community. When this benefit may be in doubt, local authorities and Regional Arts Associations are better placed than the Arts Council not only to understand local circumstances but to finance activities which may be essentially non-cultural in content and largely amateur in execution.

10. As pointed out in the introductory paper to the alternative set of recommendations by the Chairman of the former New Activities Committee, it would be advisable for the term 'new activities' to be replaced. It is unsatisfactory not only in its ambiguity and in being open to almost any interpretation, but also because its continued use for experimental fringe activities will mean that genuine new activities of the more orthodox and professional variety may unfairly come to be tarred with the same anti-cultural brush. This would be positively counter-productive from any artistic point of view – and a new phrase is therefore needed. The Council may consider that 'experimental projects' would more appropriately describe the type of activity in mind.

'Non-cultural', 'non-artistic' – such unambiguously loaded terms are not often used in the Arts Council – and they were not used in the minority recommendations referred to. But a few months had passed, and a Conservative Government had just been returned to office. And the rough equation of 'genuine' with 'more orthodox' and 'professional' was a telling part of the backlash. So, exit the New Activities Committee, enter the Experimental Projects Committee. The EPC lasted for three years – but, after a time, and not being chaired by an Arts Council member, the Committee was effectively downgraded. By December 1973, when it had its last meeting, the projects considered by the EPC seemed mainly to fall into two categories: Performance Art (responsibility for

which was taken under, the wing of the Visual Arts Panel) and Community Arts (see chapter 3).

'Artists Now' and the struggle for artists' rights

The next major initiative to cajole and persuade the Council into allocating more resources to struggling, unknown and experimental artists came from a fivesome called 'Artists Now', a group which included a painter, a composer and an author and two others who had experience of serving on Arts Council panels and committees. In 1974 they achieved a lot of journalistic coverage for their report on the *Patronage of the Creative Artist,* a document that the Arts Council didn't take sufficiently seriously to discuss at all fully, but to which the Council's senior officers responded with a press release which welcomed the report, while at the same time pointing to its many omissions and half-truths. 'Artists Now' pointed out that the Arts Council's published reports hide some important facts by not giving the size of the awards to individuals, many of these awards being of very small sums. The group proposed a number of non-competitive schemes, including art markets, and workshops for dramatists, to support new work arguing that 'all schemes which require artists to send up work for rejection by experts are bad schemes', and that 'the giving of individual maintenance grants to few creative artists is today a waste of public money'.[14] Partly in response to the spirit, if not the letter, of the *Artists Now* report, of other reports on artists' earnings, and to pressure from artists' groups[15], there were increases in the amounts of money – in bursaries, commissioning fees, and those maintenance grants that the *Artists Now* report had considered a waste of money – going directly from the Arts Council and the RAAs to artists in all media. But this served to disappoint more artists than it satisfied, since, for example, in the case of visual arts awards 'on average only about 2 per cent of the applicants were successful'.[16]

Also throughout the 1960s and 1970s, haltingly and slowly, as different groups within and outside the Arts Council came to confront the issues, the range of ways in which individual artists could be sustained and have their rights respected through legal and fiscal changes and through

improving the infrastructure in the arts, gradually came to be appreciated and, even more gradually, to be acted upon.

Copyright and royalty questions, as they affect composers, have been carefully analysed in a report published by the Arts Council in 1977, a report that suggests levy payments on radio receivers, on blank tapes, on photocopiers and tape-recorders, as potential sources of income for composers and writers:

Once legally established, these levies could provide revenue that would not be vulnerable to policy changes by large institutions such as the BBC, Performing Rights Society and Arts Council, and they would be more likely to move in line with inflation than current sources of income for composers.[17]

The British Actors' Equity Association and the Musicians' Union have, in similar vein, been pressing for the imposition of a tax on the sale or hire of blank tapes and/or video record-ing machines 'the proceeds of which would be devoted to the general good of the industries and professions damaged by home recording'.[18] The imposition of such a levy is, however, rejected in the Green Paper on copyright and designs law issued by the Government in 1981.[19]

There are some hard practical questions involved in these demands to extend and defend the rights of creators and per-formers, questions of the kind that bedevilled the three decades of struggle for a Public Lending Right for authors which finally reached the statute book in 1979.[20] But PLR apart, there was a gradual shift in Arts Council literature policy throughout the 1970s from helping the writers of con-temporary literature to encouraging the reading of it by a wider public. In 1981 the Council's individual award schemes in literature and the visual arts were discontinued.

In announcing changes in the Council's literature policy, Charles Osborne, the Arts Council's literature director, stated his belief that 'a number of mediocrities have received grants from us in the past three years'.[21] This is a rather dif-ferent emphasis from one of the conclusions of a recent sociological study of grants to writers: 'If there is wastage in the distribution of grants to writers it occurs because some recipients are not on any reasonable definition in need of

assistance.[22] For although 'quality' and 'need' have been given as the criteria for making such grants, neither concept has been seriously examined and the former has been given more emphasis as 'decision-makers prefer to play safe by backing old favourites rather than newcomers'[23] a judgement whose truth seemed to be confirmed by the announcement that in place of grants to writers and of the short-lived National Book Awards, there was to be a more prestigious bursary scheme with up to five awards of up to £7,500 being given each year. Meanwhile it has not gone unnoticed in the literary world that the Arts Council was spending a decreasing proportion of its funds on literature in England – 1.6 per cent of total funds in 1977-8, 1.25 per cent in 1979-80.

In the visual arts the rider to the discontinuation (after 1980) of individual awards was that in future more of the Council's funds would be used for purchasing work. And there has been an increasing interest in Britain in *droit de suite,* the right of the creator of an original work of art to receive a share of the price resulting from any subsequent sale of work. This right has passed into law in most western European countries but the Government's recent Green Paper does not consider arguments in support of *droit de suite* 'sufficiently logical, equitable or compelling to warrant its introduction'.[24] The fights for artists' rights, for new sources of income for artists, for the health of the live arts and entertainments industries in an increasingly electronic world, needs the wholehearted and forward-looking support of the Arts Council. And until and unless the infrastructure of the arts is very considerably improved, grants to individuals, of great promise and some achievement, provided that they are means-tested, have a part to play in this support. Again, in a world of distractions, audiences for the arts in general, and for new and experimental work in particular, need to be constantly created, wooed and re-created. This is an argument of giving a policy priority to developing a much stronger network of local arts centres – many of which might contain a bookshop and a gallery with works for sale and for loan – where new work and experimental work would be an integral part, but not the only part, of the programme.

At the same time the general principle that artists should be

paid for what they do rather than for what they are is an argument for developing artists-in-residence, artists-in-education, artists-in-industry schemes. And rather than special pleading or the results of woolly impressionism we need the results of hard research into the very varied schemes of support for artists in different countries, from the Creative Artists Public Service scheme in New York to the 'loose affiliation of gifted ones' as it unfolds in the Republic of Ireland of the 1980s.[25] Again it is important, in the face of some continuing scepticism about public subsidy, to emphasise the small economic role of the state in relation to many artists. In particular, most practising visual artists who see themselves as professional, support themselves not through grants or other forms of public assistance, but through sales of work, teaching and other jobs. When the Gulbenkian Arts Enquiry interviewed 49 professional artists in Bristol, it found only 4 who had received assistance from the Arts Council or from RAAS.[26]

Broadcasting at the time of the 1945 General Election, Keynes, in a famous passage, helped sow the seeds of the bi-partisan approach that has characterised the attitude of the two main British political parties towards the arts. In contrast to the warring of the Labour and Conservative parties over the socialising of industry, Keynes rejoiced in the fact that 'everyone, I fancy, recognises that the work of the artist is, of its nature, individual and free'.[27] For many artists this strikes at the heart of their predicament: organisations are expensive, artists are individual, and almost free.

Notes

1 Eric W. White, *The Arts Council of Great Britain*, Davis-Poynter, 1975, p.78.

2 Kenneth Clark, *The Other Half,* John Murray, 1977, p.136.

3 See, for example, Mary Glasgow 'State Aid for the Arts', in *Britain Today,* British Council, pp.12-13.

4 *Key Year, The Arts Council of Great Britain Twenty-First Annual Report 1965-6* p.13.

5 *Arts Lab Newsletter No. 2,* November 1969.

6 *The Times,* 20 December 1969. For an earlier discussion see James Allen, 'The arts lab explosion' *New Society* 21 November 1968.

7 Jeff Nuttall's phrase first used at a meeting with the New Activities Sub-Committee on 12 December 1968.

8 *Report of the New Activities Committee,* Arts Council of Great Britain, 1970, p.6.

9 *Report of the New Activities Committee, op. cit,* p.3 and p.23.

10 'The Arts Council and the New Activists' *Evening Standard,* 2 April 1970, reprinted in *Not for the Record,* Andre Deutsch, 1972, p. 163.

11 *Hansard* Volume 795, No. 53, Columns 682-4, 5 February 1970.

12 New Activities Committee, 'Alternative Set of Recommendations and Introduction by the Chairman', 1970.

13 Minutes of the Arts Council meeting 27 May 1970.

14 Artists Now, *Patronage of the Creative Artist,* 1974, p.76 and p.78.

15 The Artists Union and the Writers Action Group were founded in 1972, the Theatre Writers Union and the Association of Dance and Mime Artists in 1976.

16 George Melly 'The Piccadilly Collection', *Sunday Times* 1 March 1981.

17 Alan Rump *Money for Composers,* Arts Council, 1977, p.3.

18 British Actors' Equity Association, 'Equity and the New Technology', a policy statement approved by the Equity Council at

its meeting on 31 March 1981.

19 *Reform of the Law Relating to Copyright, Designs and Performers'
 Protection,* HMSO, Cmnd 8302, 1981.

20 For the case for PLR, and for some of the operational difficulties
 involved in it, see Richard Findlater (ed.), *Public Lending Right,
 A Matter of Justice,* Andre Deutsch, 1971.

21 Blake Morrison, 'The last of the small spenders?', *Times
 Literary Supplement,* 10 April 1981.

22 Jim McGuigan, *Writers and the Arts Council,* Arts Council,
 1981, p.105.

23 Jim McGuigan, *op. cit,* p.106.

24 *Reform of the Law Relating to Copyright, Designs and Performers'
 Protection, op. cit.*

25 For initial reports on the Irish scheme see 'State wage for 150
 artists', *The Guardian,* 7 March 1981, and 'How Ireland put its
 artists on the payroll', *Sunday Times,* 15 March 1981. Bernard
 Levin considered the scheme 'The nicest bandwagon you ever
 saw' in *The Times,* 18 March 1981.

26 See Nick Pearson, 'The Bristol Sample'. *Art Monthly.* no. 23,
 1979.

27 Lord Keynes 'The Arts Council: its Policy and Hopes', *The
 Listener,* 12 July 1945, reprinted as Appendix A in Arts Council
 of Great Britain, *First Annual Report 1945.*

8
National, Regional, Local

To talk as if England was a country where it was necessary to travel for seven days on a camel in order to reach London is, I think, a rather absurd presentation of the picture.

<div align="right">Lord Goodman[1]</div>

It depends who is on the camel.

Regional Offices

In evidence to the House of Commons Select Committee on Estimates in 1948–9 Kenneth Clark felt 'bound to say that the Arts Council, in its origin, as CEMA, was essentially a regional organisation. The first grant to CEMA was given in order to help to keep people quiet in the blackout, and it was not supposed to operate in London at all'.[2]

1939–40 saw mass evacuations from the cities and from London in particular, but there were also other artistic and social reasons to explain the extreme decentralisation of CEMA's earliest policies, which included the provision of professional touring drama, exhibitions and concerts at places of work and support for amateur musical and drama activity. Perhaps the most innovative idea – the system of music travellers – came from Sir Walford Davies (see chapter 3).

In 1942, the year in which Keynes became chairman, a network of CEMA regional offices was built up. The regional boundaries were co-terminous with those of the civil defence regions; but the development of the regional offices precipitated the first serious retreat from the countryside, the discontinuation of the music travellers scheme. The official reasons for the discontinuation were that the amateur side of the travellers work was being absorbed into the county advisory service that the National Council of Social Service was building up with the help of funds from the Carnegie Trust, while the professional side was becoming the responsibility of the new CEMA regional offices; but the discontinuation was not popular and Mary Glasgow, Secretary of CEMA, writing to *The Times* explaining the decision

provoked a bitter letter from a Welsh MP:

The late Sir Walford Davies was one of the inspirers of CEMA. He knew and loved the countryside especially in Wales; he knew that only personal contact and frequent visits could further CEMA's musical objectives in the rural areas. Accordingly he initiated the idea of music travellers. To cover the whole of rural Wales two full-time travellers were appointed to work under the National Council of Music. They have worked well for over three years and by extensive travel and judicious choice of artists have enhanced the appreciation of music in secluded places and have created a rising good will in the 'CEMA concert' in country town and village . . .

Miss Glasgow says CEMA desired 'to increase its practical help' and to develop its work into a wider pattern by 'decentralising its machinery' – an office in Cardiff, I suppose, complete with telephones and typewriters. This tinkling and tapping will not make music in a single rural village.[3]

But the protest in war-time Britain against the discontinuance of the travel-weary music travellers and the opening of the Arts Council regional offices was *molto piano* compared to the widespread fury aroused by the decision to close the last five of those offices in 1956.

There were numerous angry letters in the press though John Christie of Glyndebourne was alone in suggesting that the tedium of the decision might drive him to arson and mountaineering: 'Art is incandescent', he told *The Times*' readers, 'art is inspired. Arts Councils and offices can be forgotten. Set alight a few of those in them and let us blaze our way to Mount Everest'.[4]

The background to the closures is of some interest. After the war the Arts Council slowly reduced its direct promotions of music and drama (though not of exhibitions) preferring to grant-aid independent organisations. This gradual reduction in the direct management of arts activities was the principal justification for the closure of the regional offices in England: three were closed in 1952, one in 1953 and the remaining five in 1956.

These sweeping changes, though spread over five years, were the work of a new broom; W. E. Williams had become Secretary-General in 1951 and he was not afraid to give marching orders to what he considered to be some of the

weaker members of staff.[5] Also, in his paper on the Council's regional structure, Williams argued strongly for the power of the centre:

There is already close contact between the Specialist Directors and the major Provincial Symphony Orchestras and theatres, and the duplication of these relationships at lower and less expert levels is wasteful and frustrating. Our links with Local Authorities, which are of prime importance, are ineffective if they are not made at the highest possible levels. Nowadays discussions with Mayors and Town Clerks are invariably conducted by the Specialist Directors, and there is no doubt that they flourish better on this basis than if they were entrusted to a Regional Officer. Local Authorities considering, say, the acquisition of a theatre or the subsidy of an orchestra, want specialist professional advice which can only be provided by a fully primed officer from Headquarters.

Williams went on to emphasise 'that these proposed changes in administrative structure are primarily conceived not as economies, but as a better system of administration replacing the one which has become obsolete'.[6] In fact there was a loss of 60 staff from the regions between 1950 and 1956, and, as a percentage of total grant-in-aid, the Arts Council's administration costs fell by 3 per cent between 1954–5 and 1957–8.

Policy and structure are inseparable and behind the closure of the regional offices was a very substantial policy factor. In 1948–9 the Select Committee on Estimates had argued that the Council should:

turn their energies to making the Arts more accessible, being content at first, if necessary, with less ambitious standards, and Your Committee therefore suggests that the provinces, where the Arts are not so readily available to the public, provide a more valuable field than the metropolitan area for the activities of the Council.[7]

Over the nineteen years between the publication of that recommendation from Westminster and the report of the next Select Committee on Estimates enquiry into the arts in 1967–8 the Council pursued a course almost diametrically opposite to the one recommended by the MPs. The closure of the regional offices of the Council was one of the main ex-

pressions in practice of 'a policy of consolidation in preference to further diffusion'. Radio and television it was argued were potent agents of diffusion; the Arts Council's job was to consolidate standards in London.[8]

The closure of the regional offices did not have the whole-hearted support of all the Council members. One of them Lt Col. Vere E. Cotton argued that:

> The Provinces are always suspicious, in my opinion rightly so, of centralisation whatever form it takes and it would be difficult to find a worse time psychologically for closing the Regional offices, since it will coincide with the announcement of additional grants to Covent Garden and Sadler's Wells of £80,000 per annum.[9]

To help allay provincial suspicions the Lieutenant-Colonel strongly urged that the Council should hold two meetings a year in big cities outside London. The Council agreed to the suggestion but, in the event, only one such meeting was held – in Liverpool in September 1956. Lt Col. Cotton came from Liverpool.

The closure of the regional offices badly hit the many small arts organisations at the time and led very directly to the founding of the first regional arts association. In January 1956 the Council 'argued that no useful purpose would be served by receiving a deputation from the South West Arts Association.'[10] But those in the South-West were not to be easily brushed aside as Peter Cox, Principal of Dartington College of Arts (in an obituary article on Perry Morgan, the first chairman of the first regional arts association) has recently recalled:

> The late Cyril Wood, then Regional Director of the Arts Council, used to call together the leading members of the arts centres and societies which were fast forming in the South West and it was at these conferences that Perry made his presence felt. At the conference in Weymouth in 1956 we were informed that the regional offices were to be closed and Cyril Wood was losing his job. Thanks to Perry's forceful chairmanship, a delegation of six set off to London to meet Sir William Emrys Williams, then Secretary-General of the Council. As an Indian would say, that particular morning was an auspicious time for the visit: it was Trelawney's day, entirely appropriate for a Cornish-led rebellion. Undaunted by the fading decor of

the ballroom at 4 St James's Square, and equally unresponsive to Sir William's voluble blandishments, Perry rapped the table after a few minutes and said with quiet authority, 'Sir William, please be silent; we have come to do the talking'. We reeled out an hour later with a few thousand pounds in our pockets and the agreement to set up a regional arts association.[11]

A similar organisation was established in the Midlands two years later.

Local government and the arts – the 1940s and 1950s

From its earliest days the Arts Council expressed a strong desire to co-operate with Local Authorities. And it gave a warm welcome to the Local Government Act of 1948 which empowered all local authorities to spend money up to the product of a sixpenny rate on the arts. Previously the law had made it impossible, except by special provision, for local authorities to present concerts and plays under their own auspices and in their own buildings. And soon after the 1948 Act was passed the Council announced that it set the provision of advice to local authorities 'as one of its most urgent tasks' and it created a new post the main function of which was 'to concentrate on new regional experiments, particularly those sponsored by local authorities'.[12] But the post was established for precisely a year – the financial year of 1949–50.[13] And the ending of this short-lived appointment marked the beginning of plans to close the regional offices, the bases from which the Council could most effectively co-operate with the majority of local authorities (a few large, most small) that made up the mosaic of local government in Britain before the re-organisation of the early 1970s. So while the desire to co-operate with local authorities did not weaken throughout the 1950s, the human means with which to do so did. The exhortation to local authorities to do more for the arts has been unceasing, but the priorities remained with the large organisations particularly in London, but also in the regions. 'People like the chairman of the Halle and the chairman of the Liverpool Phil said that they would like to talk to HQ about their problems', Joe Hodgkinson, a regional director who became the Council's drama director in 1953, recalled.[14]

Sir William Emrys Williams was Secretary-General from 1951 to 1963, twelve of the thirteen consecutive years of Conservative Government – the 'thirteen wasted years' of the Labour slogan. From all accounts he personally was energetic in applying himself to the uphill task of winning more local authority support for the arts. But because he was overwhelmingly concerned 'to provide a concentration of high quality at a limited number of centres',[15] and because he had a steadily diminishing number of staff outside London to assist him in his approaches to local authorities, his effectiveness in securing more local authority support was distinctly limited. However the 1950s saw the beginnings of the enduring system of collaborative schemes for local authority assistance to the main orchestras outside London and distinct increases in local authority support for repertory theatres. There was a long tradition of local authorities' not supporting drama and music, and putting an end to that tradition and to the suspicions the arts aroused in many town halls and council offices was inevitably a slow process. But a less exclusive approach to the arts by the Arts Council might well have yielded more positive results from local authorities many of whom have a laudable and long-standing tradition of provision for recreation. Nevertheless, the difficulties in persuading local authorities to part with money for the performing arts after the 1948 Act can hardly be overstated. During the period of rebuilding after the war the arts had a very low priority and where interesting new developments did occur they were usually due to the emergence of enthusiastic individuals with strong personalities. Two such were Ted Fletcher and Arthur Blenkinsop.

The North-Eastern Association for the Arts
Arthur Blenkinsop had been a Labour MP until 1959 and was to be one again from 1964. But between the general elections in those two years he was able to give a lot of his talents to getting the North Eastern Association for the Arts (later Northern Arts) airborne. In 1959 a Gulbenkian Foundation report[16] had suggested that local authorities would benefit by grouping together to support the arts and in 1961 the Newcastle-upon-Tyne County Borough Council (basing its

arguments on those put forward by Ted Fletcher, then Chairman of the Borough Council's Finance Committee and later to be MP for Darlington) persuaded other authorities in the north-east as well as a wide range of other organisations and individuals to subscribe to the new NEAA. In the first sixteen months of its existence (December 1961 to March 1963) the new Association succeeded in raising £42,100 from within its region – of which £24,100 came from local authorities in the area. The Arts Council was asked to match the local authority contributions pound for pound, and since the Council had spent much of the previous fifteen years urging local authorities to spend more on the arts this was a symbolic moment. The Council responded with £500 – less than an old sixpence for every pound raised by the local authorities.

But a change of heart, of a kind, was to follow. Three months after the decision (in April 1962) to make an initial contribution of £500, the Secretary-General was suggesting to his directors that:

it might be wise to consider, at some time in the future, increasing Arts Council support for bodies such as the North East Association for the Arts, so that these associations could develop a stronger local responsibility for promoting the arts in their regions. There would however clearly be a risk that standards might be lowered, and it was agreed that it would be essential for the Arts Council to retain freedom of choice to select which items in the programme could be supported by the Council.[17]

Also in 1962–3, the Chairman and officers of NEAA lobbied Lord Hailsham, who had been appointed Minister with special responsibility for the North-East. Their efforts paid off for the Arts Council contribution to NEAA went up from £500 in 1961–3 to £22,000 in 1963–4.

But the earmarking of the Arts Council contributions which was felt to be essential in 1962 became less so, and within a few years the RAAs were effectively free to exercise full discretion in allocating the funds that they received from the Arts Council.

Completing the Network
Throughout the 1960s and early 1970s new RAAs emerged

from a variety of initiatives; for example the Greater London Arts Association, which was formed in 1966, grew mainly out of the work of the London Council of Social Service. The nascent associations were given a very considerable boost by the 1965 White Paper *A Policy for the Arts* and the advice of the 1967–8 Select Committee on *Grants for the Arts* was unequivocal:

The Arts Council should decentralise its support and work through regional associations, concentrating itself directly on national issues and organisations. This would imply building up the regional associations, giving them more active help and a more immediate priority in the allocation of funds, perhaps with special inducements for special initiatives.[18]

But at the end of the 1960s the Arts Council was still looking to the regional arts associations to find most of their own resources locally. The Council's new Chief Regional Adviser reported in 1969 that:

A typical Regional Association derives most of its funds from local authorities and from independent sources (industry, television companies, trusts, private patrons): all this is 'new money' over and above what is provided in subsidies for particular theatres, orchestras, galleries or programmes from the same sources. It is likely that the newly-formed Southern Arts Association will find more of its income from independent sources than from all public sources combined.[19]

In his five years as Chief Regional Adviser Nigel Abercrombie did much to help complete the network of regional arts associations that covered the country in 1973, the year in which the Council created a new regional department to service the regional associations. But ambiguity about, and suspicion of, the RAAS was very evident in the Arts Council throughout the 1970s. The tone was set by Lord Goodman in a House of Lords debate in 1972. After telling their Lordships (misleadingly) that the Arts Council had instituted the Regional Arts Associations and believed them to be excellent institutions he went on:

But when we hear the matter presented on the footing that they are probably able to speak for the regions my answer is, 'Yes, but in

some things and some things only'. We are concerned with the
Arts. This business about amateur theatricals, the crafts and the like
is something about which one needs to be very sceptical indeed.[20]

The Arts Council's Finance Director believed that the prin-
cipal task of RAAs should be in developing the audiences for
existing subsidised companies: 'If they could evolve an
increasing number of sophisticated schemes (and some are
already under way) which would result in a 10 per cent
increase of audiences, they would have accomplished more
than any other worthwhile scheme'.[21]

But those working in the RAAs wanted a bigger role than
that of marketing officers for existing companies and looked
for a more substantial expression of confidence from the Arts
Council. Lord Feversham, the first chairman of the Standing
Conference of Regional Arts Associations (later the Council
of Regional Arts Associations) told a Regional Studies Con-
ference in 1974:

During the five years in which I have been involved with this
business I have been constantly baffled by the expression of mystifi-
cation which comes into the eyes of Arts Council mandarins at the
mention of Regional Arts Associations. I cannot remember a time
when I have had the feeling of being received at the Arts Council as a
colleague involved in the same business. Rather one is given the
feeling that one is some kind of orange three-headed martian with
antennae sprouting from the forehead who has just landed by flying
saucer in Green Park.[22]

Lord Feversham expressed hope in change and in the work
of the Council's new regional department. But following
local government re-organisation which took effect in 1974, a
very firm brake was increasingly applied to local government
expenditure. It became clear that in hard financial times local
authorities tend to give priority to spending on buildings that
they own and activities that they directly manage rather than
to grant-giving; and though, by the 1970s, many local auth-
orities were contributing generously to theatres and
orchestras, the lowest priority for most was to give a grant to
a regional organisation which in turn passes most of it on
grants.

So the hopes of Neil Duncan – who could tolerate for little

more than two years the brickbats from all sides to which the Arts Council's new Director for Regional Development was subject – seem, in retrospect, pious indeed:

Our immediate aim is for each association to raise something like half its income from sources other than the Arts Council. For this to happen the local authority proportion will have to be a third at the very least, and 40 per cent might be nearer the mark.[23]

But once the network of RAAs was complete the percentage of total RAA income coming from local authorities never exceeded 30 per cent and by the end of the decade it was below 20 per cent. Before he left the Arts Council at the start of 1976 Neil Duncan was arguing that sole funding of the Regional Arts Associations by the Arts Council was the best answer; but his arguments cut little ice with his colleagues. Indeed sixteen years after the NEAA had suggested a pound-for-pound basis for its funding, Professor Harold Baldry, chairman of the Arts Council's regional committee, suggested that the Arts Council allocation to each RAA should be 'equiv-alent to the previous year's allocation, plus the percentage required to bring it up to the same value in real terms, plus an amount matching 50–50 the increase in contributions to the RAAs from local authorities'.[24] So while the principle of matching grants (much used in the USA) was considered to be an 'idle formula'[25] in the early 1960s it was back on the agenda in the late 1970s. But Professor Baldry's proposal was first modified into an incentive scheme designed to operate differently in each region, and finally effectively abandoned under the ever increasing pressures on local authority expen-diture.

Redcliffe-Maud and After
Uncertainty about the role of the RAAs, about the pace of the devolution of responsibilities to them from the Arts Council, and a relative lack of success in most cases in securing a steadily rising income (in real terms) from local authorities, precipitated three enquiries between 1974 and 1980 into the interaction between the local, regional and central govern-ment levels of public subsidy for the arts and, more specifically, into relations between the Arts Council and the

RAAs. In addition the Greater London Arts Association was the subject of a special Arts Council investigation in 1976, and in 1980 a working party was set up to recommend a new constitution for the arts on Merseyside following the decision of a Special General Meeting of Merseyside Arts Association to dissolve the Association and transfer its assets to a new Trust.

The most wide-ranging and most important of these enquiries was that by Lord Redcliffe-Maud; *Support for the Arts in England and Wales* was, in general, very well-received on its publication in June 1976.

Lord Redcliffe-Maud argued that 'we must look to local elected councils, at district and county level, to become the chief art patrons of the long-term future'[26] and said that if RAAs did not exist we would have to invent them. The Arts Council welcomed the Redcliffe-Maud report as the best account available of the complexities of arts patronage in this country and endorsed his emphasis on the need for a gradual devolution of decision-taking to the Regional Arts Associations. But it was also well aware of the hostility to devolution among many of its larger clients who feared that they would receive less money and a lower standard of assessment and of service from their regional association, than they would from the Arts Council.

Within a few months of the publication of the Redcliffe-Maud report an Arts Council Working Party, reviewing the whole spectrum of relationships between the Arts Council and the Regional Arts Associations, was reporting that 'the number of clients now funded by the Arts Council for whom transfer to a Regional Arts Association is practicable and desirable is relatively small'.[27] Nevertheless the Working Party spelt out a number of ways in which the Arts Council and the RAAs could strengthen their partnership and increase co-operation, and it listed the advantages of devolution:

It lightens the administrative burden of the Arts Council and enables the Council, its panels and committees and its officers to devote more time to strategy and problems at the national level. It increases the authority and standing of the Regional Arts Associations both locally and nationally. It spreads awareness of the arts and information about them in all parts of the country. Above all, it

ensures that decisions concerning the artistic activity involved are taken by the people aware of the local circumstances and closely connected with the local authorities.[27]

But Regional Arts Associations were far from satisfied with their position in the overall pattern of funding as the following notes, prepared jointly by their Directors for a meeting at the Arts Council in June 1978, testify:

An RAA is not just 'another ACGB-funded organisation'. Unlike most organisations the Arts Council supports, they have many of the *same* functions to fulfil as the Arts Council itself; *in addition* they have areas of work and responsibility ... which the Arts Council has either handed over or has never dealt with at all. The pressure on RAAs to initiate and to respond to the 'new' is far greater than that experienced by the Council. This role and these factors have perhaps never been significantly enough recognised in financial terms. . . . The commitment in principle to devolution as agreed Arts Council policy has further highlighted the problems of under-funding of RAAs. In a whole number of cases and over the question of devolution of community arts in particular the point has been proved only too convincingly that it is disastrous to encourage de-velopment and the assumption of regional responsibilities when there has been inadequate provision of finance to allow the RAA to assume that new responsibility without serious embarrassment.[28]

The expression of these grievances, and the publication of a paper produced by the RAA directors in summer 1979 entitled 'The Arts in the 80s', foreshadowed the setting up of another Working Party (this time of directors of the Arts Council and the RAAs) to examine the full range of issues of principle and policy involved in working *Towards a New Relationship*. This latter document faced the limitations of the present system in an incisive and imaginative way and marked two important changes of emphasis. Firstly the working party was firmly of the opinion that rather than worrying unduly about local authorities' levels of funding of RAAs 'the main direction of ACGB and RAA policy towards local government should be geared to increasing that sector's direct funding of the arts',[29] and for almost the first time in any Arts Council document there were signs of concern for the development of clear and systematic arts policies. When, in January 1981, the Arts Council discussed *Towards A New Relationship*, it took a

refreshingly positive view of the RAAS.[30]

An over-centralised system

In 1980–1 central government, through the Office of Arts and Libraries, had a budget for the arts and museums of £170 million; at least two-thirds of this was spent in London, much of it on the national museums and galleries and the British Library. Of the £70 million allocated to the Arts Council, how much was spent in London? It is impossible to say precisely – it is only possible to estimate.

Speaking at a conference in June 1978, the Arts Council's Secretary-General told his audience that 'the hard facts show that whereas ten years ago the Arts Council was spending about half its money in the metropolis, it now spends only about a quarter'.[31] The hard fact is that there are no hard facts in this area although a year later, in its *Annual Report*[32] the Arts Council published piecharts which claimed that in 1968–9 32.57 per cent of its funds were spent in London and by 1978–9 the figure had gone down to 30.00 per cent. The 30 per cent was of expenditure in Great Britain; on the Arts Council's own figures then, approximately 37 per cent of its expenditure in England is in London. But the pie-charts were, at best, thoroughly misleading, the assumptions on which they were drawn up were not stated and the pretence of being accurate to two places of decimals was risible. The Arts Council itself might take a different view of regional development if it was given a fuller picture of the geographical dispersion of its expenditures, but the presentation of statistics in the Arts Council is mainly related to the organisational structure of the Council itself and concentrates on the different art forms.

From time to time figures emerge showing the concentration of creative artists in and around London. The present director of the Tate Gallery has estimated that 90 per cent of the most serious visual artists in Britain 'live (and have always lived) around London'.[33] Of those writers who received grants from the Arts Council between 1975 and 1978 83 per cent lived south of Cambridge and 42 per cent in Greater London.[34] Of the 610 performances of opera in England by the 7 most heavily subsidised opera companies in 1978–9, 70

per cent took place in the south-east.[35]

The Arts Council has done a great deal to build up theatrical life, orchestras, and to a lesser extent other arts organisations outside London, but there has been at the Arts Council, decades of functional ignorance and gentlemanly vagueness about the regional distribution of its funds.[36] In the allocation of arts subsidies Scotland and Wales tend to be more highly favoured than the English regions. But about two-thirds of the Government's arts budget and well over one-third of Arts Council expenditure in England is still allocated to the capital. There is nothing 'inevitable' about this and there are strong arguments, both on grounds of equity and in terms of the health of the artistic life of the country as a whole, for saying that these figures are still unacceptably large.

The Regional Arts Associations – Present and Future

The twelve Regional Arts Associations in England vary considerably in size and shape and, to some extent, because of their different ages and parentages, in character. But with the oldest having passed its silver jubilee and the youngest eight years old they are now an integral and established part of the system of arts subsidy. The fact that their total income in 1979–80 was only £8.4 million while that of the Royal Opera House, Covent Garden, was £12.6 million, puts their financial resources into a national perspective. But the Annual Reports of the RAAS makes clear how much they manage to achieve with relatively small sums of money.

The very independence of the RAAS – neither branches of the Arts Council nor purely local authority associations – makes for certain constitutional difficulties. While central sources (mainly the Arts Council, but also the British Film Institute and the Crafts Council) have provided most of the funding, it is local authority representatives who have been most numerous on the governing bodies of the associations. To complicate matters the RAAS have been both partners (in funding) and supplicants (in their own search for funds) of local authorities. The Arts Council has repeatedly argued that – in respect of the RAAS – it has wanted the local authorities to put their money where their representatives are.

In addition to local councillors, most RAAs have representatives elected from their individual members serving on their governing bodies. In the one case – Merseyside Arts Association in 1980 – where a substantial group of members managed to get one of their number elected as chairman of the Association's Executive, and with him pressed to have the majority of the Executive elected from the Association's members, after months of procedural wrangle, the Arts Council and the local authorities involved closed down the Association. In its place they set up a Trust to carry on its business until a new constitution for the Association could be agreed upon by the funding bodies.

Towards a New Relationship, which was produced before the denouement of the Merseyside Arts Association drama, concluded that 'the constitutional arrangements which are most satisfactory . . . are those which ensure that nominees of national and local funding bodies jointly constitute an overall majority at all times on the ultimate governing bodies of the RAAs concerned' and agreed that there should in future be at least four Arts Council nominees per RAA.[37] Since individual RAA members (unlike local authority representatives and nominees of the Arts Council) are self-selecting, it is hard to see how the requirements of accountability in a formal and technical sense could be satisfied were RAAs to be governed by their individual members. But individual and corporate members should have an important role within RAAs – not least because by widening the membership and increasing its involvement a more broadly-based pressure group for the arts is built up.

There have, in the early years of the RAAs, been some hankerings after censorship—for example, in 1977, some Manchester councillors pressed their Regional Arts Association to withdraw support from the theatre group North-West Spanner, because of the group's left-wing leanings. But, while never giving the RAAs the wholehearted support that many would have wished for, the Arts Council has acted positively in insisting on the distinction between the obvious responsibility of funding agencies not to renew support to artists or organisations whose work does not give value for money, and unacceptable interference with the actual expenditure of money once it has been granted to an

arts organisation.

The quality of officers and of decision-making at regional and local level is often criticised (particularly in London saloon-bars) but a growth in authority in such decision-making tends to come with a growth in responsibilities, a point that is often forgotten not least by those quick to criticise paternalism in approaches to subsidy but slow to recognise their own paternalism in thinking about RAAs and local government in the arts.

The funding of RAAs will never be satisfactory until their main funds come from taxation collected and voted regionally or locally – but until that day their incomes will be drawn from a variety of sources (see Appendix A, paras.32 and 33) and in addition to the wide range of services that they provide and functions that they fulfill, they will continue to be valuable in bringing together people of very different interests and approaches. They are at present victims of half-hearted feelings about regionalism and the possibilities of regional government in England, while providing one of the vehicles for a less-centralised system of arts administration and provision. Perhaps they would be stronger if there were fewer of them.

Local Government and the arts – present and future
If not dismissed, as they are frequently, as simply philistine, local authorities are too often considered to be ignorant and unreliable in relation to the arts. There is some truth in almost any criticism of local authorities, as of the Arts Council. Yet it is only through further involving the ignorant, unreliable, philistine local governors that more resources for the arts will be unlocked at local level. More important than abuse is to understand why central government (through the Arts Council) and local government necessarily have adopted very different approaches to funding the arts. Most significant is the sheer proximity to the electorate – and to the arts organisations – at local level. Coming up for election normally every four years local governors are naturally going to be sensitive to short-term changes in local arts subsidy and to be more fearful of hostile public reaction than the Arts Council need be.

In comparison to expenditure on other forms of recreation, libraries, baths and parks for example, spending on the arts, particularly the performing arts, by local government is relatively new. And the levels of funding and the committee structures involved in such funding are very diverse.

Nevertheless, despite the fact that figures published by the Arts Council show local government spending on the arts and museums to be greater than that provided through the Arts Council,[38] dissatisfaction with local government funding has been such that the arguments for a mandatory level of local spending on the arts are increasingly frequently heard. It is doubtful whether such an innovation is either politically feasible or politically desirable. It is extremely unlikely that the local authority associations – already overburdened with statutory requirements to provide services of all kinds – would accept the idea of a mandatory rate and the problem of defining the arts in this context would be formidable.

A more constructive approach would be to celebrate more positively the achievements of those local authorities (like the GLC, Camden and Thamesdown) which, year in, year out, help provide a very substantial arts programme; secondly for the Arts Council to offer more positive financial incentives for local authorities to develop new projects; and thirdly to build on the existing partnerships between the Arts Council, Regional Arts Associations and local authorities, while respecting the differences of approach that are inevitable from the three different tiers.

Notes

1 Lord Goodman, speaking in the House of Lords, 19 April 1967, quoted in *Not for the Record*, Andre Deutsch, 1972, p.134.

2 Nineteenth Report of the Select Committee on Estimates Session 1948–9, *The Arts Council* no. 315; paragraph 5365 of evidence.

3 Letter from Moelwyn Hughes, *The Times*, 12 January 1944.

4 Letter from John Christie, *The Times*, 27 January 1956.

5 This point was made in conversation both by Lady Gertrude Williams on 23 June 1980 and by Eric White on 11 February 1981.

6 W. E. Williams 'The Regional Structure of the Arts Council', Council Miscellaneous Paper 1955/42, paras.10 and 13.

7 Nineteenth Report of the Select Committee on Estimates, Session 1948–9, *op. cit*, para.39.

8 W. E. Williams 'The Regional Structure of the Arts Council', *op. cit*, paras.4 and 5.

9 Vere E. Cotton 'The Regional Structure of the Arts Council', Council Miscellaneous Paper 1955/50, 20 November 1955, para.1.

10 Minutes of the 63rd Arts Council Meeting, 25 January 1956.

11 *South West Arts Annual Report and Accounts 1979–80*, p.3.

12 *The Arts Council of Great Britain, Fourth Annual Report 1948–9* pp.5 and 8.

13 *The Arts Council of Great Britain, Fifth Annual Report 1949–50* p.5.

14 Conversation with Joe Hodgkinson, 2 March 1979.

15 *Public Responsibility for the Arts, The Ninth Annual Report of the Arts Council of Great Britain 1953–4*, p.25.

16 *Help for the Arts*, Gulbenkian Foundation, 1959.

17 Minutes of the 550th meeting of Directorate, 10 July 1962.

18 House of Commons Estimates Committee, Eighth Report, *Grants for the Arts*, 1967–8.

19 'Report by the Chief Regional Adviser: September 1968–March 1969', Arts Council Paper No. 439.

20 *Hansard*, 22 March 1972, column 728.

21 'Funding Regional Arts in 1975' *Municipal Entertainment*, February 1975, p.14.

22. 'The Role of Regional Arts Associations', paper for Regional Studies Association conference on 'The Arts and the Regions', at University of Sussex, June 1974, p.8.

23 Neil Duncan, 'Involvement and Devolution', *Municipal Journal* 3 August 1973, p.1125.

24 'Funding of the Regional Arts Associations', Regional Committee paper, 28 December 1977.

25 Eric W. White, *The Arts Council of Great Britain*, David Poynter, 1975, p.244.

26 *Support for the Arts in England and Wales*, Gulbenkian Foundation, 1976, p.25.

27 *Toward Decentralisation*, a working party report on relations between the Arts Council and the Regional Arts Association, February 1977, paras.1.6 and 2.4.

28 Notes for 'Meeting between RAA directors and Members of the Regional Committee, ACGB, 30 June 1978'.

29 *The Arts Council of Great Britain and the Regional Arts Associations: Towards a New Relationship*, Report of an informal ACGB/RAA working party, May 1980, recommendation 14.

30 See paragraph 4 of the Addendum to the Memorandum submitted by The Arts Council of Great Britain to the House of Commons Select Committee on Education, Science and the Arts, May 1981, printed at the back of this book.

31 *Local Government and the Arts*, a Calouste Gulbenkian Foundation seminar held on 21 June 1978, p.6 of the transcript.

32 Arts Council, *Patronage and Responsibility*, thirty-fourth annual report and accounts 1978–9, p.143.

33 'Redcliffe-Maud Report', Paper for the Arts Council from Alan Bowness, December 1976 para.6.

34 Jim McGuigan, *Writers and the Arts Council*, Arts Council, 1981, p.49.

35 The south-east, for the sake of this calculation, was defined by drawing a straight line on the map from Spalding to Weymouth. It thus includes both Oxford and Cambridge.

36 The research project on 'Facts about the Arts' directed by Muriel Nissel at the Policy Studies Institute, should, when it reports in 1982, illuminate, among other things, the regional distribution of Arts Council funds.

37 *Towards a New Relationship*, op. cit, paras.43 and 44.

38 See Arts Council of Great Britain, *What it does*, p.7.

9
Youth
and
Education

W. E. WILLIAMS, SECRETARY of the British Institute of Adult Education, was one of the prime movers in CEMA, which was described in an early memorandum as concerned with 'activities on the fringe of adult education.'[1] Part of the job of diffusing the visual arts during the war was given to the British Institute of Adult Education, through its 'Art for the People' scheme, which had started in 1935. In 1940 over 300,000 people visited 'Art for the People' exhibitions in eighty places; W. E. Williams became Honorary Director of Art for CEMA and he can take up the story:

The one crisis I recall in the affairs of 'Art for the People' was caused by Lord Keynes, who, in 1942, succeeded Lord Macmillan as chairman of CEMA. There was one feature of our scheme which displeased Lord Keynes, and that was our provision of guide lecturers at every major exhibition. He thought this was wholly unnecessary because, he believed, visitors could and should do their own interpretation. There was, alas, in this great scholar and art connoisseur a streak of donnish superiority and a singular ignorance of ordinary people. The Institute time and time again reminded him that we were not a mere provider of touring exhibitions but an educational body with a mission to enlighten people about art. At the end of 1942 Lord Keynes persuaded CEMA to cut our grant for 1943 from the £10,000 we had asked for to £5,000. Fortunately this cut was strongly resisted by Sir Kenneth Clark and myself, and Lord Keynes relented as far as to make the figure £7,500.[2]

At the end of the war CEMA became the Arts Council with its chartered obligations to develop ' a greater knowledge, understanding and practice of the fine arts exclusively, and in particular to increase the accessibility of the fine arts to

the public.' This wording – particularly since increasing accessibility implies a good deal more, in terms of removing social and cultural barriers, than increasing availability – clearly implies a strong educational role, and at the start of the Council's life its educational tasks were soon on, and almost as soon, off, the agenda. In November 1945 the Minister of Education, Ellen Wilkinson, met the Arts Council and spoke of the importance of fostering young artists and audiences and of the Council's obligations to provide youth with new opportunities for educational recreation. In summer 1946 Mary Glasgow, the Secretary-General, wrote a paper telling the Council that there were two questions before it:

(i) In what ways can the Council co-operate with Local Education Authorities, and other bodies receiving grants from the Ministry?
(ii) To what extent should the Arts Council concern itself with work for children?
The second question is perhaps the easier to answer. There is nothing in the Council's Charter which limits interest to adults.

Mary Glasgow listed four ways in which the Arts Council might work with local education authorities, but also pointed out that:

An advertised connection with education, such as the phrase 'sponsored by the Great Whoopington Education Committee' on a concert poster is not always helpful. Any suggestion of 'welfare' or 'improvement' may be fatal to the success of a venture and the Education Committee does not always enjoy the highest possible local prestige. For that reason, the Council welcomes its independence of the Ministry and believes that autonomy will make co-operation more, not less, effective than hitherto.[3]

A few years later the Treasury assessor on the Arts Council, agreeing that the Arts Council was spending 'educational money' told a committee of MPs:

There is always a slight suggestion of something that is good for you about education as distinct from something which you like. The slight suggestion of powder about education, I think, is absent from the Arts Council.[4]

But it wasn't just the slight suggestion of powder that was increasingly absent. For twenty years there was very little co-

138

operation either with youth organisations or with the Ministry of Education or with The Great Whoopington Education Committee. When W. E. Williams became Secretary-General in 1951 he turned his back on much of the educational work which he had previously vigorously promoted; the guide-lecturers accompanying the exhibition programmes were phased out, grants to the Society for Education in Art ceased. The Council's educational obligations were dissolved in a concern with professional artistic standards, and, in the mid-1960s, Williams' successor, Nigel Abercrombie, reported that the Arts Council had 'not felt able to claim or exert any influence' on the formal educational system, the principal reason being that the Council

... do not really know with any certainty what is being done, and what is required. When, however, the Ministry of Education (now the Department of Education and Science) expressed anxiety about the whole direction of effort in the Arts field in schools, especially in regard to theatre, the Council set up the Young People's Theatre Inquiry.... Very large questions are involved...

'Increasing the accessibility of the Fine Arts to the public' ... involves widening and deepening the range and standards of appreciation, and will arguably be best done by 'catching 'em young'.... But any guidance which the Arts Council might give in this direction or in parallel activities for music and the visual arts, can only be uncertain so long as we rely on second-hand or third-hand experience of the young people themselves.

The suggestion has therefore been made that the Council might consider setting up a new consultative body, consisting of (say) 20 people, mostly young, whose considered advice could be sought on the whole range of these problems.

The Secretary-General exercised himself on the method of choosing members:

Perhaps the several associations of headmasters and headmistresses might be invited to choose two or three head boys and girls representing various categories of schools and geographical areas.[5]

But head boys and girls for the arts did not materialise; instead, from January 1967, two junior members (students and ex-students aged 18 to 25) were appointed to each of the Council's advisory panels. Soon these junior members were

getting together for their own meetings – it was the time of 'New Activities' (see Chapter 7) – and in May 1969 they presented the Council with a memorandum[6] which included some telling points about the principles, structure and procedures of the Arts Council and was critical of the slow progress made in pursuing the recommendations of the 1965 White Paper *A Policy for the Arts*. About a year later it was decided 'to alter the description and abandon the phrase 'Junior' Panel members'[7] and in the 1970s the Council's interest in having two members on each Panel in the age-range 18 to 25 gradually evaporated.

Meanwhile, in 1967, the Council had established a Young People's Theatre Panel. Although the professional advisory panels for Music and Drama resented the use of Arts Council funds for amateur organisations, in 1967 and 1969 respectively, the Council (using a new funding category called 'Education in the Arts') began, after much hesitation and deliberation, to fund both the National Youth Orchestra and National Youth Theatre. In 1980–1, Arts Council support was withdrawn from both these organisations as well as from the National Youth Brass Band, principally on the grounds that since they are amateur organisations 'the fairly marginal grants made in past years had crept in as anomalies'.[8] There are indeed many anomalies in arts subsidy[9] but it was arguably a much bigger anomaly for the Arts Council to cut off grants to organisations that clearly bridge the arts and education worlds when the Council's Secretary-General, Sir Roy Shaw, had repeatedly expressed the importance of arts education, declaring that 'To divorce educational policy from cultural policy is to cripple both.'[10] The Council of the National Youth Theatre arguing that the development of the NYT had been of immeasurable benefit to the theatre as a whole also pointed to a further anomaly:

The concept of Youth Theatre (i.e. theatre *for* young people and *by* young people) as pioneered by Michael Croft at both national and regional level, is one of the truly original developments in the post-war theatre. It has led to the growth of more than 500 local Youth Theatres and to the formation in recent years of a Scottish Youth Theatre, a National Youth Theatre of Wales and a Youth Theatre scheme in Northern Ireland. The above developments have one

financial factor in common: they are supported substantially by their respective Arts Councils – in the case of Scotland and Wales, from funds allocated in the first instance by the Arts Council of Great Britain. If there is 'an anomaly' concerning subsidy for our company, we suggest that it lies in the fact that the NYTGB, which provided the inspiration for these developments, should lose its subsidy whilst – and we applaud the act – these devolutionary companies are firmly supported by their respective Arts Councils.'[11]

But the Arts Council's relations with the youth organisations are symptomatic of a certain rigidity about how best 'to develop and improve the knowledge, understanding and practice of the arts' in a society in which the financial resources available to the formal educational system are 40 to 50 times greater than those available for the arts and museums.[12]

The main educational contribution of the Arts Council has been through its concern with professional arts activity. In the 1970s between 10 and 15 per cent of Arts Council subsidy to theatre companies (excluding the National Theatre and the RSC) was spent on young people's theatre; by the end of the decade there were about one hundred children's theatre, theatre-in-education, dance-in-education and young people's theatre companies in England.[13] Increasingly the major touring dance and drama companies conduct workshops in schools and there are schemes for writers, visual artists and, most recently, dance artists to work in schools, colleges and universities.[14] With proper preparation and follow-up and a careful selection of the artists involved, there is an enormous amount to be gained from this work. In drama, while children's theatre companies have usually worked along conventional lines using a writer and a director, theatre-in-education (TIE) companies are characteristically groups of trained actors who tend to adopt a collective approach to their work, which might consist of a performance with a separate session of improvisation by the children within a framework set by the company.

Turning to individual artists, the mature Picasso stated at one point that he was trying to paint like a child. Artists-in-schools are well placed to benefit from the freshness of vision that is the child's prerogative. There are many examples of

141

artists (in different media) professing a different approach to their own work after working with children. Teachers, some of whom are also artists, can benefit through being exposed to new concepts and personalities. And for children there is the stimulus and deepening of understanding that comes from facing-up, at first hand, to the demands of creative processes. For too long too many artists and teachers have worked in their different forms of isolation, despite the fact that schools have perhaps been the only major patrons of the serious arts which have their base among the people at large.

While the work of professional artists in schools developed throughout the 1970s, there has, since 1978, been considerably greater emphasis on the educational aspects of the Council's Charter with conferences and pilot projects, and three new posts at the Arts Council, to encourage greater collaboration between educational bodies on the one hand, and artists and subsidised arts organisations on the other.[15] *The Arts Council and Education*, a consultative document issued in July 1981, takes stock of these important developments.

Although the Arts Council is beginning to square up more fully to its chartered obligations and, as prescribed by its charter, is advising and co-operating with central and local government agencies in doing so, it has yet seriously to join the debate about the purposes of education and the relations between the different sectors of the educational system. For education, like the arts, is value-saturated and at the centre of any policy that links the arts with education lurks a vital argument about the relative importance of practice and understanding, expression and appreciation, in developing arts activities. Sir Roy Shaw has argued forcefully that 'training in creativity and self-expression and in the appreciation of the arts are both necessary and that to oppose them would be to make the mistake of saying either/or when the right approach should be both/and.'[16]

Such sentiments are unexceptionable, and yet opposing self-expression and creativity, or, more precisely, characterising artistic expression in the educational context as a lower-order therapy, is what Shaw and the chairman of the Arts Council, Kenneth Robinson, have done elsewhere. After describing participation in the arts in schools as thera-

142

peutic, Robinson, at a conference on arts education, warned that 'taking part in the school play may be more likely to inculcate a taste for amateur theatricals than to develop enthusiasm in later life for Shakespeare or Tchekov or Ibsen.'[17] And in a BBC television programme on the Arts Council, Shaw told a group of schoolchildren that:

There is rather too much emphasis . . . on doing it yourself rather than learning about what great artists have produced in the past and are producing at present. For instance, if I wanted to be a Sunday painter, I'd doubtless get a great kick out of it, but I know very well that I'm not going to produce anything that anybody would get any benefit out of seeing, and whilst it might be good for me, good for my mental health, to paint or to act a bit, it would also be extremely good for me to look at the paintings of Rembrandt or Picasso or the sculptures of Henry Moore.[18]

Perhaps leaden joylessness is more of an enemy of the arts in education than 'doing it yourself'. In contrast to Robinson and Shaw, Henry Morris, founder of the Cambridgeshire Village Colleges, not a man to settle for soft options or passing fashions, 'summed up his ideas for presenting the arts to adolescents by saying that they should, like games, be free from discourse and from examination pressure and be so organised that the practice or experience of music or dancing, drama or painting or poetry should be enjoyed by the young and looked forward to like games periods after Latin or Maths.'[19] Freedom from examination pressure in the arts is perhaps more self-evidently desirable than freedom 'from discourse' in arts education, for the very rich and diverse artistic heritage must surely be rendered alive and relevant to each generation. There is nothing straightforward about that but, beyond the harsh parameters of schooling, the balance between appreciation and creative self-expression has to be considered in the light of Shaw's admission that 'appreciation looms larger in adult education provision than does creative work, for every one course on creative writing, there will be a score on the appreciation of literature',[20] and the broader judgment of many involved in arts education that in education generally and schooling in particular:

. . . . the dominant tradition derives from an education reserved for an elite. Where the arts are concerned the emphasis is on high

culture; education is seen as a preparation for a life of, at best, appreciation and patronage of the fine arts; there is a celebration of the classical excellences and the form of beauty. All this at the expense of personal competence and self-expression. This dominant tradition, then, finds its apotheosis in the great public schools and their imitators the grammar schools. So it is that the comprehensive school in its infancy has to appeal to the only working model of secondary education available and take over a whole network of practices, assumptions and values whose applicability to the new scene has come into increasing doubt as the comprehensive movement has developed.'[21]

The main thrust of the system of arts subsidy which has been built up to sustain professional arts organisations on the one hand and, it is hoped, appreciative audiences on the other, reinforces the dominant tradition. And it has also played some part in reinforcing the divisions within the wider society. For example, this is an eye-witness account of 25 young National Front supporters disrupting a play at the Royal Court's Theatre Upstairs:

Beneath the racialist abuse and the chanting of slogans lay a deep-seated class hatred: they despised the apparently middle-class, super-educated audience whose evening they had interrupted and whose accents they derisively imitated. Their daring outburst was like breaching the walls of a cultural barracks. It is impossible to imagine the opposite kind of situation, so effectively have the arts been denied to such people.[22]

Neither the educational system nor that of arts subsidy can alone heal the destructive divisions within society. But the tensions, divisions, confusions within the wider society find their expression in arts education which is not primarily about artists, but about people being stretched and growing through a disciplined use of the imagination: 'If we begin to look on the arts more as forms of behaviour and less as an unapproachable domain for genius we should resolve a large number of seemingly inexplicable problems.'[23]

There are some big questions surrounding and linking the concepts of 'creativity' and 'growth' and a greater than usual danger of glib and superificial argument at this point.[24] Arts teaching demands considerable skill and great dedication. But if there is to be a further move away from the instrumental-

technological view of education, the view which allows examinations to determine the curriculum and insists on the priority of the cognitive over the affective; if there is to be a further move towards the humanist conception of education as lifelong personal development, and the full realisation of human potential, there will have to be much more opportunity to practice the arts as well as study them. This has implications for the provision of arts facilities for young people of all ages. And that in turn suggests that the Arts Council's responsibility for developing the knowledge, understanding and practice of the arts should not be construed overwhelmingly in terms of supporting professionals, nor its educational programme be limited to placing professional artists in educational contexts, or 'encouraging exemplary forms of cooperation between education and arts providers.'[25], however important such work may be. The Arts Council and its clients are not responsible for the educational system, but they are an influence on it; and there are some big tasks ahead for, at the time of writing, there is a real threat, from the uncoordinated activities of dozens of local education authority finance committees, to decades of achievement in the disciplines of arts education.[26]

Notes

1 Reported in 'Notes on the Arts Council and Education' Council Paper 213, 17 June 1946.

2 W. E. Williams 'Pre-history of the Arts Council' in *Aims and action in adult education 1921–72*, National Institute of Adult Education, 1972. Guide lecturers were paid according to a sliding scale of charges fixed on a population basis. In spring 1944, the scale ranged from £6 per week in towns of over 200,000 people to £2 per week in towns with less than 10,000 people (Minutes of the meeting of CEMA Art Panel 29 February 1944).

3 'Notes on the Arts Council and Education', Council Paper 213, 17 June 1946.

4 Mr. E. Hale, Minutes of Evidence Taken Before the Select Committee on Estimates (Sub-Committee C), 'The Arts Council', *House of Commons Paper 315*, HMSO, 1949, p.54, para.4574.

5 'The Arts Council and Young People', Council Paper 413, 4 January 1966.

6 Memorandum to the Arts Council from Junior Panel Members, May 1969.

7 Hugh Willatt, 'Junior Panel Members', Council Paper 449, 21 October 1970.

8 Kenneth Robinson 'The Arts Council and Its Grants', *Sunday Times*, 22 March 1981.

9 For example in 1967 the Department of Education and Science agreed 'to accept responsibility for subsidising colleges and academies of music but not the comparable institutions in the theatre world' (Minutes of Arts Council meeting 26 July 1967).

10 Quoted in Ken Robinson (ed.) *Exploring Theatre and Education*, Heinemann, 1980, p.6.

11 Paper from the Members of the Council of the National Youth Theatre of Great Britain to the Chairman of the Arts Council of Great Britain. The immediate future of the national youth organisations has been secured by business sponsorship; but that the announcement of the discontinuation of the National Youth Theatre's grant of £15,000 was made in the same week as the Arts Council advertised for a public affairs (i.e. public relations) officer, to be paid a five-figure salary, fuelled cynicism about the Arts Council's priorities.

12 In 1979–80 approximately £9,500 million was spent by central and local government on education and approximately £209 million on the arts and museums. (These latter figures, taken from the Arts Council booklet *What it does*, exclude expenditure on broadcasting and libraries – except national libraries.)

13 For facts, figures and definitions in the area of children's and young people's theatre see the Arts Council *Drama Advisory*

*Panel's Children's Theatre Working Party Report February 1977–
November 1978.*

14 For more about this work see W. Forster, *The Universities, the
Arts and the Public*, Arts Council, 1979, and Irene Macdonald
Professional Arts and Schools, Arts Council 1980, and the thrice-
yearly Arts Council *Education Bulletin.*

15 Collaborative enterprises between artists, arts organisations
and adult education agencies are summarised in Geoffrey
Adkins, *The Arts and Adult Education*, Advisory Council for
Adult and Continuing Education, 1981.

16 Sir Roy Shaw 'Education and the Arts' in Malcolm Ross (ed.)
The Arts and Personal Growth, 1980, p.73.

17 Kenneth Robinson, 'The Arts, Society and Education', in
Malcolm Ross (ed.) *Arts Education: Towards 2000*, University
of Exeter School of Education, 1978.

18 *Running the Arts, 2: Calling the Tune*, BBC–2, 10 July 1980.

19 Harry Ree, *Educator Extraordinary, The Life and Achievement of
Henry Morris*, Longman, 1973, p.85.

20 Sir Roy Shaw, 'Education and the Arts', *op. cit*, p.72.

21 Michael Golby 'The Responsive School' in Malcom Ross (ed.)
The Arts and Personal Growth, Pergamon Press, 1980 p.20. On
the ideology of secondary schooling being derived from the
practices of independent public schools, see also Douglas
Holly, *Society, Schools and Humanity*, MacGibbon and Kee,
1971.

22 Gerald Chapman in Ken Robinson (ed.) *Exploring Theatre and
Education*, *op. cit.* p.182.

23 John Allen, *Drama in Schools*, Heinemann, 1979, p.36

24 For a considered argument for encouraging young people to
express themselves creatively through the arts see Malcolm
Ross, *The Creative Arts*, Heinemann, 1978; for a considered
discussion of how an emphasis on 'creativity' and

'self-expression' has helped to divert attention from some of the most important functions of drama in school see Ken Robinson, 'Drama, Theatre and Social Reality' in Ken Robinson (ed.) *Exploring Theatre and Education*, *op. cit.* The Gulbenkian Foundation report, *The Arts in Schools, Principles, Practice and Provision*, 1982, contains a valuable discussion of the concept of creativity.

25 Arts Council of Great Britain, *What it does,* n.d., p.6.

26 See, for example, 'The arts at risk; the Philistines gather at the school gates' *Times Educational Supplement*, 6 February 1981, and 'Is music education?' *The Guardian*, 27 February 1981.

10
Power
and
Policy

In *Power: A Radical View*, Steven Lukes argues for a three-dimensional view of power which 'allows for consideration of the many ways in which *potential issues* are kept out of politics whether through the operation of social forces and institutional practices or through individuals' decisions'.[1] Lukes also draws attention to the importance of examining both decision-making and non-decision-making. What is a non-decision? 'A decision that results in suppression or thwarting of a latent or manifest challenge to the values or interests of the decision-maker'.[2] In other words, some issues are organised into politics while others are organised out, for organisation is the mobilisation of bias.

At any one time the governing group in the arts will include some or all of the following: the Minister for the Arts, a senior civil servant or two, members of the Arts Council (particularly its chairman), and senior officers of the Arts Council (particularly its Secretary-General).

This governing group has a considerable capacity for managing and orchestrating its arguments (in recent years the Arts Council has acquired both a Press Officer and a Public Relations Officer). Crucially, it controls the agenda for what gets discussed at the highest levels. And controlling the agenda makes for great powers of non-decision-making. Thus, the affairs of the national companies have often dominated Arts Council agendas; the question of how the arts are constituted (the selective tradition), relations between amateurs and professionals, the interplay in an era of electronic communication between broadcasting and the live arts, these and other major questions have, taking the 35-year

biography of the Arts Council as a whole, been relegated to relatively minor positions on the agenda. But there has been a further tactic open to the Arts Council in coping with challenges to its values and hegemony. Government in practice depends on the devolution of unpopular tasks, and it is to the Regional Arts Associations that responsibility for some of the stickier questions of arts subsidy – that for community arts, mixed media, small experimental arts centres – has been passed. In the next decade, the RAAs will probably face more unpopular tasks than the Arts Council; that is one of the prices of devolution.

But more serious than the fixing of agendas and the divide-and-rule of every day government are, in Lukes' phrase, 'the *potential* issues that are kept out of politics'. For 35 years, the Council, which has considerable discretionary powers, has effectively excluded from its deliberations a number of questions that go to the heart of the relation between art and society. For example how one hundred years later, is William Morris' assertion that the chief source of art is man's pleasure in his daily necessary work, to be treated both by those concerned with nurturing the sources of art and those concerned with unemployment?

Morris was anxious that there should be no illusions about the future of art: 'I do not believe in the possibility of keeping art vigorously alive by the action, however energetic, of a few groups of specially gifted men and their circle of admirers amidst a general public incapable of understanding and enjoying their work.'[3] For Morris 'swift progress towards equality' was a pre-requisite of a 'genuine new birth of art', and central to his view of art was a critique of the division of labour under capitalism. The de-skilling which Morris foresaw has become commonplace, and although William Morris is now better known for his wallpapers than for his ideas, many of the questions which Morris raised about the arts and the organisation of work and production, retain their charge. Thirteen years ago the majority of members of the New Activities Committee (see chapter 7) recommended that the Arts Council should initiate a full enquiry into the relationship between industry and the arts. It has never done so. And related to the questions about work are those about the

purposes of education raised in the previous chapter.

And thirdly, after the traumas engendered by much public architecture and planning in the last three decades, how should the system of arts subsidy relate to the one art which affects everybody? Thirty years ago in *Art and the Nature of Architecture*, Bruce Allsopp wrote:

It will be very hard to provide architecture for everybody. But it could come about that every home was a pleasant satisfying piece of architecture; modest and simple probably, but right... It is simply a question of the value we place upon the arts and art should begin in homes and schools, shops and factories, in all the buildings which make up our environment.[4]

If the Arts Council has re-inforced the distinction between the fine and the applied arts, and neglected homes and schools, shops and factories, whose interests has it served? Many artists have benefited financially from public subsidy for the arts, but from another perspective, Arts Council subsidies have served to improve conditions and to keep down ticket prices at theatres and concert halls, at which nearly all audience surveys have produced similar profiles, i.e. largely middle class and with dominant proportions whose formal, full-time education was (or will be) completed beyond the age of 19, mainly at universities, polytechnics or colleges of further education. Studying the Arts Council it is easy to see what Marx and Engels meant when they denounced the state as a committee for the management of the affairs of the bourgeoisie.

For whatever the extent of the Arts Council's power to act independently, its place as part of a governing group remains unaffected. The Arts Council is the product of a class and has the loyalties of that class. By the time that they are appointed, Council members and directors are generally into a state of middle-aged affluence. This (exceptions always readily conceded) is not the stuff of which radical reformers tend to be made. And, as the power of governments to meet the expectations of citizens seems to be in decline, the state necessarily shows its more authoritarian side. The Arts Council, as a state agency for distributing arts subsidies, has always acted as a kind of punchbag for oppositional cultures

and groupings, but in December 1980 some peculiarly tough decisions had to be made, and the more authoritarian side of the Council, complete with despatch-riders on motorbikes, was all too evident.

Until the cuts announced in December 1980, the decision-making processes at the Arts Council could be characterised, in the jargon of some social scientists, as 'disjointed incrementalism'[5] – 'disjointed' because *ad hoc* and piecemeal, and 'incrementalism' because only a limited range of policy options are considered and because, in practice, the Arts Council has gradually increased the range of its responsibilities, while resisting any radical revision of the guiding principles from which it has worked. Sir Roy Shaw has recently put it this way:

We *have* a policy even though it is perhaps not worked out in a schematic and logical way as say the French might have done it, and it has 'just growed' like Topsy. The many decisions taken in the arts field in the past, and still being taken, do amount to a policy and a fairly clear, and I dare to say, impressive one at that.[6]

But a policy is more than the aggregate of past decisions; it outlines a course of action, it involves a set of priorities. Certainly, the Arts Council has policies, and has published policy guidelines[7], and 'the many decisions taken in the past' have contributed to them. But typically the Council's policies have been too vague, too ambiguous, and, partly in consequence, little attempt has been made to fully evaluate the Arts Council's work. The principal, but not the sole, principle of that work has been the policy of response. This guiding principle has often been strongly defended by Arts Council spokesmen. For example, in the *1970–71 Annual Report*:

The Arts Council is concerned with artists and the ways in which they work in the community, some together in performance, some in isolation. Their needs and outlook change. In a society which we like to call free, the Council must not direct or control. Its function is to support, to provide the means, to respond to changing needs.[8]

Intelligent response is an essential element of policy for any arts funding agency, but an undue reliance on 'response' in the absence of some clearly articulated priorities, can result in

too haphazard or too centralised a pattern of activities. It has not only been artistic abilities, projected programmes and sound administration to which the Arts Council has responded, but influence, prestige, local authority.

But it seems probable that the policy of response will become increasingly more qualified. It has relied partly on the assumption that the public finance available will increase in real terms each year. For the moment this seems highly unlikely; Government public expenditure forecasts show a fall in total expenditure on the arts and libraries at least until 1983–84. Secondly, while it is very hard to formulate longer-term policies when the size of the grant-in-aid is learned about only a few months before the start of the financial year, the Arts Council has, in 1981, begun the process of articulating its policies more fully. The detailed policy statements of its advisory panels have been considered by the Council.[9] It will be interesting to see whether the result does anything to break what Walter Bagehot called the 'cake of custom', those unexamined and often implicit premises and assumptions upon which so much politics rest.

Notes

1 Steven Lukes, *Power: A Radical View*, Macmillan, 1974, p.24.

2 Steven Lukes, *op. cit*, p.44.

3 See Asa Briggs (ed.), *William Morris: Selected Writings and Designs,* Pelican, 1962, pp.143–4.

4 Bruce Allsopp, *Art and The Nature of Architecture*, Pitman, 1952, p.118.

5 See, for example, David Braybrooke and Charles E. Lindblom, *A Strategy for Decision*, Collier-Macmillan, 1963.

6 Sir Roy Shaw, 'British Cultural Policy', University of London Extra-Mural Studies Lecture, August 1979.

7 The policies are succinctly stated in The Arts Council of Great Britain's booklet *What it does*. See also appendix A. 'Policy

Guidelines for Council Panels and Committees' have been published in the *Arts Council Bulletin*, October 1981.

8 *Twenty-sixth Annual Report and Accounts*, Arts Council of Great Britain, 1970–71, p.29.

9 Commencing in the October 1981 issue of the *Arts Council Bulletin*, policy documents relating to the work of the Council's panels will be published periodically.

Conclusion:
Reform and Devolution

It should no longer be permissible for politicians, civil servants, lawyers, bankers, accountants, scientists and other professional people to persuade themselves that their function is to deal with one particular facet of society's problems in an abstract manner from outside. They themselves are part of these problems: in fact, it is they who constitute the most important problem that we have to tackle today. The idea that clever people, climbing to strategic peaks in the structure of society and thence surveying social and economic questions from a great height, can make objective assessments of costs and benefits, right and wrong, true and false, that will be valid for us all – that is one of the biggest lies in the soul of institutional man.

<div align="right">James Robertson[1]</div>

The purpose of the Arts Council of Great Britain is to create an environment, to breed a spirit, to cultivate an opinion, to offer a stimulus, to such purpose that the artist and the public can each sustain and live on the other in that union which has occasionally existed in the past in the great ages of communal civilised life.

<div align="right">Lord Keynes[2]</div>

The Arts Council has stood for, and insisted on, high quality work. It has been a very important stand to take. But the Council has also allowed its concern with quality to become confused and interwoven with a preoccupation with prestige, a defence of oligarchy, an exaggerated exclusiveness, and an excessive secrecy. In this book, I have tried to untangle some of the threads woven into the Council's history and practices. [The Arts Council is badly needed – for in the short-term at any rate any alternative method of public funding of the arts is likely to prove more fickle, or more cautious, or both – and the Arts Council is badly in need of reform.)

Amidst the public expenditure cuts, its present position is unenviable, but better management and much more openness would probably win greater public sympathy for the Council's concerns. Public subsidy is not dealing with unassailable truths but with points of view which can and should be subject to political debate.

Though decidedly not part of the Civil Service, the Arts Council shares many weaknesses with Whitehall, as well as with its very varied quango sisters. However, the nature of its work makes the Arts Council peculiarly exposed to public and press criticism. The force, if not always the accuracy, of the criticism, coupled with pressure from some of the Council's staff and clients, finally persuaded the Council at the end of the 1970s to appreciate the need to reform its own structures and methods of working. The process of reform has begun. It has only begun.

First, on the question of secrecy. In the autumn of 1981, it was announced that the Arts Council had 'reached the unanimous conclusion that a greater degree of openness was desirable in the conduct of its work'.[3] In practice, this means that grants and guarantees to companies are being announced as they are agreed (previously this information was only available when the Arts Council's *Annual Report* was published each autumn), some policy papers will be published and the possibility of opening certain advisory panel meetings to the public is being considered. Arts Council meetings are not being opened for fear that 'frank discussion might be inhibited'. In 1771, Parliament abandoned its right to forbid its proceedings being reported and published. More than two centuries later, the Arts Council should follow Parliament's example. The business of Council, its panels and committees, could be organised so as to separate general policy questions from particular grant applications with the former normally being discussed in open session. Open government at the Arts Council could help clarify the assumptions behind decisions, and thereby produce a better informed arts lobby; and it could help satisfy the taxpayer who has a right to know that the whole range of views and opinions has been considered by the Council.

Secondly, the Arts Council has decided that there is every argument for explaining in writing why a grant is given or withdrawn. This represents an important change of heart, for, as recently as 1978, the Secretary-General was arguing against attempts to explain unfavourable judgements (see chapter 4). But there is no question yet of such assessments and explanations being published. The regular publication of

assessments of individual clients raises difficult questions in relation to the trust built up between the Council and its clients over the years. But the legitimate call for confidentiality needs to be balanced against the advantages of publication set out below. The minimum requirements for any such publication might be that drafts of a report are discussed with the clients concerned, and that, if necessary, the client be offered a right of reply in any publication. But among the advantages of regular published assessments are (a) their potential use to the subsidised organisations concerned, (b) as a regular assortment of case-studies, their use to the Arts Council in decision-making about the whole range of the Council's work, (c) their use as public education about the work and problems of subsidised companies, (d) if they involve, and are available to, RAA and local authority officers they should encourage similar detailed assessments at regional and local levels, and (e) they should be useful to future decision-makers because 'good decisions' require a knowledge of the result of previous relevant decisions.

Thirdly, the culture of the Arts Council tends to be too cosy and incestuous. There is a need for an elected element on the Arts Council (see Chapter 2), but also too many panel members are drawn from client organisations of the Arts Council and too many Arts Council officers become part of the Council's furniture, good quality furniture though much of it is. The Arts Council has more than its share of able and intelligent staff, but there are good reasons for officers and directors being on, say, five or seven year contracts, renewable perhaps for another five or seven years; it's an exceptional person who can sustain a freshness of approach and sufficient openness of mind in, effectively, the same job, for more than ten or a dozen years. Again, the same point applies to the Regional Arts Associations, and, by extension, to officers of local authorities.

Fourthly, the Arts Council has for years suffered from weak management. This was diagnosed by the Council's Organisation Working Party in 1979; more recently, three academics from the University of Sheffield, who spent more than two years studying the internal workings of the Council, particularly as they relate to opera, came to the view

that:

> Decision making for opera subsidy is fragmented in the Council. The roles of the various committees and panels are not clear in practice, and there is confusion on the part of Music Panel members as to what is expected of them. There is still disagreement within the Arts Council as to the role of financial detail in the overall assessment of companies, and whether the Panel members should, or even can, take it into account. Information provision to be used as the basis of policy evaluation is limited. Although Council and the Music Panel sometimes spend considerable amounts of time discussing individual clients, there does not appear to be any routine evaluation of the overall effect of the opera subsidy in Great Britain; the last time such an overall analysis took place in a formal and observable way seems to have been in 1972 when the Opera Report was published.[4]

But organisational and procedural reforms are of limited value without a much richer discussion of the Arts Council's role and the breadth of possibilities contained in its chartered obligations. For example, the electronic media, particularly television, play such a central part in people's experience of the arts, and the BBC is such a major patron of the arts, that it is an extraordinary indictment of the compartmentalisation of public responsibility that the Arts Council has never looked comprehensively or systematically at the relation between the live arts and the electronic media. There are numerous contacts between Arts Council officers and broadcasting producers and executives, and the Radio Theatre '81 project – 19 productions jointly commissioned for dual presentation on stage and radio – provides an excellent example of what is possible by way of collaboration. But with technological development, heralded by the video cassette revolution, bringing about far-reaching changes in the electronic media, it is important for the Arts Council thoroughly to examine its own work and priorities in relation to technological developments.

The Arts Council has wide responsibilities, and too much of its energy has gone into its banking function; partly because the financial position of most arts organisations is permanently tenuous and precarious, finance has stepped in where policy has feared to tread. And there has been another

general blockage in the Arts Council's approach to its task: a considerable diffidence about systematic enquiry. There have been many working parties, reports and surveys, but often these have been by one sectional group of its own area of work.

What kind of future should the Arts Council look to?

Whilst economic growth, as conventionally measured, may no longer be either achievable or desirable, the arts have a strong claim to be given a much higher priority in the pattern of public spending. That claim could be argued on economic grounds alone, but it needs to be argued, steadily and consistently, on social, cultural and educational grounds, as well as economic ones. The emergence of a pressure group to popularise and display the importance of these arguments is long overdue.

Quality and diversity in the arts need diverse sources of funding. No single source is completely reliable. Fiscal changes could encourage more corporate and private giving; the arguments for a levy on blank tapes and cassettes to fund the live arts need to be driven home; the independent television companies should contribute more to the development of the artistic talent that they use; and the example of the Theatre Investment Fund (which, for the last five years, has used public money to encourage commercial productions) might be considered in other art forms. The concept of subsidised entrepreneurship should supplement and, to some extent, replace that of arts administration. The Arts Council system of subsidy provides many safeguards to those involved in promoting the arts, but little by way of incentives to encourage entrepreneurship.

But however much increased diversity is introduced into funding the arts, the financial resources available for arts activities will never be able to match the claims made on them. Unpopular and tough decisions will always be needed. At the same time, crisis management in the arts is not enough; it is important to look further ahead.

My own view is that the Arts Council should see its life as half over and its work half done. If we are to return to a great age of 'communal civilised life' (Keynes' words), it will be in

villages, towns and districts that can be seen whole, that have a human scale and self-confidence, that don't all look to London for standards, funds, laws, decisions, art, entertainment and talking heads. It will be a de-centralised society with regional governments and, from these governments, very considerable powers devolved to local communities. The local economy and local communications will become much more important.

. If the Arts Council is to take its own commitment to devolution seriously, it should also see its strategic role over the next two or three decades as particularly important. This strategic role might include the setting of priorities and establishing of exemplary procedures for assessment and policy making, innovating schemes (in architecture, education, the media) in conjunction with other bodies, initiating research and training programmes and co-ordinating touring. Much of its grant-aiding function can be – and to some extent is being – gradually handed over to the Regional Arts Associations. They are also better placed (though insufficiently funded) to use their expertise to take a more positive attitude to the more participatory and less well-endowed areas of arts activity, for example, to those small arts centres which should be prominent in the life of every town.[5]

But devolution is very far from being a panacea. There is nothing to guarantee that it will lead to an increase in democracy, justice, tolerance and personal fulfillment. The most reactionary forms of parochialism may well come into play. But 'parochial' like 'amateur' is a term too readily used in a dismissive or a derogatory way. The final legacy of the Irish poet Patrick Kavanagh is a distinction of the greatest significance for all artists:

Parochialism and provincialism are opposites. The provincial has no mind of his own, he does not trust what his eyes see until he has heard what the great metropolis towards which his eyes are ever turned has to say on any subject. This runs through all his activities. The parochial mentality on the other hand is never in any doubt about the social and artistic validity of his own parish. All great civilisations are based on parochialism: Greek, Israelite, English. Parochialism is a universal and deals with fundamentals.[6]

This book has raised many more questions than it has answered. But it has suggested some answers, some reforms, within the limited compass of its subject and it has pointed to the need for more systematic enquiry. It is the first book on the politics of the Arts Council, not the last word. The politics of the Arts Council cannot be abstracted from wider political forces. It is my belief that organised demands for greater equality of wealth and opportunity will always be an essential political force and that the views of the late E. F. Schumacher, and of others who share his ecological perspective, are set to gain wider intellectual respectability and political currency. Not before time.

Notes

1 James Robertson, *Power, Money and Sex*, Marion Boyars, 1976, p.74.

2 Lord Keynes 'The Arts Council: its policy and hopes', *The Listener*, 12 July 1945, reprinted in The Arts Council of Great Britain, *First Annual Report, 1945*.

3 *Arts Council Bulletin*, no. 42, September 1981, p.8.

4 Richard Graham, John Norman, David Shearn, *Cost Effectiveness of Opera Subsidy, Final Report*, University of Sheffield, Division of Economic Studies, July 1981, p.2.

5 See John Lane, *Arts Centres: Every town should have one*, Paul Elek, 1978.

6 'Come Dance With Kitty Stobling', BBC Radio 3, 3 October 1980.

Appendix A

Memorandum Submitted by the Arts Council of Great Britain to the House of Commons Select Committee on Education, Science and the Arts, 13 May 1981

ORIGINS

1. The Arts Council grew out of the Council for the Encouragement of Music and the Arts (CEMA), set up following the outbreak of the Second World War in 1939. On 12 June 1945 it was announced in the House of Commons that CEMA would continue as a peacetime organisation under the name The Arts Council of Great Britain, and the Council was granted a Royal Charter of Incorporation on 9 August 1946.

THE PRESENT CHARTER

2. In February 1967 the Council was granted a new Charter which provides that the Council is established and incorporated: 'To develop and improve the knowledge, understanding and practice of the arts; to increase the accessibility of the arts to the public throughout Great Britain; and to advise and co-operate with Departments of Government, local authorities and other bodies on any matters concerned whether directly or indirectly with the foregoing objects.'

SOURCE OF INCOME

3. The Council receives an annual grant-in-aid from the Government, and the grant for the year ending 31 March 1982 was announced in December 1980 as £80,000,000, of which £2.5m is for capital and £77.5m for revenue purposes and on this basis the Council will enter into revenue commitments totalling £77,750,000. Annual grants-in-aid are summarised at Appendix A and the allocations for 1980/81 and 1981/82 are shown at Appendix B. The Council's annual reports contain full details of the expenditure of the grant-in-aid.

MINISTERIAL AND DEPARTMENTAL RESPONSIBILITY

4. For the first twenty years of its life the Arts Council received its grant direct from the Treasury and was responsible to the Chancellor of the Exchequer. However, in 1965 it was decided in future to route the grant through the Department of Education and Science and a Minister of State in the DES was given special responsibility for the Arts. The Secretary of State for Education and Science became responsible in Cabinet for the arts vote, and for the appointment of Council members and an assessor to the Council.

CHAIRMEN

5. The following have served as Chairmen of the Council:

1945–1946:	Lord Keynes
1946–1953:	Sir Ernest Pooley
1953–1960:	Lord Clark
1960–1965:	Lord Cottesloe
1965–1972:	Lord Goodman
1972–1977:	Lord Gibson
1977– :	The Rt Hon. Kenneth Robinson

SECRETARIES-GENERAL

6. The following have served as Secretaries-General:

1945–1951:	Miss Mary Glasgow
1951–1963:	Sir William Emrys Williams
1963–1968:	Mr Nigel Abercrombie
1968–1975:	Sir Hugh Willatt
1975– :	Sir Roy Shaw

MEMBERSHIP OF THE COUNCIL

7. The Charter provides for a Council consisting of 'a Chairman, a Vice-Chairman and not more than eighteen other members' all to be appointed by the Secretary of State for Education and Science after consultation with the Secretaries of State for Scotland and Wales.

163

8. Appointments are made for periods not exceeding five years. Members are not eligible for immediate reappointment at the end of their term unless they hold office as Chairman or Vice-Chairman of the Council, of the Scottish Arts Council or the Welsh Arts Council, Chairman of a panel.

9. Although it is not laid down in the Charter, the present practice is that two members of the Council should be from Scotland and two from Wales.

10. Members of the Council (and its committees and panels) are not paid for their services as such but may claim reimbursement of expenses incurred in the performance of their duties. They are chosen as individuals, not as representatives of particular interests or organisations.

SCOTTISH AND WELSH ARTS COUNCILS

11. The Council is enjoined by the Charter to appoint, with approval respectively of the Secretary of State for Scotland and the Secretary of State for Wales, 'committees, to be called the Scottish Arts Council and the Welsh Arts Council,' to exercise, or advise on the exercise of, its functions in Scotland and Wales. The Chairmen of these two committees must be members of the Arts Council of Great Britain.

12. The Scottish and Welsh Arts Councils are virtually autonomous, although their allocations form part of the Arts Council of Great Britain's total grant-in-aid.

OTHER COMMITTEES AND PANELS

13. In the words of the Charter, 'the Council may appoint other committees and panels to advise and assist them in the exercise of such of their functions as may be determined by the Council... The Council shall appoint as Chairman of any such committee or panel a member of the committee or panel who is a member of the Council... The Council may appoint to any such committee or panel members who are not members of the Council...'.

14. There are two committees of the Council which concern themselves with matters affecting Great Britain as a whole. They are the Finance and Policy Committee and the Housing the Arts Committee, and both have Scottish and Welsh representation. The Chairman of the Council chairs the Finance and Policy Committee and a member of the Council chairs the Housing the Arts Com-

mittee. All members of the Finance and Policy Committee are also members of the Council; the Housing the Arts Committee includes members with specialist qualifications who are not serving Council members. The principal functions of the Finance and Policy Committee are to recommend the allocation of the annual grant and the apportionment between England, Scotland and Wales and to give initial consideration to matters of policy and forward planning. The Housing the Arts Committee advises the Council on the spending of a special allocation, for Great Britain as a whole, from which contributions are made towards the cost of building new concert halls, theatres, arts centres and galleries, or adapting and improving existing buildings.

15. Five panels have been appointed to advise the Council and the officers on the formulation and implementation of policy on Art, Dance, Drama, Literature and Music. Each panel has as its Chairman a member of the Council. The Scottish and Welsh Arts Councils have similar advisory structures. The Council's structure of Advisory Panels, Committees and Sub-Committees is shown at Appendix C.

The membership of these advisory groups totalling about 170 enables the Council to draw on a wide range and rich variety of experience in each area of activity. For example the Drama Advisory Panel comprises directors, performers, playwrights, a designer, the Chairman of a repertory company, two Council members and members with academic and broadcasting experience. This membership is able to cover the range of artistic, administrative and budgetary experience necessary to fulfil the Panel's advisory function. In addition a further 40 independent ad hoc advisers based in the regions attend performances and report on them to the Council.

HOW THE ARTS ARE SUPPORTED

16. The Council's financial support for the arts is advanced principally through assistance to the professional arts. The arts are defined in practice as widely as possible, and are supported chiefly under the following heads: dance, drama, literature, music, visual arts, including arts films and photography, community arts, and multimedia experimental projects that often combine two or more of the disciplines mentioned above.

17. The Council responds with subsidy, advice and encouragement to initiatives being taken to promote the arts, subject to its assessment of their quality and value and to the availability of resources.

At the same time, however, it is ready to take or promote initiatives of its own where it identifies substantial gaps in existing provision. It also lays particular emphasis on co-operation between arts providers and education providers of all kinds.

18. In accordance with its chartered duty 'to develop and improve the knowledge, understanding and practice of the arts,' the Council encourages its clients to engage in broadly-based educational work without duplicating the work of education providers. The Council has a small Education Unit where staff encourage exemplary forms of co-operation. The Unit's role is an advisory and co-ordinating one. It has no specific funds to provide financial assistance; grant applications are considered by the appropriate art form department.

19. One of the perennial problems of the Council in pursuing its chartered aims had been the rival claims of maintaining standards on the one hand, and bringing the arts to as many people as possible on the other. This has often been summarised as a dilemma between whether to 'raise' or 'spread'. In its early years the Council decided unequivocally to raise. The present climate of opinion puts greater emphasis on the need to spread – reflected in the subsidising of small-scale touring theatre and community arts. Some would argue that the need to spread is now greater than the need to raise, but the policy of the Council is still to attempt to do both. To do both adequately would, however, call for much larger resources, and difficult choices often have to be made. Hence the Council cannot please everyone.

20. In making choices it is salutary to remember that the room for innovation by panels and committees, and the Council itself, is limited by past decisions and commitments – just as succeeding panels and committees will be limited by the consequences of decisions being made now.

21. Most of the Council's funds are made available as subsidies. Among the organisations receiving financial assistance on an annual basis are the national opera, dance and drama companies: the Royal Opera, the Royal Ballet, the English National Opera, the National Theatre, and the Royal Shakespeare Company at Stratford and London. The Council's subsidies cover visits to regional centres by those companies and others such as London Festival Ballet, Cambridge and Oxford Theatre Companies, Kent Opera, Scottish Opera and Welsh National Opera. Annual subsidy is also made available to the 9 principal orchestras, 6 major regional theatre companies (in Birmingham, Bristol, Leicester, Manchester, Not-

tingham and Sheffield) and 34 other building-based theatre
companies in the regions as well as smaller touring and community
theatre companies and children's/young people's companies, 4
dance companies, music and arts festivals and art galleries. All of
these – and most of the Council's other clients – are established on a
non-profit-distributing basis and registered as charities.

22. Among other organisations to which help is given, often for
specific programmes or projects, are community arts groups, arts
centres, small dance, mime and drama companies, music and opera
groups, organisations concerned with literature and magazine-
publishing, and groups and galleries engaged in visual arts
activities.

23. The Welsh and Scottish Arts Council support a similar range of
arts organisations in those countries. Organisations supported by
the Scottish Arts Council include Scottish Opera, Scottish Ballet,
Scottish National Orchestra, Scottish Philharmonic Society, the
Edinburgh Festival, the Third Eye Centre, Glastow, and 7 reper-
tory companies including Glasgow Citizens and Edinburgh
Lyceum theatres.

24. Organisations supported by the Welsh Arts Council include,
Welsh National Opera, BBC Welsh Symphony Orchestra, Moving
Being, Chapter Arts Centre, Cardiff, Theatr Clwyd, Theatr Bara
Caws, Mostyn Gallery, Llandudno and the Welsh Books Council.
In Wales support for literature and drama relates to work in both
English and Welsh. The Welsh Arts Council also supports film and
craft activities in Wales with the help of funds from the British Film
Institute and the Crafts Council.

25. All subsidies are agreed by the Council after careful scrutiny of
estimates prepared by clients. In many cases the amount of subsidy
to be provided is agreed in negotiation with local authorities, who
are frequently expected to contribute to the total subsidy required.

26. Once an organisation is in receipt of continuing subsidy the
Council appoints an assessor to evaluate its work. Continuity of
support is dependent on the annual re-assessment by the Council of
client organisations' programmes and policies.

27. A proportion of the grant is also spent on the Council's own
promotions, mainly exhibitions at the Hayward Gallery and the
Serpentine Gallery; the circulation of art exhibitions throughout the
country; the production and distribution of films on the arts and
films by artists; tours of modern music through the Contemporary

Music Network; the administration of the Wigmore Hall; and the Arts Council Shop in Long Acre, London.

28. The Scottish Arts Council operates the Fruit Market Gallery in Edinburgh as well as a Travelling Gallery which tours throughout Scotland, visiting communities which have no gallery of their own.

29. The Welsh Arts Council operates Oriel, a gallery and bookshop in Cardiff; creates and tours art and craft exhibitions; promotes some 50 orchestral and chamber concerts throughout Wales each year; promotes recordings of contemporary music; and publishes series of volumes on the literature of Wales.

30. Local authority expenditure on a range of leisure and recreational activities throughout the country is substantial but in the sectors in which they and the Arts Council act jointly there are variations which make generalisation impossible. Some authorities are approaching parity with Arts Council subsidies to organisations in their areas, a very few exceed Arts Council subsidies but most are markedly the minor contributors. Present restrictions on local government expenditure and the fact that arts spending is discretionary seem likely to lead to some deterioration.

AID FOR CREATIVE ARTISTS

31. The Council gives aid to individual artists as well as to organisations, through a great variety of bursary and award schemes – an area in which the guidance of the Council's advisers has a special importance. Details are provided in a periodically updated *Guide to Awards and Schemes*, published by the Council. The Councils also maintain a Slide Index of the work of contemporary British artists. Details are also available of grant schemes through the Scottish and Welsh Arts Councils.

REGIONAL ARTS ASSOCIATIONS

32. A network of 12 regional arts associations now covers England (except Buckinghamshire). For some years the Council has gradually decentralised support for activities in England which are wholly regional in scope and character, by transferring responsibility for such activities to the regional arts associations. Grant-aiding the associations is a central feature of the Council's policy for regional development of the arts. On average the associations receive over 70 per cent of their income from the Arts Council.

33. Regional arts associations are concerned with all the arts. They are independent and autonomous, being neither regional branches

of the Arts Council, nor purely local authority associations, but they are funded by, and work in partnership with, both. Many also receive funds from the British Film Institute and the Crafts Council. There are no regional arts associations in Scotland where the Scottish Arts Council has developed a working relationship with district and regional local authorities. In Wales 3 regional arts associations are funded by the Welsh Arts Council to promote and market the arts in their regions and offer grant-aid to arts organisations serving local communities.

STAFF AND DEPARTMENTS

34. The Council's chief executive officer, appointed by the Council with the approval of the Secretary of State for Education and Science, is the Secretary-General. He is supported in the central administration of the Council's work and policies by his deputy. There are separate departments for Art, Dance, Drama, Finance, Literature, Music and Regional matters, each headed by a director. In addition, the Personnel and Administration Department has specialist staff dealing with central services such as information, personnel, marketing and publications and there are separate sections dealing with press and education. The Scottish and Welsh Arts Councils have similar departmental staffing structures headed by a director in each case.

35. Most of the Council's staff in England are based at 105 Piccadilly, London, in Scotland at 17 Charlotte Square, Edinburgh and in Wales at Holst House, Museum Place, Cardiff.

26. In mid-1980 there were 266 staff in England, 52 at the Scottish Arts Council and 66 at the Welsh Arts Council. The Council's departmental and staffing structure in England is shown at Appendix D.

DELEGATION OF AUTHORITY

37. The Council has delegated to the Secretary-General, supported by his senior officers, the responsibility for the day-to-day administration and management of the Council's business in England within the framework of policy advised by Panels and Committees and agreed by the Council. The Council's guidelines to the Secretary-General are set out at Appendix E which also indicates those areas in which the Council itself expects to take decisions.

38. The most significant area of change arising out of the delegation of authority is in the Council's subsidy operations where the

officers now make recommendations for approval by the Secretary-General in accordance with the Allocation of Grant determined in advance by the Council. The Allocation of Grant includes individual figures for each revenue funded client. The Finance and Policy Committee monitors the exercise of delegated authority by the Secretary-General and the Directors.

CONCLUSION

39. The Council believes that the essential features of the system described above, and in particular the distance which it places between the Government and those responsible for detailed decisions about individual subsidies for the arts, operate in the best interests of the arts as a whole. It is instructive that they have been widely copied in other countries, most notably in the United States and in the Commonwealth; and that they are much envied in those countries where arts subsidy is a direct function of government. The best testimony of the particular strength of the system's operation in Britain is the range, extent and quality of the artistic provision which it sustains, notwithstanding the comparatively low level of central Government spending on it.

ARTS COUNCIL OF GREAT BRITAIN: GRANT-IN-AID FROM 1945/46

Appendix a

	TOTAL £	%+/-	ENGLAND £	%+/-	SCOTLAND £	%+/-	WALES £	%+/-	HOUSING THE ARTS £	%+/-
1945/46	235,000		235,000							
1946/47	350,000	49	350,000	49						
1947/48	428,000	22	392,000	12	36,000					
1948/49	575,000	34	533,000	36	42,000	17				
1949/50	600,000	4	558,000	5	42,000	0				
1950/51	675,000	13	593,000	6	82,000	95				
1951/52	875,000	30	823,000	39	52,000	-37				
1952/53	675,000	-23	618,000	-25	57,000	10				
1953/54	785,000	16	679,250	10	75,750	33	30,000			
1954/55	785,000	0	677,250	0	75,750	0	32,000	7		
1955/56	820,000	4	703,915	4	82,270	9	33,815	6		
1956/57	885,000	8	771,700	10	78,050	-5	35,250	4		
1957/58	985,000	11	859,914	11	82,176	5	42,910	22		
1958/59	1,100,000	12	971,220	13	84,850	3	43,950	2		
1959/60	1,218,000	11	1,089,200	12	84,850	0	43,950	0		
1960/61	1,500,000	23	1,328,783	22	110,394	30	60,823	38		
1961/62	1,745,000	16	1,543,388	16	123,267	12	73,345	29		
1962/63	2,190,000	26	1,937,044	26	144,666	17	108,290	38		
1963/64	2,730,000	25	2,414,968	25	174,600	21	140,432	30		
1964/65	3,205,000	17	2,846,636	18	202,789	16	155,575	11		
1965/66	3,910,000	22	3,312,188	16	257,890	27	189,922	22	150,000	
1966/67	5,700,000	46	4,744,714	43	450,286	75	305,000	61	200,000	33
1967/68	7,200,000	26	5,840,000	23	630,000	40	430,000	41	300,000	50
1968/69	7,750,000	8	6,207,500	6	705,000	12	487,500	13	350,000	17
1969/70	8,200,000	6	6,378,250	3	833,750	18	518,000	6	470,000	34
1970/71	9,300,000	13	7,206,000	13	950,000	14	564,000	9	580,000	23
1971/72	11,900,000	28	8,983,903	25	1,259,862	33	886,235	57	770,000	33
1972/73	13,961,500	17	10,850,149	21	1,400,000	11	886,351	0	825,000	7
1973/74	17,138,000	23	12,810,570	18	1,905,000	36	1,152,430	30	1,270,000	54
1974/75	21,335,000	24	16,518,150	29	2,414,700	27	1,852,150	61	550,000	-57
1975/76	28,850,000	35	22,559,560	37	3,100,000	28	2,340,440	26	850,000	55
1976/77	37,150,000	29	28,837,052	28	4,406,400	42	2,736,548	18	1,150,000	35
1977/78	41,725,000	15	33,027,678	15	4,970,000	13	3,202,322	16	525,000	-54
1978/79	51,800,000	24	40,584,000	23	6,017,000	21	3,849,000	20	1,350,000	157
1979/80	63,125,000	22	49,410,500	22	7,352,000	22	4,514,500	17	1,875,000	39
1980/81	70,970,000	12	56,115,000	14	8,400,000	16	4,985,000	11	1,470,000	-22
1981/82	80,250,000	13	62,923,000*	12	9,344,000*	11	5,483,000*	10	2,500,000*	70

*Estimates

Appendix b

ARTS COUNCIL OF GREAT BRITAIN ALLOCATIONS

1980/81 £			1981/82 £
56,115,000		**A1 ENGLAND**	62,923,000
52,857,400	1)	General Expenditure on the Arts	59,288,500
	a)	Royal Opera House, Covent Garden Limited, English National Opera, National Theatre Board and Royal Shakespeare Theatre — 21,000,000	
	b)	Music, Opera and Dance — 12,248,500	
	c)	Drama — 11,570,000	
	d)	Art — 3,892,000	
	e)	Literature — 852,000	
	f)	Festivals — 114,500	
	g)	Arts Associations, Arts Centres and Regional Projects — 9,031,500	
	h)	Training in the Arts — 580,000	
3,100,000	2)	Administration and Operational Expenditure	3,440,000
157,600		Unallocated	194,500
8,400,000		**A2 SCOTLAND**	9,344,000
7,876,000	1)	General Expenditure on the Arts	8,771,040
	a)	Music, Opera and Dance — 4,306,300	
	b)	Drama — 2,031,040	
	c)	Art — 903,900	
	d)	Literature — 374,000	
	e)	Festivals — 388,300	
	f)	Arts Associations, Arts Centres and Regional Projects — 767,500	
499.000	2)	Administration and Operational Expenditure	572,960
25,000		Unallocated	—
4,985,000		**A3 WALES**	5,483,000
4,564,000	1)	General Expenditure on the Arts	4,911,000
	a)	Music, Opera and Dance — 1,854,000	
	b)	Drama — 1,315,500	
	c)	Art — 500,500	
	d)	Literature — 488,500	
	e)	Festivals — 85,000	
	f)	Arts Associations, Arts Centres and Regional Projects — 667,500	
421,000	2)	Administration and Operational Expenditure	507,000
—		Unallocated	65,000
1,470,000		**A4 HOUSING THE ARTS**	2,500,000
70,970,000		*TOTAL*	80,250,000

ARTS COUNCIL ADVISORY PANELS AND COMMITTEES FROM 1 APRIL 1980

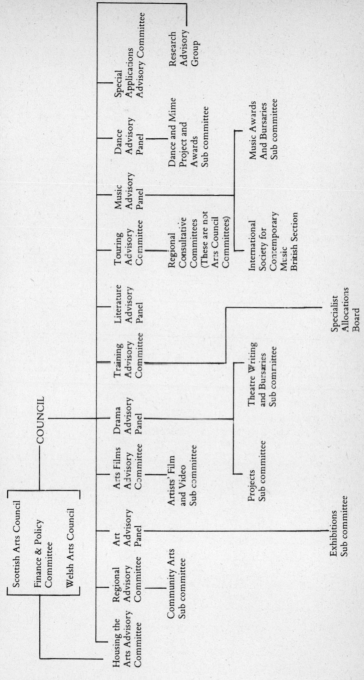

Appendix d

THE COUNCIL'S DEPARTMENTAL AND STAFFING STRUCTURE IN ENGLAND

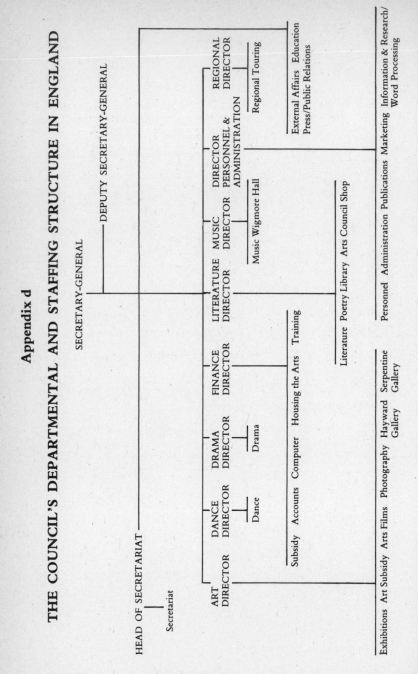

Appendix e

THE COUNCIL'S GUIDELINES TO THE SECRETARY-GENERAL

1. The Council delegates to the Secretary-General, supported by his senior officers, the responsibility for the day-to-day administration and management of the Council's business within the framework of policy advised by panels and committees and agreed by the Council. He is, however, expected to report to the Council on matters of current interest, and Council bears the ultimate responsibility for decisions taken on its behalf, and for the allocation of grant.

2. The Council itself expects to take decisions in respect of the following matters in particular.

General

i) Proposed new annual commitments and new areas of activity and the abandonment of existing activities.

ii) Major changes in the Council's methods of operation.

iii) Questions affecting the Council's rights or obligations under its Charter.

iv) Questions affecting relations between Council and the Government.

v) The function, formation and disbandment of the Council's advisory panels, committees and sub-committees including the appointment of their chairmen.

Financial

vi) The Council's annual estimates and any major alterations subsequently proposed in these estimates.

vii) The Council's annual allocation of grant and any major alterations subsequently proposed in the allocation.

viii) Negotiations relating to the acquisition or disposal of freehold or leasehold premises.

Staff

ix) Major alterations in the terms and conditions of service of staff.

x) The appointment of staff at Director level and above and major changes in responsibilities at that level.

xi) Recognition of staff representative bodies.

March 1980

Addendum

1. *TAXATION*

Organisations in receipt of annual revenue subsidy from the Arts Council are registered charities governed by non-profit distributing constitutions the main aims and objects of which are educational.

We believe that their constitutions place these organisations in an identifiable and restricted category which would limit the area of benefit if tax legislation were introduced to assist this group.

i) *Income tax concessions for individuals*

In the United States of America substantial tax relief for charitable donations has helped to encourage donations from individuals and private foundations to such an extent that funds from these sources now represent the largest proportion of the income of arts organisations and far exceed the amount provided by business and commerce.

It would greatly assist arts organisations in Britain if legislation were introduced allowing individuals donating funds to arts educational charities to offset such donations against their assessments to income tax.

ii) *Value added tax*

The charitable status referred to above has enabled successive governments to relieve from corporate and various other taxation organisations in receipt of subsidy from the Arts Council. However no such relief has been granted from value added tax.

The imposition of VAT at the full rate of 15 per cent distorts the natural elasticity of the market in which arts organisations operate and deprives them of the full benefit of maximising box office revenues. In effect, the Government gives public subsidy with one hand, and takes a large slice of it back with the other.

In most countries of the EEC the arts are more favourably treated for

176

VAT purposes than in this country. In West Germany subsidised theatre is totally relieved of this tax.

The Council believes that arts organisations registered as charities should be granted zero-rated status for the purposes of value added tax.

2. NOTIFICATION OF GRANT-IN-AID

The greatest single impediment to sensible planning in the Arts Council's operations is the lack of early notification of the annual grant-in-aid.

The reason why early notification is of crucial importance to us is that unlike most other items of government expenditure, by far the greatest proportion of the Council's grant-in-aid is allocated in turn as subsidy to other organisations. The grant for the current financial year was announced on 9 December 1980, which was appreciably earlier than in previous years (when it was once as late as the middle of February). Even so, the period of notice which this enabled the Council to give its clients in relation to their 1981/82 subsidies was quite inadequate: all the organisations the Council supports have themselves to plan ahead on a far longer timescale than such a period permits.

Following the recommendations of the Estimates Committee session 1967/68, the Council's grant-in-aid was put on a rolling triennial footing on a 'not-less-than' basis. Regrettably as a result of general economic pressures this system lapsed within its initial triennium.

Present economic circumstances perhaps make it unrealistic to hope for a return to advance notification of grant-in-aid on the rolling triennial basis recommended by the 1967/68 Estimates Committee. Nevertheless, the earlier the grant-in-aid can be announced, the more efficient will be the use of the funds available. In this connexion the Government's published forecasts of expenditure offer very little guidance because the Arts Council's figure is bound up with other arts expenditure figures and because of the inevitable uncertainty about the allowance to be made for inflation from one year to the next.

The problems generated by the lack of advance notification of grant-in-aid were highlighted by the events of last December when in the light of the total funds available for 1981/82 the Council decided that it could not continue to provide subsidy for all its existing clients. The Council readily acknowledges and is keen to respond to the general view that there should have been a longer

period of notice of withdrawal. However, under present arrangements, the Council could only do this by indicating which companies might lose their subsidy on the basis of a series of quite hypothetical alternative figures for its own total grant. Apart from its inherent absurdity, such a procedure would be highly disruptive and disturbing to all the organisations supported by the Council and by implying that their futures were at risk could destroy their trading positions unnecessarily.

This is not to say that the Council is in any doubt about the need to warn clients when, irrespective of the level of its own grant, their subsidy is at risk as a result of inadequate performance: the Chairman has already publicly undertaken to the Minister that the Council will ensure this is done.

3. PROBLEMS CAUSED BY A STATIC GRANT IN REAL TERMS

By the measure of the retail price index, the Council's grant-in-aid in 1981/82 was almost at the same level in real terms as for 1980/81. This has led some commentators to ask why it was necessary for the Council to terminate the grants referred to above.

In recent years, the Council has come under increasing criticism from its clients, the unions and the public generally for spreading available finance too thinly leaving companies with insufficient funds to mount their work. Thus new theatre buildings have sometimes been closed for as much as a third of the year; new performing groups have often been unable to perform for more than a few weeks at a time; orchestras have been denied the opportunity to develop a wider repertoire; and established opera and dance companies have had to restrict touring and cancel projected new productions.

The Council set out these problems clearly in its submissions to the Government on its financial needs for 1981/82. It explained that its clients were experiencing growing financial difficulties; and that without an increase in its grant which provided real growth over and above the expected level of inflation, the situation would inevitably deteriorate in 1981/82 precipitating the uncontrolled collapse of some companies.

The arts almost by definition represent development and it is difficult to sustain the arts on the basis of static resources. Arts organisations depend on the capacity to improve and develop in terms of output and standards. An artistically successful organisation cannot stand still. If the total available resources remain at the existing level the result would inevitably be the erosion of standards

and further diminution of the numbers of organisations we can sustain.

In addition to the need for a controlled and planned progression of development in established companies, the Council also has to recognise the needs of those new or less established organisations supported for the first time in quite recent years when there seemed good reason to expect continued growth in the resources available.

Finally, the retail price index does not represent inflation in the arts. First the arts are highly labour-intensive by their nature and do not benefit from the general improvements in labour productivity which help to keep the overall index down. Secondly, they are highly dependent on such things as hotel, transport and utility prices, which are normally well ahead of the overall index and on specific materials such as wood, which are soaring in price even today. A research study is in progress which is designed to quantify these problems as far as possible.

4. THE ARTS COUNCIL AND THE REGIONAL ARTS ASSOCIATIONS

As a result of almost simultaneous suggestions made independently by CORAA and the Council's Organisation Working Party in 1979, the Council invited an informal working group of Regional Arts Associations and Arts Council officers to examine working relationships between the Arts Council and the RAAs and to make recommendations.

The group's report *Towards a New Relationship* (a copy of which was enclosed to the Committee)[1] was received by the Council at its meeting in May 1980 when it was agreed that it should be widely distributed as a public discussion paper. Council returned to a substantive discussion of the report at its meeting in January 1981 in the light of comments made by interested organisations and individuals.

Throughout their discussion of the report, members of the Council were warmly supportive of the Regional Arts Associations (RAAs). From the Council's point of view the RAAs perform four vital functions:

i) given that the impetus for establishing RAAs began with local authorities, they provide a common focus for the interest and involvement in the arts of individual local authorities from District to County Council levels;

[1] Not printed.

179

ii) they provide at regional level a body of specialist expertise and advice which is more extensive than any individual local authority could normally hope to provide and which is also directly available to arts organisations of all kinds;

iii) they provide a means of assessing local artistic needs and demands on the basis of a degree of day-to-day familiarity with the regions which the national body like the Arts Council could never develop for itself;

iv) as a result of (i) to (iii), they constitute an invaluable resource to which the Arts Council itself can turn for advice, consultation and discussion in developing those of its own policies which have a regional dimension.

The Council recognises that, for a variety of reasons explored in the report, the RAA system itself and the pattern of relationships between central funding bodies, local authorities and RAAs have had their imperfections. However, it firmly believes that the advantages of the system very substantially outweigh any such imperfections, and that the right course for the foreseeable future is to work with the RAAs themselves and with other central and local funders to improve the system rather than to embark on any fundamental changes.

As with any system – and perhaps particularly one which depends on regional bodies within a wider national framework of government which lacks a regional tier – many of the imperfections of the past can be attributed to inadequate communications between the various parties involved. The recommendations in the report on working links between the Council and the RAAs should contribute to a major improvement, and the Council has broadly endorsed them.

Some of the problems have, however, been seated in constitutional matters, affecting both the RAAs and the Arts Council, and in uncertainty about certain aspects of RAA funding. Here too, the Council has generally endorsed the relevant recommendations of the report.

The question of devolving to the RAAs responsibility for assessing Arts Council clients and activities has been a major source of friction for some time, and continues to attract controversy, particularly among the clients themselves and their representative bodies. However, the Council believes that the report's reformulation of the devolution issue in terms of the need to determine the most appropriate assessment base for individual clients and activities is both sensible in itself and likely to offer a constructive basis

for future progress. The precise details of such progress will nevertheless require a good deal of thought, not least in relation to the highly contentious question of whether clients should ever be devolved against their own wishes. Council has asked that the matter be examined on a client-by-client basis, initially by its own and RAA officers working informally together, with a view to a further discussion by the Council of the complex issues of practice and of principle involved. The Council will be returning to the whole question of devolution at its next meeting.

One important area on which the report touched at several points (though comprehensive detailed discussions would have been outside the working group's terms of reference) is relationships between the RAAs and local authorities. Following a meeting with the local authority associations convened by the Minister for the Arts, the Chairman of the Council has agreed to chair a small group of members and officers representing the Council, the local authority associations and the Council of Regional Arts Associations to explore the report's implications for those relationships.

One issue which will no doubt arise during discussions by such a group will be the level of local authority finance for the RAAs, which currently averages only about 20 per cent of total RAA incomes and is in the case of one RAA as low as 8 per cent.

May 1981.

Appendix B

Open Letter to Melvyn Bragg, Chairman, Literature Panel, Arts Council of Great Britain from the Federation of Worker Writers and Community Publishers

Dear Mr Bragg,

We are once again approaching the Arts Council Literature Panel for money for a national co-ordinator and literature promotions worker. In spite of past refusals – based we believe in error and prejudice rather than in malice – we do not yet despair of receiving fair treatment at your hands. In fact we hope that you will take the opportunity of correcting an injustice that has lingered over two years.

As is now well known the Federation is a national organisation which has grown to comprise some twenty-four writers' workshops and community publishing groups concerned with furthering the cause of working class writing and community publishing. The focus on working class writing – a term broadly rather than narrowly interpreted – has frequently been explained and was a response to the serious neglect of the literary creativity of a very large section of our population. We note, as you must have, that it has given no grounds for disquiet in a specialist adviser commissioned by the Arts Council itself. We note too that the neglect of which we complain (and about which we are trying to do something, not without success) was tacitly acknowledged two years ago by the Arts Council in its decision to grant £2,000 towards the publication of our first anthology, *Writing*.

It is also well known that the post of national co-ordinator is an integral part of the Federation's structure. It is through the co-ordinator that the often financially frail workshops and publishing groups are kept in touch with each other, provided with an information service, advice and support. It is through the national co-ordinator that new groups are identified, advised and brought into the supportive framework of a movement. It is through the co-ordinator too that groups and individual writers are brought into touch with opportunities for furthering or developing their work.

The success of the Federation as an organisation for helping

working class writers does not seem to be in dispute. In recent years nearly 200 titles have been offered to the public with sales somewhere in the region of half a million. Public readings have been held, meetings and conferences organised, radio and television programmes made. Partly for this reason the Gulbenkian Foundation has been willing to give generous financial help, including the underwriting of the co-ordinator's salary for a year on the assumption, which regrettably turned out to be incorrect, that the Arts Council would match the contribution.

The Federation's success has been recognised within the offices of the Arts Council itself. Mr Charles Osborne, Literature Director, commented in December 1978 on the 'growing strength and scope of community publishers and writing all over the country'. And Mr Blake Morrison, a Poetry and Fiction Editor for the Times Literary Supplement, who was commissioned by the Arts Council to give an objective assessment of, *inter alia* the work of the Federation, has quite unequivocally described it as:

A useful co-ordinating agency in one of the few growth areas of contemporary literature.

and has urged the Arts Council to consider 'with greater thought and care' than hitherto subsequent applications for funds.

Reasons for the Arts Council's resistance to the Federation applications are something of a mystery. In a letter of December 1978 already quoted Mr Osborne wrote in somewhat patronising terms to say that the Literature Finance Committee was not convinced that the Federation's productions were of 'solid literary value'. This judgement was repeated in much the same terms after Federation representatives had met the Literature Finance Committee in March 1979. The committee, apparently unanimously, decided that the Federation was 'successful in a social, therapeutic sense, but not by literary standards'. What these literary standards are and who is applying them and whether they are always applied (or only to some organisations) remains obscure and there is a suspicion that standards and the aesthetics underlying them are not much debated in Arts Council meetings.

In fact the only person connected with the Arts Council to make clear the assumptions by which he judged the Federation's work has been their specialist adviser, Mr Morrison. Mr Morrison's report on the work is admirably thorough. He finds it of varying standard but is in no doubt that a great deal of it displays sufficient merit to deserve Arts Council support.

Mr Morrison's report with its essentially favourable judgement

on the Federation and its member groups has not yet been published. We find this strange given the debate over standards currently taking place.

Mr Morrison is not alone in finding literary merit in the output of the Federation's members. For example, in a recent article in *The English Magazine*, Mr Gerry Gregory of Shoreditch College applies traditional literary critical standards, and comments:

While you will find much that is dull, flawed and frankly poor, you will also find as much to admire as in any other reasonably comparable body of writing. There is no space here to provide examples of a sufficient length to demonstrate this – and fragments do not meet the case. However the Arts Council of Great Britain verdict must surely surprise anyone who has read, say, Joe Smythe's poem 'When the Soldiers Came' (*Voices* 19), Ken Clay's short story 'On the Knocker' (*Voices* 15), the Strong Words' documentary publication *Hello Are You Working?*, much of the work that has emerged from the various projects within Centerprise (Hackney), and practically anything produced by the Scotland Road Writers' Workshop.

And Raymond Williams, writing in the *Times Literary Supplement* of 6 June this year has this to say in a piece, 'The role of the literary magazine':

What has been happening for twenty years in the geographical area that we call the British mainland ... has been the emergence of some new kinds of writer and writing: for example, among many others, the *Lifetimes* pamphlets, the Centerprise publications, the Writers and Readers Cooperative.
Much of this work is still finding its way; in some cases literally finding, trying to find its forms... The most important function of literary magazines, within the existing and increasing cultural hegemony, is to provide many openings for experiments, for first attempts, and then for collaborative exchange and experiment: the processes from which real identities, as distinct from the competitive shortcut to a market identity can come. Thus I would rather see a hundred magazines of this kind – and really a useful number would be in the thousands – than three or four new London or axis glossies...

Instead of this producing a change of attitude by the Arts Council, it seems to have led to a new excuse for rejection. In a recent letter to a Federation member Sir Roy Shaw has argued that the applications were 'rejected not because our literature advisers thought that none of your members capable of writing anything of

merit, but because the need for someone to be engaged at a fee to stimulate people into writing was not regarded as valid.'

Yet the Arts Council has spent considerable money on schemes aimed at stimulating people into writing: what else are the various writing grants, projects for writers in residence, writers in schools and the National Poetry Secretariat all about, to name but a few? Sir Roy also gets wrong the functions of the national co-ordinator who was *not* employed to stimulate writing where the impulse was weak but rather to assist working class writers of strong impulse and few resources, by providing advice, support, opportunities for readings, and contact with other writers, publishers, persons and agencies concerned with publishing and distributing new work. However we are intending to appoint a literature promotion worker. The reasons for this appointment will be evident from the enclosed job description.

Later in the letter Sir Roy argues that the problem in Britain lies not in getting people to write but in getting people to read, a formulation also popular with Mr Osborne who astonishingly wrote to another of our members in the following style:

It may seem to you unfair that some people are more talented than others, and indeed it is unfair; however it remains a fact that talent in the arts has not been handed out equally by some impeccably heavenly democrat. You are right to think that the Arts Council views itself as a patron of the arts. This is indeed our function. It is important that we do all we can to increase audiences for today's writers, *not that we increase the number of writers*. (Our italics)

Not only does this miss the connection between creativity and consumption (writers *are* readers) but it ignores the extent to which the Federation has opened up markets for not only its own work but literature (and theatre) in general.

We feel obliged to point out that we have patiently been seeking assistance from the Arts Council since the first half of 1978 and that in that time have tried – at some expense – to meet every request for information about our organisation, for examples of our work and for submissions and resubmissions. We have no wish to quarrel with the Arts Council but its response to us seems to have been evasive and patronising throughout: as we meet each objection raised, another seems to be found. We are forming the impression that the real objection to us is not based on the quality of our work but on the fact that we are concerned with working class writing and that our methods of encouraging writers are based on workshops and collectives rather than on the traditional concept of the

185

artist-in-a-garret. In reply we quote your specialist adviser, Mr Morrison once again:

FWWCP's attachment to 'working class writing' has, I know unsettled at least one member of the Arts Council's literature panel, who felt that this was a sign of political rather than literary ambition. I do not think that this distinction holds. To encourage the growth of literature in a section of society which for various social and economic reasons, has not yet made a proportionate contribution to literary culture – this is a literary as well as a political function.

We find it rather disquieting that the decisions taken to refuse us funds are seemingly arrived at by a very small group of people. We have a certain amount of evidence that very few judges of literature in the Arts Council have had a chance to assess our work – in spite of our willingness to make it available. We have all along made it clear that we are willing to debate – in private or in public – the quality of our work and the principles of our organisation.

In conclusion we would say this in great good faith: surely the time has come for the Arts Council to put aside the past, to act in the spirit of its specialist adviser's report and treat us justly in the way we ask? Surely there can be little objection to giving a few thousand pounds for a few years to an organisation which is demonstrably enriching and widening participation in literary culture on a variety of levels? We can understand, though we do not approve of it, the kind of thinking which has traditionally made the Arts Council the patron – with a few exceptions – of a generally privileged minority, the talented middle class and its societies and institutions. We would not trouble the Arts Council if we had other sources of funds. But we don't and our financial position is parlous. The Gulbenkian Foundation which has so generously assisted us for years can do so no longer. The working people of this country are the major contributors to the financing of the Arts. We ask that some of their money be used for them.

Barbara Shane.
Chairperson FWWCP
16.6.1980